American Narrative Painting

Cover
Benjamin West (1738-1820)
William Penn's Treaty with the Indians, 1771
(detail)
Catalog Number 5

Catalog notes by Nancy Wall Moure Essay by Donelson F. Hoopes

American Narrative Painting

★ ★

Los Angeles County Museum of Art, in association with Praeger Publishers, Inc.

Exhibition dates: October 1 - November 17, 1974

Library of Congress
Catalog Card Number 74-7858
Copyright © 1974 by
Museum Associates of the
Los Angeles County Museum of Art
ISBN 0-87587-060-0

Published by the
Los Angeles County Museum of Art
in association with
Praeger Publishers, Inc.

Printed in the United States of America

Contents

Addison Gallery of American Art, Phillips Academy
Albany Institute of History and Art
American Philosophical Society
Anonymous Lender
Anonymous Loan, Courtesy of the
 Fine Arts Gallery of San Diego
The Art Institute of Chicago
The Brooklyn Museum
Mr. and Mrs. John S. Broome
The Butler Institute of American Art
Corcoran Gallery of Art
Mrs. Bradley King Criley
Dr. and Mrs. Carl S. Dentzel
The Detroit Institute of Arts
The Fine Arts Museums of San Francisco
Fireman's Fund American Insurance Companies
Fort Worth Art Museum
Jack Frost Fine Arts
Mr. and Mrs. Julian Ganz, Jr.
Graham Gallery
The Historical Society of Pennsylvania
The Home Insurance Company
Mrs. C. Ruxton Love, Courtesy of Hirschl and Adler Galleries
IBM Corporation
M. Knoedler & Co., Inc.
Bernard and S. Dean Levy, Inc.
Meredith Long & Company

Los Angeles Athletic Club
Los Angeles County Museum of Art
Arthur and Nancy Manella
Mann Galleries
The Metropolitan Museum of Art
Munson-Williams-Proctor Institute
Museum of Art, Carnegie Institute
Museum of Fine Arts, Boston
National Collection of Fine Arts, Smithsonian Institution
National Gallery of Art
The Oakland Museum, Kahn Collection
Ohio Historical Society
Pennsylvania Academy of the Fine Arts
Philadelphia Museum of Art
The Rhode Island Historical Society
Dan H. Russell
Santa Barbara Museum of Art
The St. Louis Art Museum
Ira Spanierman, Inc.
Victor D. Spark
Robert C. Vose, Jr.
Wadsworth Atheneum
Hermann Warner Williams, Jr.
Mrs. Norman B. Woolworth
Worcester Art Museum
Yale University Art Gallery

Because of the very gratifying spirit of cooperation shown me by everyone to whom I turned in organizing "American Narrative Painting" I feel obliged to express my thanks individually to Christopher C. Cook, Director, and Nicki Thiras, Registrar, Addison Gallery of American Art; Norman S. Rice, Director, Albany Institute of History and Art; George W. Corner, Executive Officer, American Philosophical Society; Merrill C. Rueppel, Director, and Laura C. Luckey, Assistant, Department of Paintings, Museum of Fine Arts, Boston; Sarah Faunce, Curator, The Brooklyn Museum; Mr. and Mrs. John S. Broome; Clyde Singer, Associate Director, The Butler Institute of American Art; Herdis Bull Teilman, Curator of Painting and Sculpture, Museum of Art, Carnegie Institute; John David Farmer, Curator of Earlier Painting, The Art Institute of Chicago; R. Frederick Woolworth, Chairman, Coe Kerr Gallery, Inc.; Roy Slade, Director, and Dorothy Phillips, Curator, Corcoran Gallery of Art; Dr. Carl S. Dentzel; Frederick J. Cummings, Director, and Larry Curry, Curator of American Art, The Detroit Institute of Arts; Ian McKibbin White, Director, and Lanier Graham, Chief Curator, M. H. De Young Memorial Museum; Henry Gardner, Director, Fine Arts Gallery of San Diego; R. E. Hoefert, Vice President, Fireman's Fund American Insurance Companies; Dorothy Malone, Registrar, The Fort Worth Art Museum.

Jack Frost; Mr. and Mrs. Julian Ganz, Jr.; Robert C. Graham, Jr., Graham Gallery; E. Maurice Bloch, Director, Grunwald Center, UCLA; Jane L. Richards, Cecily Langdale, and Stuart P. Feld, Director, Hirschl and Adler Galleries; Dorothy C. Gates, The Home Insurance Company; Gloria Sullivan, IBM Corporation; H. Bruce Ewart, Thomas Jefferson University; Deedee Wigmore, Director, American Art, M. Knoedler & Co., Inc.; Mastin Kratz; S. Dean Levy, Bernard and S. Dean Levy, Inc.; Robert A. Mann, Mann Galleries; Arthur and Nancy Manella; George B. Snow, Clerk, Board of Selectmen; Meredith Long, Meredith Long & Company; Margaret Lawson, John K. Howat, Curator, American Paintings and Sculpture, and John Buchanan, The Metropolitan Museum of Art; Edward H. Dwight, Director, and Marjorie C. Freytag, Registrar, Munson-Williams-Proctor Institute; Alice G. Melrose, Director, National Academy of Design; Joshua C. Taylor, Director, National Collection of Fine Arts; William P. Campbell, Curator of Painting, J. Carter Brown, Director, and Jack C. Spinx, Chief of Exhibitions, National Gallery of Art; Eloise Scofield, Ohio Historical Center; George W. Neubert, Curator of Art, and Marjorie Arkelian, Art Department Historian, The Oakland Museum; Nicholas B. Wainwright, Director, The Historical Society of Pennsylvania; Evan H. Turner, Director, Philadelphia Museum of Art; Susan G. Ferguson, Acting Curator,

The Rhode Island Historical Society; Beatrix T. Rumford, Director, Abby Aldrich Rockefeller Folk Art Collection; Dan H. Russell; Charles E. Buckley, Director, and Mary-Edgar Patton, Registrar, The St. Louis Art Museum; Paul C. Mills, Director, Santa Barbara Museum of Art, Ira Spanierman; Victor D. Spark; Alfred T. Collette, Administrator, Syracuse University; Dr. and Mrs. Jacob Y. Terner; Robert C. Vose, Jr.; Peter O. Marlow, Chief Curator, Wadsworth Atheneum; Mrs. Bradley King Criley; Dagmar Reutlinger, Curator, and Stephen B. Jareckie, Registrar, Worcester Art Museum; Alan Shestack, Director, and Theodore E. Stebbins, Curator, Yale University Art Gallery; Hermann Warner Williams, Jr.; and William H. Gerdts.

To the staff of the Los Angeles County Museum of Art who have worked so tirelessly on the exhibition goes my lasting gratitude. Especially to my colleague, Nancy Wall Moure, Assistant Curator, Department of American Art, I owe particular thanks for her great contribution in preparing the catalog entries; and to Rae Avrutin and Diane Stutts for their many hours at manuscript typing. The Registrar Pat Nauert and her staff, Kristin McCormick and Elinore Cytron, supervised the many details involved in bringing together the actual exhibition. Edward Cornachio and his staff were most cooperative in providing photographic services. The entire project received the diligent attention of Jeanne Doyle, Coordinator of Exhibitions and Publications, and her able assistant Nancy Grubb who edited the catalog text.★

DONELSON F. HOOPES, *Senior Curator of American Art*

The storytelling element in American painting from the colonial era until comparatively recent times has been the dominant concern of artists of major importance. One of the earliest American narrative paintings, the example by Hesselius in the present exhibition (cat. no. 1), is a mythological subject, though naive religious paintings are far more in evidence throughout the eighteenth century than is genre. History painting, commemorating the great events of the Revolutionary War, gained impetus in the next century and gave America its first popular subjects for engravings. A strong genre tradition emerged in the second quarter of the nineteenth century, and it has tended to eclipse those other aspects of narrative painting. The present exhibition seeks to remove genre painting from isolation and to relate it once again to the full context of narrative art in America.

★ I ★

The Englishman John White made drawings of the settlement at Roanoke as early as 1585; even earlier, the Frenchman Jacques Le Moyne had made a set of idealized watercolor studies of Indian life in the territory now known as Florida. These remain the first pictorial records by Europeans of life in America, and for almost two centuries no colonial artist appeared to fix in paint or pencil the images of human activity during those important formative years. No artist was present to record the framing of the Mayflower Compact or the landing of the Pilgrims at Plymouth Plantation in Massachusetts (although there was an extremely fanciful and factually inaccurate rendition of the famous and probably equally fanciful landing on Plymouth Rock made in 1803 by Michel Felice Corné, ca. 1752-1845, Collection Department of State, Washington, D.C.). Nor was the single most important event in the history of the Western Hemisphere—its discovery—commemorated by any important American artist until John Vanderlyn was commissioned to paint his *Landing of Columbus* for the Rotunda of the United States Capitol in 1841.

Certainly by the end of the seventeenth century artists found employment in the Dutch colonies along the Hudson River, and in the English colonies in New England and the middle Atlantic territories, but "painting" in these early years meant portraiture rather than historical pictures. Occasionally descriptive elements were appended to a formal portrait, as in the portrait of Brigadier General Samuel Waldo (Walker Art Museum, Brunswick, Maine). Painted about 1750 by the elusive itinerant genius Robert Feke (active ca. 1741-1750), it portrays the victorious colonial general grandly presiding over the seige of the French fort of Louisbourg. The first genuine genre painting of consequence was created about five years later by John Greenwood

(1727-1792) in his *Sea Captains Carousing at Surinam* (fig. 1), although this, too, is essentially portraiture of a picaresque sort, conceived in the mode of the eighteenth-century "conversation piece."

Fig. 1

John Greenwood (1727-1792)
Sea Captains Carousing at Surinam, ca. 1775
Oil on canvas
37¾ x 75¼ in. (95.9 x 191.1 cm.)
St. Louis Art Museum

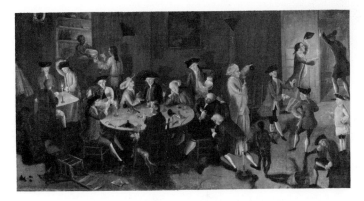

Allegory appeared briefly in colonial painting at the opening of the eighteenth century, then effectively disappeared as a concern of professional artists, although examples of naive art from this period are encountered frequently, particularly as wall decoration in houses. By far the most interesting examples of allegorical painting were created about 1720 by the immigrant Swedish artist Gustavus Hesselius, probably in Philadelphia. His subjects are drawn from classical mythology and reflect the penchant then current in European art for borrowing themes from Greek and Roman sources. Two of his allegorical paintings survive, *Bacchus and Ariadne* (Detroit Institute of Arts) and *Bacchanalian Revel* (cat. no. 1), and reveal the artist's considerable assimilation of style from Dutch painting. Although the Province of Pennsylvania was governed under a charter of liberal enlightenment, the celebration of orgiastic pleasures presented by Hesselius in these paintings could not have found general acceptance even there. The English colonies in America were dominated by Protestant Calvinism, which set a decidedly sober moral tone—a century before Hesselius, the Puritans had brutally crushed an outbreak of Cavalier libertinism at Merry Mount. It was not until about the middle of the eighteenth century that American colonists even seemed willing to have their portraits

painted in any costume more worldly than plain broadcloth. Only in the province of Maryland and certain other portions of the South when Royalists and Cavaliers dominated the cultural climate was there any evidence of opulence in the portraits of the citizenry.

Born within a few months of one another in 1738, John Singleton Copley and Benjamin West together brought American painting to its first flowering. Both began their careers by making copies in oil paint of engravings after European artists, as well as painting portraits from life. A technical crudity of execution in their early works masks latent energy and imagination waiting for release. Encouraged by his patrons at home, West was the first American artist to study in Italy where he stayed until 1763, immersing himself in the art of the ancient world and the renaissance. He had at first intended to return home after three years of study in Italy, but instead remained in London, probably because he anticipated a more successful career abroad. West's career was meteoric; within five years of his residence in London, King George III appointed him a charter member of the newly formed Royal Academy of Arts, and in 1772 he was named historical painter to the king. These honors resulted in large part from the hugely successful *Departure of Regulus from Rome* (Kensington Palace, London), a royal commission for a historical subject completed by West in 1767. West had already astonished his contemporaries that year with his audacity in painting the *Death of General Wolfe* (National Gallery of Canada, Ottawa) in the costume of the period. Prevailing custom in historical painting would have interpreted this event from the French and Indian Wars as an episode from antiquity.

In his later treatment of the history of colonial Pennsylvania, *William Penn's Treaty with the Indians* (cat. no. 5), West chose to depict William Penn in the same historically accurate manner as he had painted General Wolfe. The *Penn* picture combines his concept of the idealized classical composition, in its static frieze of figures, with the Rousseauian ideal of the American Indian as the "noble savage." Upon seeing the Apollo Belvedere in Rome, West had astonished his friends by comparing the statue to a Mohawk warrior, and he extended this notion to the Indian figures in his *Penn* picture. The only concession to mundanity in his otherwise lofty approach to this painting is the paunchy figure of Penn himself and the plain Quaker dwellings in the background. In choosing this subject, West effectively equated it with the grandeur of classical antiquity, while at the same time urging history painting toward greater relevance to contemporary events. Without this impetus, John Trumbull, one of West's many American pupils, might well have neglected

history painting for more secure employment at portraiture.

It was from portraiture, in which he excelled above all colonial artists, that John Singleton Copley advanced upon London in 1775 on the eve of the American Revolution. West had written him in 1773, a year before Copley's departure from Boston, urging him to study in Italy. West especially recommended that Copley study the works of Raphael where he might see ". . . the fine fancey in the arrangement of his figures into groops, and those groops into a whole with that propriety and fitness to his subject, Joynd to a trouth of character and expression, that was never surpass'd before nor sence." But it is not the influences of renaissance painting that one sees in Copley's *The Nativity* (cat. no. 3) but rather the impress of West himself. Copley had not come to London as a novice; for more than twenty years he had painted portraits in America, and out of his immense store of native genius, unaided by any great teacher, he had brought his art to a pinnacle of excellence. It was more than his Tory sympathies that persuaded him to remain in London for the rest of his life. Like West, he found America unready for the work he now wished to undertake. The year following *The Nativity,* Copley painted his most ambitious figure composition to date, *Watson and the Shark* (National Gallery of Art, Washington), several versions of which are extant (Museum of Fine Arts, Boston; Detroit Institute of Arts, cat. no. 4; and an attributed example, The Metropolitan Museum of Art, New York). The original version (Washington), from which the Detroit replica was taken, was painted in the same year, 1778, as West's celebrated *The Battle of La Hogue* (National Gallery of Art, Washington; replica, The Metropolitan Museum of Art, New York). It is tempting to speculate upon West's influence on Copley's choice of subject matter. Both pictures deal with historical events; the West is a naval engagement, the Copley, a dramatic event in the life of a rather important individual. Surely the figures straining to rescue the hapless Watson have counterparts in the central figures of West's great canvas. West did not discourage imitation, nor did he fear the success of a talented rival; indeed, it was these very qualities of openness and helpfulness that marked him as the great teacher of his time. Copley's London career eventually focused on history painting to the virtual exclusion of all else. At the very moment when West was gravitating toward allegorical and religious subject matter, Copley filled the vacuum as the principal painter of English history.

West gradually responded to the appeal of romanticism. Edmund Burke (1729-1797) had written his *Philosophical Enquiry into the Origin of Our Ideas of the Sublime and the*

Beautiful in 1757, in the midst of Europe's delirious plunge into classicism stimulated by the rediscovery of Pompeii nine years before. Burke's treatise, certainly one of the principal harbingers of the Romantic Movement, rejected the classical notion that beauty resided in an object itself. Instead, he argued that beauty was to be found in the pleasurable emotions certain objects evoke. Burke opposed the concept of beauty to the darker aspects of human experience which give beauty its meaning and existence, and he found the sublime to exist in whatever was massive, irregular, powerful, and ominous. Through contemplation of the opposing forces of the sublime and the beautiful, the mind might be brought into confrontation with ". . . the most extensive province of pleasure and pain." It was with this notion of the sublime that West began to experiment as the eighteenth century ended. By 1783 he had made his first preparatory drawing for *Death on a Pale Horse* (Pennsylvania Academy of the Fine Arts) which was finished in 1817. His treatment of this subject reveals West at the height of his inventive powers, motivated initially by Burke's notion of the sublime. The smaller 1802 study in oils (cat. no. 6) was a sensation of the Paris Salon of that year, and West was personally invited by Napoleon to join the official entourage at the Salon's opening. West's picture undoubtedly exerted an influence, as yet undocumented, upon the future course of French romantic painting. Indeed, the extent of West's importance in the history of nineteenth-century European art has yet to be accurately assessed, though his position as president of the Royal Academy of Arts from 1792 until his death in 1820 certainly made him the foremost artist in England.

And as the most capable teacher of his day, West inevitably influenced the principal American artists who by the turn of the century were beginning to gravitate to him for guidance. In 1801 Washington Allston (1779-1843) sought him out, and a year later Rembrandt Peale (1778-1860) came to him for instruction. West's romanticism impelled both men to create their own images of the "terrible sublime." Allston's huge canvas *Belshazzar's Feast* (fig. 2), intended to be his crowning achievement but left unfinished at his death, and Peale's immense, lugubrious *Court of Death* (fig. 3) both attest to the nearly hypnotic effect West had on the younger generation of artists.

Largely due to the work of Benjamin West narrative painting appears at the opening of the nineteenth century in a revitalized form. Its aim henceforward would be to provide moral instruction, rather than to commemorate the pieties of the past as the classicists had done. This determination extends to the work of Thomas Cole, who is usually cited as the founder of a school of landscape painting; however, even with this artist, the overriding ambition was to make his pictures awaken the moral impulse.

Fig. 2

Washington Allston (1779-1843)
Belshazzar's Feast, begun 1817
Oil on canvas
144 x 192 in. (365.7 x 487.6 cm.)
Detroit Institute of Arts

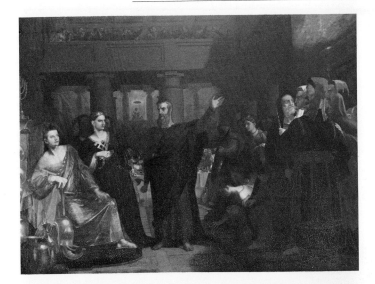

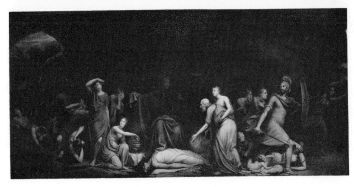

Fig. 3

Rembrandt Peale (1778-1860)
The Court of Death, 1820
Oil on canvas
138 x 281 in. (350.5 x 713.7 cm.)
Detroit Institute of Arts

Vastness was a corollary to the idea of the sublime, but none of West's many pupils was able to deal with the demands of physical size required for maximum effect in a painting like the final version of *Death on a Pale Horse,* which measures nearly fifteen by forty-six feet. No American painter was successful in attaining the level of West's mastery in controlling a huge composition until Emanuel Leutze painted *Washington Crossing the Delaware* (fig. 4) in 1851. John Trumbull, who studied with West in London in 1784, conceived his finest history pieces there. Trumbull painted a set of pictures commemorating the Revolutionary War in which he avoided the problems of immensity by only using canvases of modest size. The most dramatic and aesthetically pleasing is his *Battle of Bunker's Hill* (fig. 5), for which *Lieutenant Grosvenor and His Negro Servant, Peter Salem* (cat. no. 8) is a preparatory sketch. The gifted Samuel F. B. Morse, who studied in London with Allston and West between 1810 and 1815, also chose to limit the physical size of even his most ambitious compositions. His *Judgement of Jupiter* of 1815 (cat. no. 13) is a salon piece which displays a high degree of assurance in handling by a painter who was then only twenty-four years old. Before inventing the telegraph and abandoning his painting career, Morse produced a number of pictures intended to earn him an income through private showings with paid admission. Such a picture is *Exhibition Gallery of the Louvre* (fig. 6) calculated to give rural America a palpable tour of the Salon Carré. A wonder of painted deception, in the words of Oliver Larkin, it shows us the Louvre ". . . filled with light and its contents . . . summarized with a free brush which somehow conveys in a space fifteen inches long the drama of Poussin's *Diogenes,* the radiance of Claude, and the tragedy of Titian's *Entombment."*

Morse was late arriving at his admiration for French culture. Thirty years before he painted his *Louvre,* Paris had already begun to assume the mantle of pre-eminence in European art under the patronage of Napoleon, and Americans going abroad to study art began to favor Paris over London.

John Vanderlyn took up residence there in 1803 and remained for almost fifteen years. His Paris career began with a commission from Robert Fulton and Joel Barlow to illustrate the latter's patriotic epic poem, "The Columbiad." Vanderlyn was instructed to produce ten oil sketches which would serve as a point of departure for the engraver of the poem's illustrations. Having already spent some seven years studying historical painting, Vanderlyn produced a fully developed rendition of *Death of Jane McCrea* (cat. no. 10) instead of contenting himself with sketches. It is a meticulously painted picture composed

as a neoclassical frieze of figures closer to antique statuary than to life. It was painted in a manner calculated to link Vanderlyn's art with the official style of the Salon of 1804 whose patron, Napoleon, had become Emperor of France that year. Fulton and Barlow refused to pay for Vanderlyn's extra labor, and the shock discouraged the artist from further American subjects. He began a forthright program of producing neoclassical paintings for the Salons, and *Marius amidst the Ruins of Carthage* (M. H. De Young Memorial Museum, San Francisco) won him a gold medal at the Salon of 1808. Four years later he created his masterpiece in this idiom, *Ariadne* (Pennsylvania Academy of the Fine Arts, Philadelphia). While *Ariadne* is perhaps the first successful nude in American art, its arrival in America provoked a storm of controversy. Vanderlyn's critics correctly saw that the picture had little to do with the Greek myth of Theseus' hapless companion, but that it was instead a frankly sensual nude. Perhaps only another artist could recognize the picture's painterly qualities; Asher B. Durand acquired *Ariadne* and completed his own replica of it (cat. no. 15) in reduced size for an engraving which he published in about 1836.

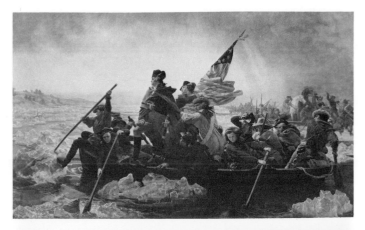

Fig. 4

Emanuel Gottlieb Leutze (1816-1868)
Washington Crossing the Delaware, 1851
Oil on canvas
149 x 255 in. (378.4 x 647.7 cm.)
The Metropolitan Museum of Art, New York

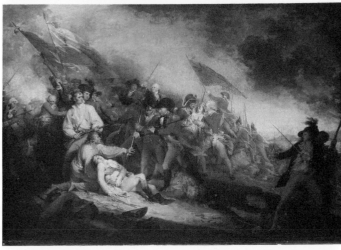

Fig. 5

John Trumbull (1756-1843)
Battle of Bunker's Hill, 1786
Oil on canvas
25 x 34 in. (63.5 x 86.3 cm.)
Yale University, New Haven

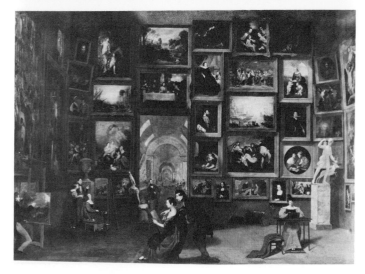

Fig. 6

Samuel Finley Breese Morse (1791-1872)
Exhibition Gallery of the Louvre, ca. 1832
Oil on canvas
76 x 106½ in. (193.0 x 270.5 cm.)
Syracuse University

Fig. 7

Charles Willson Peale (1741-1827)
Exhuming the Mastodon, 1806-1808
Oil on canvas
50 x 62½ in. (127.0 x 158.7 cm.)
Peale Museum, Baltimore

★ II ★

In the period between the two wars with England, American life experienced a period of unprecedented cultural growth which was manifested in the restrained dignity of Federal architecture and decorative arts and was also expressed in the plastic arts. In *The Tea Party* (cat. no. 9), Henry Sargent portrays a fashionable gathering in an elegant double parlor of a Boston town house. The restraint and dignity of Sargent's style seem but a reflection of the fastidious taste that generally informed the culture of the Federal era.

This period was also marked by advances in the sciences which influenced the choice of subject matter of several American artists, including Charles Willson Peale. While portraiture was Peale's principal occupation as an artist, he also found time for an interest in natural science and he enriched the new Republic with his establishment of the first museum of natural history in Philadelphia in 1794. Among its curiosities were a few fossilized bones of a mastodon which Peale had unearthed from a marl pit near Newburg, New York. His extraordinary discovery was of the greatest scientific importance; it reinforced the growing empirical approach to explaining terrestrial life which would culminate some fifty years later in the publication of Charles Darwin's *Origin of the Species.* Peale's *Exhuming the Mastodon* (fig. 7) painted in 1806 is perhaps more a document than a successfully realized work of art; yet the artist's insistence upon relating a contemporary event in terms of descriptive realism is actually an extension of West's own precepts about art. In his old age, Peale returned to a more traditional narrative in *Noah and His Ark* (cat. no. 7).

While *Noah* was apparently inspired more by Peale's abiding fascination with all aspects of natural science than by his interest in Old Testament narrative, the manner in which it is painted bears a striking similarity to that of indigenous American religious painting. This style may be characterized as an essentially unsophisticated form of expression relying upon line and flat, bright local color for effect, with composition and thematic materials often borrowed entirely from available academic paintings and prints. Certainly the unknown artist who labored over his *Christ and the Woman of Samaria* (cat. no. 2) early in the eighteenth century appears to have based his design on an available pictorial model, perhaps an engraving in an illustrated Bible. Some one hundred fifty years later Erastus Field's *"He Turned Their Waters into Blood"* (cat. no. 22) shows little change in either method or viewpoint: its static frontality betrays a direct copying from a print source. Field was the most prodigious painter of religious themes in the nineteenth century, and seldom

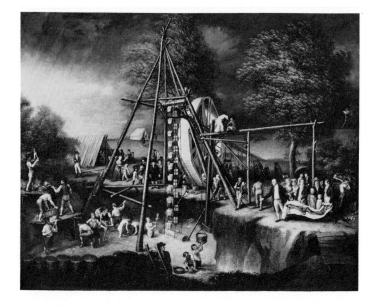

departed from his habit of relying upon such models. However, his fanciful *Historical Monument to the American Republic* of 1876 (Museum of Fine Arts, Springfield, Massachusetts) suggests that the widespread patriotic fervor of the great Centennial year permeated even the consciousness of a naive artist like Field who was preoccupied by traditional Biblical themes. The *Historical Monument* picture, an enormous canvas charged with a vast assortment of minute detail, yet dominated by a strong composition, attests to Field's considerable native genius. It implies also that the naive style unifying religious painting in America for a century and a half is a function of the subject matter rather than the relative abilities of the various artists who practiced this idiom. Religious subject matter in the visual arts, so personal to the artist and yet so foreign to the spirit of Calvinist sobriety in America, always lay outside the mainstream of professional creative effort here until the last quarter of the nineteenth century. Therefore, it was material the naive artist could securely lay claim to without fear of comparison with the work of academically trained professionals. Most important, the naive artist was expressing ideas which had no basis in the reality of his daily existence. Thus religious subject matter, especially in the nineteenth century, ran counter to the trend toward greater realism by artists whose principal concerns were landscape and genre painting. When Henry Kip painted his *Resurrection* around 1860 (cat. no. 64), he was continuing an archaic tradition which had essentially insulated itself against change.

Closely allied to the naive artists who produced religious

pictures were two painters, John Quidor and Albertis D. O. Browere, who flourished in New York. Theirs was also a literary form of expression, and their "Bible" was the *History of New York,* published in 1809 by a precocious young writer of twenty-six, Washington Irving (1783-1859). Under the pseudonym "Diedrich Knickerbocker," Irving lampooned the brief and colorful rule of Dutch New Amsterdam which was ingloriously surrendered to the English in 1644. Irving, of English descent, was merciless in his satire of the comic-opera Dutch colony. In a passage near the conclusion of his *History* he observes of the capitulating Hollanders, "In a private meeting of the leading citizens it was unanimously determined never to ask any of their conquerors to dinner." Irving's *History* was the first American book to gain widespread attention in Europe, and for America it offered a readable and illuminating, though biased, account of a colorful historical era. As Irving noted years later, "Before the appearance of my work the popular traditions of our city were unrecorded. . . . Now they form a convivial currency and . . . link our whole community together in good-humor and good fellowship." While the tempestuous events of New Amsterdam recorded in Irving's *History* prompted Browere (cat. nos. 36, 37) and especially Quidor (cat. nos. 16, 17) to flights of painted fantasy of a somewhat naive order, Irving also appealed to other artists whose reputations were solidly established at the prestigious National Academy of Design. In 1820 Irving published his most successful work, *The Sketch Book of Geoffrey Crayon, Esq.,* and from this source a host of professionals drew thematic materials. Henry Inman, Asher B. Durand, and William Sidney Mount all produced paintings during the 1830s that were based on stories in the *Sketch Book.* Thomas Cole painted landscapes of Sleepy Hollow, the home of Ichabod Crane, Irving's most celebrated character, and a similar subject found in Irving's *Tales of a Traveller* of 1824 inspired Charles Deas' *The Devil and Tom Walker* (cat. no. 51). Indeed, writers like Irving and James Fenimore Cooper provided narrative source materials for most of the important artists of this period.

At the same time, literary and artistic journals like *The New-York Mirror,* published between 1823 and 1842, and later *The Knickerbocker,* published from 1833 until 1865, provided the public with engravings of the artists' paintings. At no other time in the history of American art was the writer so closely allied to the artist, for the *Mirror* and the *Knickerbocker,* as well as other journals such as *The Crayon,* founded in 1855, were equally devoted to the publication of literature, discussions of aesthetics, and critical reviews of art. Through the pages of these journals an incipient body of art critics evolved, notably John Neal, Henry Tuckerman, James Jackson Jarves, and William Dunlap. These writers served to sharpen the taste and judgment of public and artist alike, and increased knowledge of the development of American art. Writing in 1829 John Neal noted, "We certainly either by Nature, which is not very probably, or by accident, have something that appears like a decided predisposition for painting in this county."

This "predisposition" was coupled with a pervasive romanticism which emerged most passionately in the works of the acknowledged leader of American art of his day, Thomas Cole. Although his landscape paintings helped establish a tradition for this branch of art in America, now known as the Hudson River school, Cole's chief contribution was in narrative painting. He was probably familiar with the writings of the French skeptic C. F. Volney (1757-1820) whose *Ruines, ou méditations sur les révolutions des empires,* published in 1791, seems to have been a seminal influence on Cole's philosophy. Volney's thesis that civilizations evolve from their foundation through maturity to their final overthrow was an idea that especially appealed to Cole. He produced a five-part series of paintings in 1836 entitled *The Course of Empire* (New-York Historical Society), whose central and largest composition, *Height of Empire* (fig. 8) derives not

Fig. 8

Thomas Cole (1801-1848)
Course of Empire—Height of Empire, 1836
Oil on canvas
51 x 76 in. (129.5 x 193.0 cm.)
New-York Historical Society

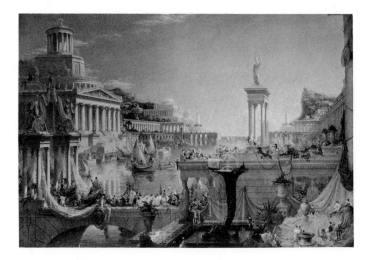

only its substance but its very title from Volney. Coincidentally, another Frenchman who had traveled extensively in America, Alexis de Tocqueville (1805-1859), published his *Democracy in America* this same year. Although Tocqueville was primarily concerned with the manners and morals of the fledgling Republic, there are passages within *Democracy* that echo the melancholy of Volney:

It is this idea of destruction, this conception of near and inevitable change which gives . . . so original a character and so touching a beauty to the solitudes of America. . . . The idea of this natural and wild grandeur which is to end mingles with the superb images to which the march of civilization gives rise. One feels proud to be a man, and at the same time one experiences I know not what bitter regret at the power God has given us over nature.

Cole's images of a civilization that suggest the Roman Empire in *The Course of Empire* are really a metaphor for America, and the moral lesson he strove to convey in his paintings is really the same lesson that Tocqueville discussed in print. Cole's subsequent composition, *The Voyage of Life* (1840), of which the second panel, *Youth* (fig. 9), has enjoyed the greatest popularity, is an extension of the *Empire* theme. The series symbolizes the

Fig. 9

Thomas Cole (1801-1848)
Voyage of Life—Youth, 1840
Oil on canvas
52½ x 78½ in. (133.3 x 198.1 cm.)
Munson-Williams-Proctor Institute,
Utica

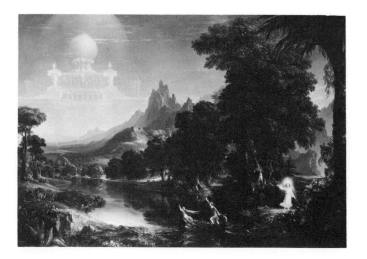

various climactic moments of human existence from birth to death in terms of the "river of life." Transitoriness as expressed in *The Voyage of Life* comes close to a point of religious experience with Cole. The basis for Cole's metaphor is again derived from literature, in this case from the poem "Thanatopsis" (1816) by Cole's friend William Cullen Bryant. Cole's expression of the opposing active and contemplative states of human nature received a lyrical treatment in *L'Allegro* (cat. no. 19) with its now lost companion *Il Penseroso.* Cole was as much indebted to the poetry of Milton as he was to the effusions of the Transcendentalists who published in another journal of letters, *The Dial,* between 1840 and 1844. Ralph Waldo Emerson saw the ideal artist as "a transparent eyeball," a visionary in whose works the reality of creation could be distilled and apprehended with a heightened awareness. Though widely admired, Cole's religious and allegorical paintings formed no legacy for American art. His only student, Frederic Church (1826-1900), painted landscapes that were the ultimate realization of the Hudson River school's tendency to deify nature.

In early nineteenth-century America there appeared a new spirit in politics that also infused the country's art. This new spirit was manifested in the administration of Andrew Jackson, when power was transferred from an elite to an egalitarian society. It is no coincidence that there was a proliferation of artistic expression in America at this time and that subjects which had not been apparent before now became popular. Landscape and genre painting reflected a Rousseauian faith in the virtue of the unspoiled wilderness of America and the perfectibility of human society within it. Thomas Cole expressed this sentiment for American artists when he wrote in an article for *The American Monthly* of January 1836:

. . . whether he beholds the Hudson mingling waters with the Atlantic, explores the central wilds of this vast continent, or stands on the margin of the distant Oregon, the American is still in the midst of American scenery—it is his own land; its beauty, its magnificence, its sublimity, are all his; and how undeserving of such a birthright if he can turn toward it an unobserving eye, an unaffected heart.

Thus, while an artist like Cole could embody the grand poetry of decay in his allegorical paintings, he could at the same time espouse a positive attitude about the potential of America. Even if they found corruption in their society, American genre painters working in the first half of the nineteenth century preferred to advance wholesome views of life in the new country. As the artist and writer Charles Lanman wrote of William S. Mount in 1845, "His productions are stamped with an entirely American

character, and so comically conceived that they always cause the beholder to smile . . ." Mount's benign Long Island farmers reflect the stability of rural life in pre-Civil War America. Although Mount received some rudimentary instruction from the popular portrait painter, Henry Inman, he was notably self-reliant. Beginning as a painter of crudely executed subjects based on episodes in the Bible, Mount progressed with astonishing rapidity to a level of thorough competence as a genre painter. *The Breakdown* (cat. no. 24), created only a scant eight years from the date of his first hesitant efforts with religious subjects, proclaims his mastery as a self-taught genius of American genre. As a technician in oils, Mount was thoroughly competent; at the same time he strove to minimize his presence in the execution of a picture so that the viewer was conscious only of the painting's subject. In this subordination of the act of painting to the results, Mount was very much in accord with one of the principal leaders of American landscape painting, Asher B. Durand.

Mount rarely permitted himself the dramatic sweep of a picture like James Clonney's *Militia Training* (cat. no. 29), preferring to focus on more intimate scenes. Yet, in spite of this difference, the work of these two artists is characterized by an energy and a good-humored love of life, a similar response to the essentially optimistic spirit of their times. It is interesting to note that the most important political event in American history at this time, the war with Mexico of 1846-1848, was most effectively recorded by our artists when they dealt with the subject remotely, as in William Woodville's *War News from Mexico* (fig. 10). Although probably showing a Baltimore scene, it was painted in Düsseldorf concurrently with the German Liberal Revolution of 1848. *War News* conveys no sense of the discord of war, but rather confirms the secure values of an agrarian American society. One of the most powerful images of that mood of intense optimism is to be found in Jerome Thompson's lyrical scene of peace and plenty, *A "Pic Nick," Camden, Maine* (cat. no. 38).

The virtue of much American genre painting from the period prior to 1850 is its emphasis upon a firm identity with nature and a strict avoidance of sentimentality. However, at mid-century the latter began to emerge as circumstances in American culture favored the growth of an urban middle class, new patrons who preferred sentimentality to realism. And, of great importance to changing taste was a continuing exhibition of European paintings which opened in New York in 1849. As a safety measure during the uncertain days of the 1848 Revolution in Germany, the Prussian consul in New York had transferred to that city the collections of the Düsseldorf Academy. Known as the "Düsseldorf

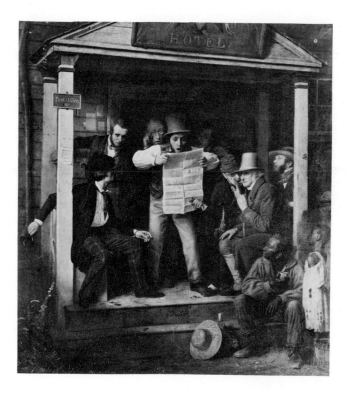

Fig. 10

Richard Caton Woodville (1825-1856)
War News from Mexico, 1848
Oil on canvas
27 x 25 in. (68.5 x 63.5 cm.)
National Academy of Design, New York

Gallery," the exhibition became an immediate sensation. The American Art-Union *Bulletin* heralded it as ". . . one of the most gratifying and instructive collections that have ever been seen in the United States. It is full of evidence of that indefatigable and minute study of Form which characterizes the German schools . . ."

The Düsseldorf artists excelled in two areas particularly, historical narrative and sentimental genre painting. Among the emigrants who fled Europe in the wake of the 1848 uprisings were a number of artists who brought to America the prevailing foreign styles of painting. Johann M. Culverhouse, a Dutchman, became celebrated in his adopted New York for romantic nighttime scenes (cat. no. 49), and the Alsatian Christian Schussele was active in Philadelphia as a teacher at the Pennsylvania Academy of the Fine Arts. His *Organ Grinder* (cat. no. 59) is typical of sentimental genre painting of the Düsseldorf variety that had begun to influence native American artists by mid-century. William Winner, a native of Philadelphia, probably came under Schussele's influence, as can be seen in a characteristic example of his effective anecdotal views of life in Philadelphia (cat. no. 39). One of the hallmarks of the Düsseldorf style, besides its penchant for sentimentality, is the tendency to overcrowd compositions with detail. Thomas Rossiter, who had made two trips

to Europe before painting his *Rural Post Office* (cat. no. 48), brings these mannerisms into full play here. It is useful to compare Rossiter's work in the genre idiom with examples by Mount in order to perceive the evident changes which had come about in fashions of painting after the influx of European taste.

Although George C. Bingham worked in Düsseldorf between 1856 and 1859, his style had already matured long before then. Bingham is to the art of the West what Mount is to that of rural New York, and Bingham's *Jolly Flatboatmen* (cat. no. 27) possesses the same virtues found in the best of Mount's genre scenes: simplicity of composition and an honest, direct observation of life. Although Bingham's rivermen are somewhat idealized, the force of his artistic ability convincingly recreates an aspect of the real world, unlike the patently imaginary creation of Rossiter's *Rural Post Office* (cat. no. 48).

For the mid-nineteenth-century American artist, much of the enchantment with genre subjects bears a striking kinship to the philosophical thrust of the country's leading men of letters, especially to that of Ralph Waldo Emerson. In his address to the Harvard Class of 1837 entitled "The American Scholar," Emerson said, "The literature of the poor, the feelings of the child, the philosophy of the street, the meaning of household life are the topics of the time . . ." He often repeated such sentiments in lectures given under the aegis of the American Art-Union where artists gathered, suggesting that virtue and true morality reside in the humble stations of life. This idea produced a variant subject of genre painting that became a persistent and pervasive theme in American art: the street urchin. In *The Young Merchants* (cat. no. 26) by William Page, though the two young people are shown sympathetically, they are not idealized nor used to make an emotional appeal to the spectator. By 1865, paintings like James Freeman's *Savoyard Boy in London* (cat. no. 25) had adopted the sweetly sentimental view of the street urchin that would persist in American art through the turn of the century with J. G. Brown's enormously popular shoe shine boys and match sellers. Occasionally, Lilly Martin Spencer could resist the charm of sentiment and produce a genuinely affecting scene of domesticity (cat. no. 54), a companion subject to the urchin theme in nineteenth-century painting.

In the first half of the nineteenth century, history painting attracted few American artists. Ceremonial by its very nature, it requires an appropriate setting to be effective; no museums, in the modern sense, existed in the United States until the period following the Civil War, and the federal government sponsored only one project—the embellishment of the Capitol Rotunda in 1841. Trumbull was well represented there, as were Vanderlyn

and Weir. With the approval of the Congress for the enlargement of the Capitol in 1851, the federal government established itself as a major patron of the arts. Despite the lack of patronage, in the early years of the nineteenth century historical subjects were occasionally essayed by artists known primarily for their work in other areas. Jacob Eichholtz, a quasi-primitive portrait painter from rural Pennsylvania, painted *An Incident of the Revolution* (cat. no. 11) on the fiftieth anniversary of the surrender of the British at Yorktown, and two years later Asher B. Durand, the landscape painter and engraver, commemorated in his *Capture of Major André* (cat. no. 14) another celebrated incident from the same period of history. It was not until the German-born Emanuel Leutze seized the popular imagination with his monumental *Washington Crossing the Delaware* (fig. 4) that the Washington "cult" achieved its fullest flowering in America. The version in this exhibition (cat. no. 44) is probably a reduction made by Leutze and his studio assistants for use by the engraver who produced the widely distributed print published at mid-century by the International Art-Union. Following Leutze's success, a number of other artists essayed the same theme, including George C. Bingham. William Ranney, who painted *Recruiting for the Continental Army* (cat. no. 32) in the wake of Leutze's revival of interest in the American Revolution, also attempted a very similar subject in his *General Marion Crossing the Peedee* (private collection, Seattle). While working in Europe, the celebrated portrait painter George P. A. Healy had readily accepted a commission from Louis Philippe of France in 1846 for a historical subject dealing with Benjamin Franklin (cat. no. 30); Healy's well-known *Lady Washington's Reception* (The Brooklyn Museum) is probably the pendant for it. Historical painting was very much in the ascendency at this time in European art centers; Healy in Paris and Leutze in Düsseldorf both gave full rein to their powers of invention, turning their attentions to episodes from American history. *Ferdinand Removing the Chains from Columbus* (cat. no. 43) was just one of Leutze's many compositions dealing with the discovery of America and they won him almost instantaneous success and acclaim in the German art center. Thus, by the time of the establishment of the Düsseldorf Gallery in New York in 1849, American artists on both sides of the Atlantic were actively engaged in the production of historical paintings.

It seems all the more strange then that both the War of 1812 and the Civil War did not stimulate the production of more easel pictures. Thomas Birch managed to enshrine in art some of the more illustrious naval engagements of the earlier war. And, except for Winslow Homer, the Civil War seems not to have

compelled the attention of this country's best painters. Homer, who began his career as an illustrator for magazines, produced a number of paintings dealing with that long and terrible struggle. While his best drawings for *Harper's* were action subjects such as infantry and cavalry charges, his most powerful subject in oils, *Prisoners from the Front* (cat. no. 68), deals not with the action of war, but with human interest and psychological penetration of character. Similarly, David Blythe, that erratic polemicist of American art, produced one of his most powerful protest pictures in *Libby Prison* (cat. no. 41), a study of hopeless inaction. The tendency to treat contemporary events with detachment is endemic to the art of the Civil War period and reflects the difficulty with which the artists addressed themselves to a radically changing world. The use of static subject matter dealing with war finds its logical extension in the painterly *Monitor and Merrimac* (cat. no. 52) of James Hamilton. Created more than a decade after the event depicted, the Hamilton is more a salon painting than a record of history.

The American West was a natural subject for the artist and the explorer. Early in the nineteenth century, Europeans like Prince Maximilian zu Wied and Sir William Drummond Stewart led parties across the western prairies in search of the living embodiment of Rousseau's "noble savage." Each had an artist accompany him: Prince Maximilian had the Swiss Karl Bodmer (1809-1893), and Stewart employed an American, Alfred Jacob Miller (1810-1874). Other painters followed independently, and recorded with varying degrees of competence the life of the Amerind. John Mix Stanley's heroic frieze of Indians (cat. no. 35) and the one produced by Charles Wimar (cat. no. 62) are quite similar in approach despite the fifteen years that separate them. With the destruction of American Indian culture, the artist turned to the events in the progress of western civilization. William Ranney recorded the endurance and the pastimes (cat. no. 31) of the pioneer settlers and celebrated his subjects as champions of racial supremacy over the vanishing Red Man. Meanwhile, the gold rush had created an Anglo majority in Spanish-speaking California. The German immigrant painters Charles Nahl (cat. no. 50) and William Hahn (cat. no. 74) reported on life in the California Republic as it was in those frantic days of discovery and development. The American West, which would furnish generations of writers and artists with thematic material, became as much a myth in their hands as if it had been invented rather than explored. Albert Bierstadt, who produced views of the western landscape often heavy with theatrical effects, created the dramatic scenario of *The Ambush* (cat. no. 63) as if in anticipation of the cinematic genre that would follow a half-century later.

As the Civil War had been destructive to American culture as it existed before the conflict, so the new orientations in American life in the years immediately following can be directly associated with the war as well. As a result of the war technology, communications with Europe improved; travel was vastly enhanced by steam vessels and telegraphic service opened in 1866. The overture to the European cultural experience, first sounded by the Düsseldorf school in America, was quickly succeeded for American artists by the attraction of Munich and Paris. A new realism in art was quickly becoming a vast movement in Europe with Manet and Courbet leading the advance in Paris, while the realist Wilhelm Leibl in Munich taught the first wave of Americans in the early 1870s. Scarcely twenty years separates Tompkins Matteson's *Erastus Dow Palmer in His Studio* (cat. no. 33) and Thomas Anshutz' *Dissecting Room* (cat. no. 80), yet these two studio interiors represent the enormous changes that had come about in American art. The neoclassicism of Palmer's art was rendered irrelevant as the tide of realism and science swept away the dead past. Thomas Eakins, Anshutz' teacher at the Pennsylvania Academy of the Fine Arts, sundered outworn conventions by conducting his life drawing with the use of nude models whom he regarded with the same objectivity he accorded medical school cadavers. Eakins believed that the study of human anatomy was central to a humanistic art and that such study was ". . . not going to benefit any grown person who is not willing to see or be seen seeing the naked figure . . ." *The Swimming Hole* (cat. no. 76) is his paean to a liberated human sensuality, and while American genre painting in the last quarter of the nineteenth century tended to regress into expressions of sentimental anecdote, Eakins' work shone like a beacon. The growing importance of the camera as a tool for picture-making—a tool that Eakins employed with great effect in the scientific study of human and animal motion—is revealed in the approaches certain artists were taking. The examples by Horace Bonham (cat. no. 67) and John G. Brown (cat. no. 65) appear to have been created from an assemblage of individual camera portraits; and the Charles Ulrich interior scene (cat. no. 84) shares with the Bonham the quality of the frozen instant, characteristic of the camera image. The ultimate expression of the painted photographic image is to be found in the *trompe l'oeil* still life paintings of the period, especially those of William M. Harnett (1848-1892) and his followers. Henry Alexander's concern for the minute rendering of descriptive detail (cat. no. 86) conveys the same obsessive concern for photographic realism in the genre idiom.

Such realism in painting in no way replaced the romantic,

Fig. 11

Thomas Eakins (1844-1916)
The Gross Clinic, 1875
Oil on canvas
96 x 78 in. (243.8 x 198.1 cm.)
Jefferson Medical College, Philadelphia

academic mode that flourished among the great majority of American artists. Eastman Johnson, in particular, pursued this style from his student days in Düsseldorf and The Hague, where he was known as "the American Rembrandt." *The Rendering Kettle, Sugaring Off* (cat. no. 56) conveys a mellow lyricism, not unlike the prevailing sombre mood established by the much admired Barbizon painters in France. Much the same can be said for Frederic Rondel's *The Picnic* (cat. no. 60) where this artist sustains the general intent, if not the robust substance of the same subject painted in earlier, less complex times by Jerome Thompson. Certainly no more striking comparison can be made to illuminate the changes that were occurring in late nineteenth-century art than to oppose Eakins' *The Gross Clinic* of 1875 (fig. 11) with Eastman Johnson's decidedly old-fashioned genre subject *The New Bonnet* (cat. no. 57), painted a year later. Eakins' bold realism is of the new wave of European art, decidedly reminiscent of Manet, while Johnson's work follows a much more cautious program well within the established boundaries of an American linear style. Johnson's exact contemporary, Thomas W. Wood, also carried an earlier and increasingly outmoded style of painting well into the last quarter of the nineteenth century. To judge from its appearance, a pleasantly innocuous genre subject like *The Critical Moment* (cat. no. 55) might have been painted thirty years earlier.

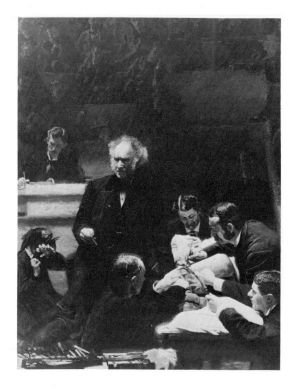

Material prosperity of the post-Civil War era had given middle-class Americans—for whom such pictures were painted—an overwhelming sense of confidence in the orderly material progress of the Republic. However, this increasing materialism, which Emerson had inveighed against earlier in the century, was at the same time proving inimicable to the development of art in America. In fact, the American critic William Dean Howells, in observing the machinery exhibits at the Centennial Exposition of 1876, found the machines superior to what he saw as the debased art of the country and remarked, "It is in these things of iron and steel that the national genius most freely speaks. . . ."

The national confidence bred by material security is perfectly symbolized in John G. Brown's *Waiting for a Partner* (cat. no. 66) where the *dramatis personae* act out the stages of life from infancy to old age in a world of sweetness and light. Brown's congenial boating-party gentlemen (cat. no. 65) seem to belong to a different age than Winslow Homer's desperate fishermen in *Lost on the Grand Banks* (cat. no. 69), a painting that transcends its time, like so many of Homer's great canvases. Homer's abiding concern as an artist was to understand the elemental forces of nature and to represent its moods; his art was deeply committed to that purpose. Homer, like Eakins, was a

solitary genius; both men made their distinguished contributions in conditions of relative physical and spiritual isolation from their contemporaries who viewed life so differently. While vast numbers of their countrymen looked to Europe for artistic inspiration, Homer and Eakins chose to fashion their careers in America.

The attraction of Europe was frequently fatal to artists whose ambitions outstripped their abilities. While Thomas Cole found the transition from landscape painter to allegorist an easy one, a significant number of American painters who tried to embrace allegory and fantasy could not do so successfully. William West, whose namesake had triumphed in this field, found little inspiration in the London of 1835 to sustain such an ambitious program as his *Muses of Painting, Poetry and Music* (cat. no. 12) who appear as fashionably pretty women in fancy dress rather than awesome mythological spirits. Similarly, Tompkins Matteson, an otherwise competent genre artist, strains to symbolize in *The Bible Lesson* (cat. no. 34) the two sides of human nature—savage and civilized—through racial and religious allusions. When European-trained Daniel Huntington paused in his career of seemingly endless portrait commissions to try his hand at allegory in *Philosophy and Christian Art* (cat. no. 42), he borrowed heavily from Venetian renaissance examples and pro-

duced a competently drawn but emotionally bland result. Eighteen years before, Huntington had produced a hugely successful allegory entitled *Mercy's Dream* (The Corcoran Gallery of Art, Washington) taken from John Bunyan's *Pilgrim's Progress.* Conversely, an Italian émigré, Dominico Tojetti could only devise his *Progress of America* (cat. no. 46) as a tableau of Wagnerian Valkyries. Traditionally American art has always been at its strongest point when dealing with reality; symbolism has been used most effectively by the few visionaries the culture has managed to produce. Such artists were David Blythe (cat. no. 40), William Rimmer (cat. no. 45), and Albert P. Ryder (1847-1917) whose minds bordered on madness and whose works are intensely personal statements that owe no allegiance to any school of painting. Of all the academic artists who deliberately set about to employ fantasy as subject matter, Elihu Vedder comes closest to succeeding. *The Questioner and the Sphinx* (cat. no. 70), with its eerie light and enigmatic subject, approached the kind of distortion of reality found in surrealism. The mood of fantasy prevails also in *The Moose Chase* (cat. no. 81) by George de Forest Brush. By 1888, when Brush painted his picture, the American Indian had nearly ceased to exist free of the constraints of the white man's civilization. This painting recaptures the timeless world of heroes and legends.

In 1891 James Bryce, the English diplomat and essayist, published his observations about the United States and its culture in *The American Commonwealth.* His remarks in one particular passage from this book underscore the problem of historical painting in America:

> *Time will take away some of the monotony which comes from the absence of historical associations; for even if, as it is to be hoped, there comes no war to make battlefields famous like those of twenty-five years ago, yet literature and the lives of famous men cannot but attach to many spots associations to which the blue of distance will at last give a romantic interest. No people could be more ready than are the Americans to cherish such associations. Their country has a short past, but they willingly revere and preserve all the memories the past has bequeathed to them.*

In 1834 Robert M. Weir had been among the artists selected to design murals for the Capitol in Washington. The theme was the discovery of America and it offered a rare opportunity to correct the "absence of historical associations," in Bryce's phrase, that beset the American history painter. But this was temporary employment, and Weir had to delve into European history (cat. no. 21). But by 1876 more opportunities for historical painting were

Fig. 12

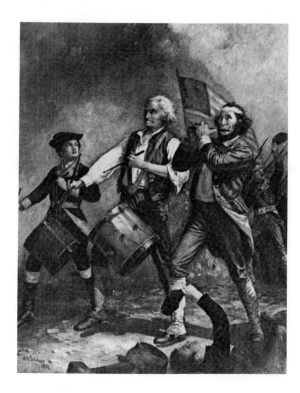

Archibald Willard (1836-1918)
Spirit of '76, 1876
Oil on canvas
120 x 96 in. (304.8 x 243.8 cm.)
Marblehead Historical Society

generated by the celebration of the nation's Centennial. Archibald Willard's *Spirit of '76* (fig. 12) revived the kind of Düsseldorfian posturing that had caught the popular imagination in Leutze's *Washington.* And George Boughton's image of *Pilgrims Going to Church* (fig. 13), although riddled with factual errors, has become accepted through use as historically accurate. Yet historical narrative painting ultimately demands accuracy, and it is to be expected that academically trained artists would come forward. Both Peter Rothermel (cat. no. 47) and Edwin Blashfield (cat. no. 79) stand comparison with the best illustrator and mural painter of their day, Edwin Austin Abbey (1852-1911). And the cool professionalism of Francis Davis Millet (cat. no. 78), whose work conjoins with that of the English neoclassical revival painters Leighton and Alma-Tadema, encompasses in one artist the considerable technical ability that was at once the glory and the defect of the typical Beaux-Arts acolyte.

Pausing at the turn of the century to survey the onrush of history and its attendant forms of art expression, it is apparent that the thrust of narrative painting was blunted by the new movements within the mainstream of western art. However, the venerable Edward L. Henry could still be found pursuing a life-long theme (cat. no. 75) in a painting style current in American

Fig. 13

George Henry Boughton (1833-1905)
Pilgrims Going to Church, 1867
Oil on canvas
28 x 51 in. (71.1 x 129.5 cm.)
New-York Historical Society

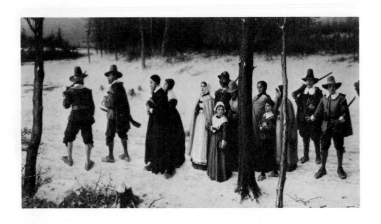

art before the Civil War. Even as an anachronism Henry is an interesting painter; yet evocations of the past, however finely rendered, were becoming increasingly irrelevant in an international art scene dominated by the new realism of impressionism and its subsequent offshoots. In his waning years, Eakins reaffirmed the dignity of realist genre in *Salutat* (cat. no. 77) whose sweaty boxer seems to hail the new century. In American terms, it would be a small group of tough, city-born and city-bred artists—among them "The Eight," dubbed the Ashcan school— who would carry forward into this century the one viable remaining banner of American narrative painting. The examples by Luis Mora (cat. no. 83) and George Bellows (cat. no. 87) included in the present exhibition are representative of the final burst of energy that so handsomely adorns the history of American realist painting prior to the landmark Armory show of 1913.

With the impressionist schism and succeeding waves of revolutionary art movements of the twentieth century, "abstract" values have been elevated above the literary in one of the periods of greatest social and political change the world has known. Paradoxically, the pictorial recording of those changes has been accomplished, if at all, by artists whose methods lie outside the acknowledged mainstream of modern creative effort. The term "social realist" as applied to painting of this century usually connotes an overriding political bias that often limits the artist so concerned to the role of propagandist. With few exceptions in the modern era—notably the leading Mexican mural painters and the American "regionalists"—the contemporary narrative painter has labored futilely at an exhausted vein of art. The magnitude and diversity of modern times has taxed to the limit traditional forms of pictorial expression; art has turned to technology in order to comprehend and express the human experience. ★

DONELSON F. HOOPES, *Senior Curator of American Art.*

Hesselius was born in Sweden to a family of distinguished clergymen and received his artistic training in Europe. He came to America in 1711, landing in Christina (now Wilmington), Delaware. For the most part he remained in the area once encompassed by the colony of New Sweden, living briefly in Philadelphia and Wilmington, then settling in Prince Georges County, Maryland, from about 1718 to 1733. He returned to Philadelphia from 1733 to his death. He began his American career as a painter specializing in portraits but also executed some large religious and classical scenes and did the usual coach and ornamental work. Hesselius was the principal portrait painter of the middle colonies at a time when America had few painters at all. Towards the end of his life he specialized more in the making of organs and spinets, entrusting his portrait work to his son John.

I

Bacchanalian Revel, ca. 1730

Oil on canvas

24½ x 32½ in. (62.2 x 82.6 cm.)

Pennsylvania Academy of the Fine Arts,

Temple Fund Purchase, 1949

Hesselius' *Bacchanalian Revel* describes a feast to Bacchus, god of wine and revelry, which in ancient Rome was permitted to occur only once every three years; attended by shameless orgies and drunkenness, it appealed especially to women. In this re-creation of a classical landscape the revelers show various signs of intoxication. The figure asleep on the left wears a crown of grape leaves, one of the symbols of Bacchus.

Unlike the work of many other early American painters, *Bacchanalian Revel* is not a copy of a European painting. It is the artist's own creation, probably inspired by works he saw in Europe by Dutch classical painters of the Utrecht school. Obviously painted by a limner, it was executed with much less sophistication than its models. There was little demand for this type of painting in the early colonies, and though Hesselius was the first to introduce the late baroque tradition of figure painting to America, it apparently had little influence on artists then or later.

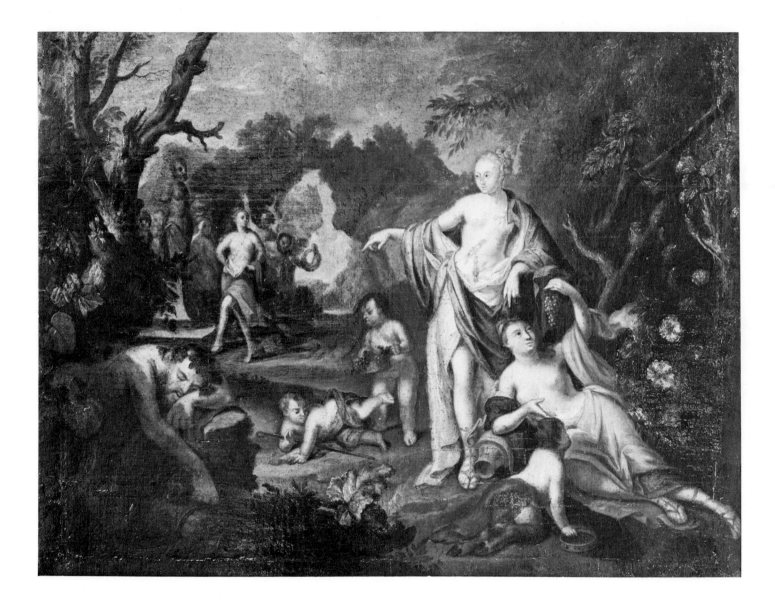

Primitive painters, relatively untrained and seldom remembered by name, have contributed greatly to this country's culture. In eighteenth- and nineteenth-century rural America such artists usually painted portraits of their families and pictures of their farms. Many primitive artists also made naive copies from prints of well-known works of art; others recorded historical events they had experienced. A much smaller number responded to their inner spiritual needs by painting stories from the Bible.

2

Christ and the Woman of Samaria,
ca. 1720 - 1740
Oil on canvas
20⅜ x 26⅛ in. (51.8 x 66.4 cm.)
National Gallery of Art, Gift of
Edgar William and Bernice Chrysler
Garbisch, 1953

Christ and the Woman of Samaria, dated ca. 1720-1740, is an unusually early religious work painted at a time when American art consisted primarily of portraits executed in the Anglo-American style. It portrays the moment of Christ's encounter with a woman from Samaria at Jacob's well, when he revealed himself to her as the Messiah (John 4:7-26). Like most art of this period the painting was probably inspired by a reproduction of an earlier work. The gesture of Christ and the posture of the listening woman, as well as the treatment of the drapery, are artistic devices associated with Christian images almost from their origin two centuries after the death of Christ. The buildings in the background look medieval as do the woman's shoes. Scenes like this were often based on prints that were sold throughout the colonies, but this particular work may have been inspired by a Bible illustration.

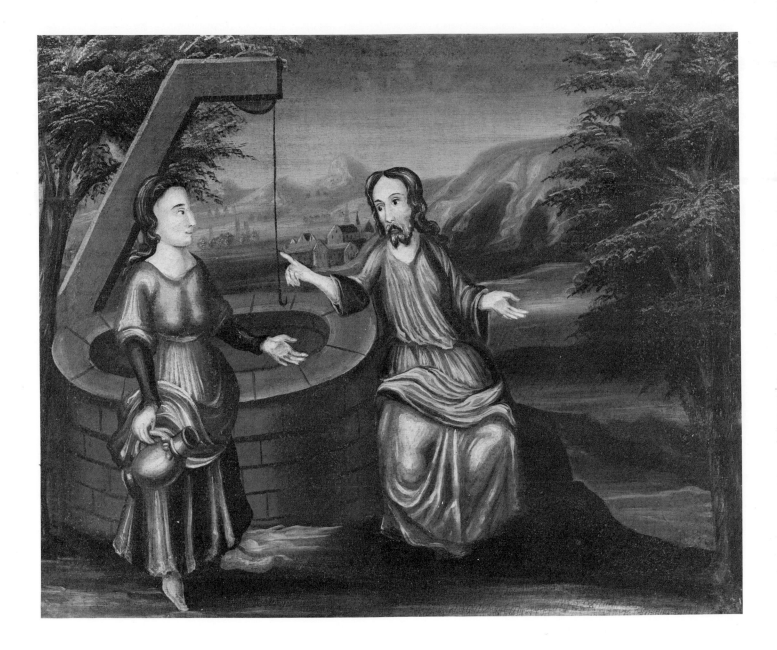

John Singleton Copley, portraitist and historical painter, was born in or near Boston where he was brought up by his widowed mother. When he was about ten she married Peter Pelham, a painter and engraver. Although Pelham died less than four years later, Copley's association with his stepfather was instrumental in his art instruction.

His earliest portraits date from shortly after Pelham's death and his precocious ability attracted an abundant clientele even before he came of age. After sending a portrait of his stepbrother to England in 1766, he received acclaim from Benjamin West who invited him to work in London. The invitation pleased Copley, for he believed that America was artistically barren, yet felt bound there by his financial success. It was several years before he made the move, finally encouraged by the political atmosphere of America just prior to the Revolution. Copley left for England alone and made a European tour, returning in 1775 to London where his family joined him. He remained there for the rest of his life, painting portraits and historical themes. Copley's style was formed in America where his best work was done, and his move to London deprived this country of one of its greatest mature painters.

3

The Nativity, ca. 1776-1777
Oil on canvas
24⅞ x 30⅛ in. (63.9 x 76.5 cm.)
Museum of Fine Arts, Boston,
Ernest Wadsworth Longfellow Fund

Copley painted *The Nativity* immediately after his first tour of the Continent, and it was obviously strongly affected by both his initial contact with centuries of European painting and by Benjamin West's potent influence. The background of *The Nativity,* it has been suggested, is based on a Raphael or Domenichino painting of a Roman sacrifice and includes typically renaissance devices: dramatic illumination, a landscape seen through an opening, and secondary figures. His choice of a religious subject, a distinct change from the portraits he executed in the colonies, was probably inspired by his desire to prove himself in a society where historical and religious pictures were the prescribed means to success for a painter.

Like many of the artists in this exhibition Copley used people he knew as models, and in *The Nativity* his wife and newborn child posed for Mary and the infant Christ. Their reclining position on the pillow and tapestry seems to some reviewers to be as awkward as the recumbent posture of Vanderlyn's *Ariadne.* The renaissance-type robes of the men on the left contrast with Mary's rather fanciful costume in which Copley has combined elements of Indian, Persian, and contemporary English styles to produce an effect both classical and Near Eastern.

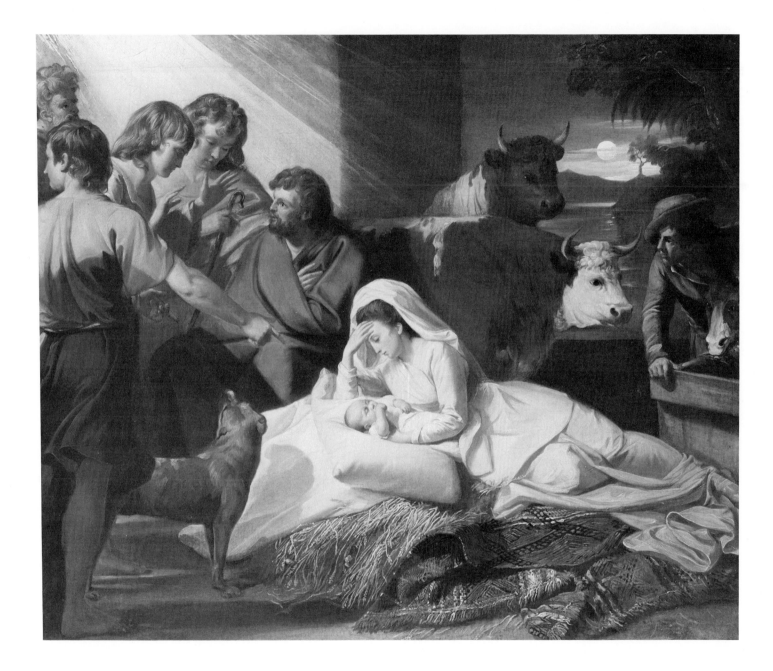

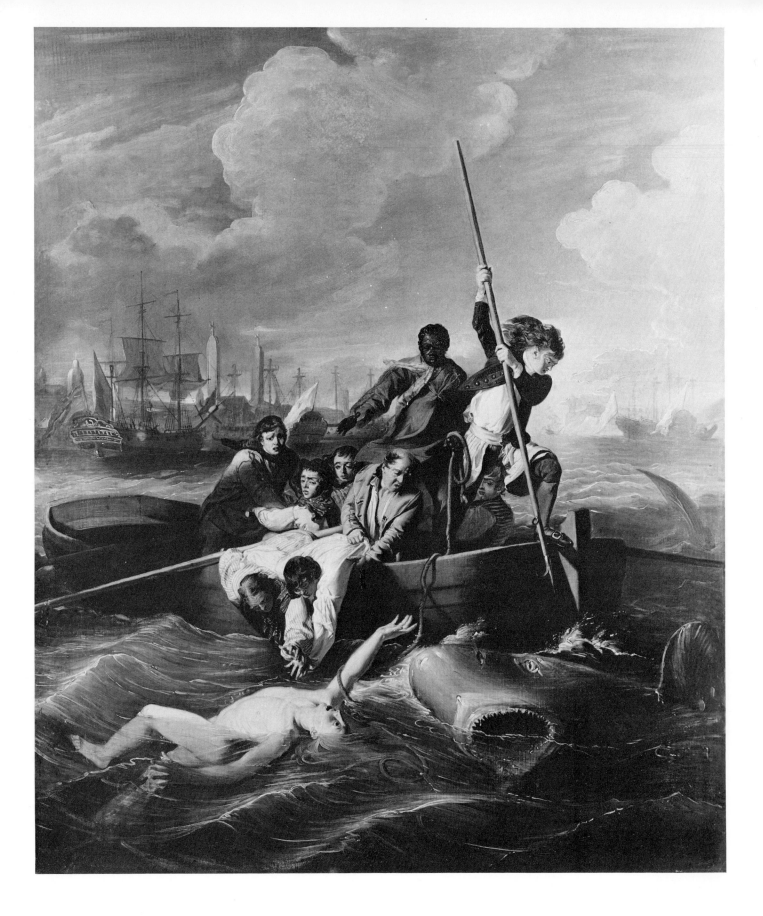

4

Watson and the Shark, 1782

Oil on canvas

36 x 30½ in. (91.4 x 77.5 cm.)

The Detroit Institute of Arts,

Dexter M. Ferry, Jr., Fund

After his move to London, Copley was anxious to prove himself as a historical painter. His chance came when Brook Watson, a prosperous London merchant, commissioned Copley to paint a scene from Watson's youth. In 1749, when Watson was a fourteen-year-old boy living in Cuba, he had been attacked by a shark while swimming in Havana Harbor. The moment Copley depicted is the boy's rescue from the shark after his foot was bitten off at the ankle. This was Copley's first English history painting and the novel subject is in striking contrast to his later, more conventional works dealing with celebrated events in Britain's history.

American narrative painting began with Benjamin West, this country's first expatriate artist. Son of a Quaker innkeeper, West was born near Springfield, Pennsylvania. His early interest in art led him to study books and engravings and to execute a number of portraits. He only worked in America briefly—in Philadelphia from 1756 to 1759 and in New York around 1759 or 1760—painting portraits and religious works before his departure for Italy. With his usual diligence he studied antique sculpture and made anatomical drawings. He was especially influenced by Titian's use of color and delicate brushwork. Intending to return to America in 1763, West stopped in England for a brief visit along the way and remained there for fifty-seven years. Artistic ability combined with an attractive appearance and friendly personality soon gained him entrance to the highest English art circles. His style, different from the prevailing English art, caught on almost immediately and he was commissioned to do several religious and historical works. By 1766 he had received patronage from King George III and six years later was appointed historical painter to the king. A good part of his time thereafter was taken up in executing the king's commissions which included many portraits of the royal family. Much of West's importance in American art was his influence on the many American pupils who came to study with him. These include Charles Willson Peale, John Trumbull, Washington Allston, Samuel Morse, and Henry Sargent.

Among the most significant works of Benjamin West were subjects from American history. Though painter to the King of England, he was immensely proud of his native country and its democratic ideals.

William Penn's Treaty with the Indians portrays Penn, a religious leader and converted Quaker, signing an agreement with the Indians regarding the rule of Pennsylvania, a tract of land granted to Penn by the King of England.

Obviously influenced by the writings of Jean Jacques Rousseau, West proudly represents the Indians as "noble savages." Curiosity about the dying native race attracted several European artist-scientists to America to study Indians in the early nineteenth century. George Catlin's comparison (1835) of Indians to ancient Greek sculpture echoed West's statement on seeing the Apollo Belvedere in Rome in 1760, "How like a young Mohawk warrior."

The figures in *William Penn's Treaty with the Indians* are clothed in the costume of their own period, but before West painted his *Death of General Wolfe,* historical works had been painted in the neoclassical style, with figures clothed in Greek or Roman dress. The English painter Joshua Reynolds wrote in 1783, "The use of modern dress was 'mean and vulgar.'" West felt however that "the same truth that guides the pen of the historian should govern the pencil of the painter," and he established a precedent that revolutionized historical painting.

Shortly after *Penn's Treaty* was painted, the American Revolution made it impossible for West to continue such subjects and remain in good graces with the king, so he returned to portraits and religious paintings.

William Penn's Treaty with the Indians, 1771

Oil on canvas

75½ x 108¾ in. (191.8 x 276.2 cm.)

Pennsylvania Academy of the Fine Arts,

Joseph and Sarah Harrison Collection, 1878

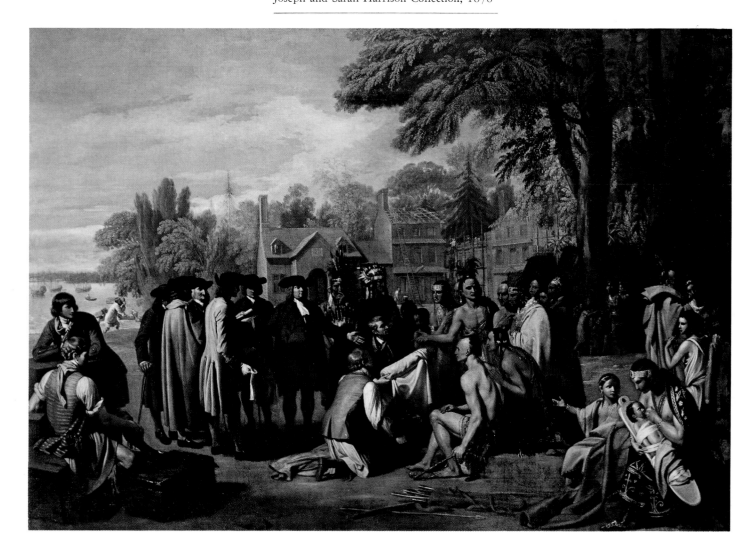

6

Death on a Pale Horse, 1802
Oil on canvas
21 x 36 in. (53.3 x 91.4 cm.)
The Philadelphia Museum of Art, Gift of
Theodora Kimball Hubbard in Memory of
Edwin Fiske Kimball

Benjamin West was a deeply spiritual man and religious themes occupied much of his later work. In *Death on a Pale Horse* he interprets John's vision of the Four Horsemen of the Apocalypse. According to the Book of Revelations, the fourth was "a pale horse, and its rider's name was Death, and Hades followed him, and they were given power over a fourth of the earth, to kill with sword and with famine, and with pestilence and by wild beasts of the earth" (Revelation 6:8). Although the title mentions only death, the painting includes all four horsemen.

Just as West's painting of General Wolfe had changed the style of costuming in historical paintings, so this oil study, exhibited in Paris in 1802, was to expose his contemporaries to romanticism. The movement of this brightly-colored painting was explosive, characterized by violent action and emotion. The French, as well as the English, regarded this painting as stylistic heresy. French critics could not guess that this style foreshadowed a major art movement that would appear in their own country a quarter of a century later with the work of Delacroix.

7

Noah and His Ark, 1819

Oil on canvas

40¾ x 50½ in. (103.5 x 128.3 cm.)

Pennsylvania Academy of the Fine Arts,
Collections Fund Purchase, 1951

In Washington during the winter of
1818-1819, Peale socialized with a Colonel
Bomford who had in his art collection a
painting by the English animal painter
Charles Catton. The picture, of Noah
herding his charges into the Ark, was of
interest to Peale both as an artist and a
naturalist; he later borrowed it to make a
copy for his museum, introducing varia-
tions of his own. His composition is
reminiscent of *The Peaceable Kingdom* by
Thomas Hicks, another Pennsylvania artist.
However, Hicks sought primarily to
express an allegorical harmony among the
various animals, while Peale, with his
naturalist's eye, undoubtedly delighted
mainly in painting the many different
textures and forms.

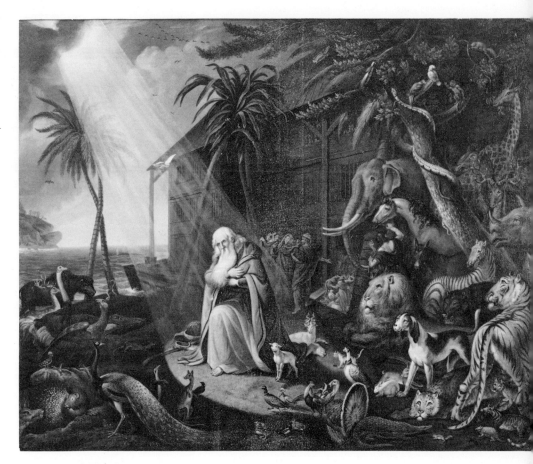

Charles Willson Peale was a man of many careers. He began as a saddlemaker in
Maryland, but was forced out of business by an unscrupulous partner and by creditors
unsympathetic to his anti-Loyalist views. He later felt this had been a fortunate
turning point because it allowed him to paint uninterruptedly. His portraits of himself
and his wife attracted commissions, and he traveled throughout New England and
Virginia as an itinerant portraitist. Almost completely self-taught except for brief
instruction from John Hesselius and John Singleton Copley, he welcomed the chance
to study in England offered him by several patrons in 1767. He spent two and a half
years in London studying painting, modeling, miniature painting, and mezzotint
engraving with Benjamin West. On his return to the colonies he continued his career
as an artist and in the spring of 1776 moved to Philadelphia, where he remained
until his retirement. Besides practicing art, Peale fought in the American Revolution,
started a public museum of natural history (now the Philadelphia Museum), wrote a
variety of books, and was instrumental in founding the Pennsylvania Academy
of the Fine Arts.

Born near New London, Connecticut, the son of the state's governor, Trumbull was unusually precocious, entering Harvard at age twelve and graduating in 1773, the youngest boy in his class. His desire to be an artist was discouraged by his father, but Trumbull continued to study on his own. After the Revolutionary War, he went to Boston to take up art, then traveled to London in 1780, and studied with Benjamin West until 1789. His most productive period was from 1786 to 1789, when he painted several historical works, including the *Declaration of Independence* and *The Battle of Bunker's Hill.*

Throughout his life Trumbull painted portraits, pursued various business ventures, and traveled extensively in the United States, England, France, and Germany. From 1793 to 1797 he aided the U.S. in implementing the Jay Treaty. Later, he was president of the American Academy of Fine Arts, painted scenes for the U.S. Capitol, established the Trumbull Gallery at Yale University, and wrote his autobiography.

Trumbull and Morse belong to the first major American school of narrative painting. Both men studied in England with Benjamin West, specializing in historical scenes characterized by careful attention to authentic detail. Their works were romantically neoclassical, reflecting the link of early American narrative painting to the past, but the subjects were fresh and interesting to the self-conscious new country. Trumbull was born to the gentry, and Morse considered himself a gentleman; both were disappointed men who bitterly resented their lack of patronage.

8

Lieutenant Grosvenor and His Negro Servant, Peter Salem, ca. 1785-1786
Oil on panel
15 x 11⅝ in. (38.1 x 29.5 cm.)
Yale University Art Gallery,
The Mabel Brady Garvan Collection

The *Battle of Bunker's Hill,* painted in London, records an event that Trumbull had watched through field glasses while with his regiment at Roxbury. With this picture he realized his longstanding desire to paint a subject of American history that would pay "a just tribute of gratitude to the memory of eminent men who had given their lives for their country."

The complete tableau (fig. 5) represents the battle's climactic moment on June 17, 1775, when General Warren of the American forces lay dying, protected by two colonial soldiers against the hordes of British surging forward to capture the hill. The study exhibited here is of Lieutenant Thomas Grosvenor and his servant, Peter Salem, of the Third Connecticut Regiment. Though of only a part of the larger work, the study includes similar characteristics: dramatic poses, triangular composition, tempestuous cloudy background, and a pervasive romantic atmosphere. About one hundred years later Edwin Blashfield painted his *Suspense, the Boston People Watch from the Housetops the Firing at Bunker Hill* (cat. no. 79), representing this same battle from an entirely different viewpoint.

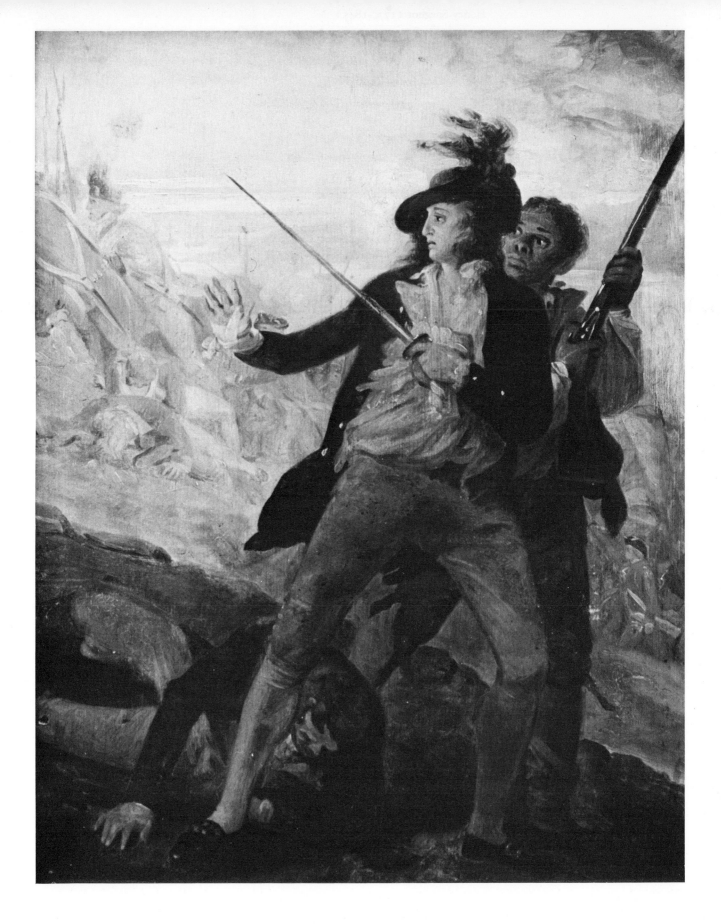

Born in Gloucester but raised in Boston, Sargent showed no interest in becoming an artist until he reached his majority. Encouraged by his mother, he was possibly also inspired and tutored by his elder brother who was already an artist. Sargent went to London in 1793 and studied with Benjamin West, returning to Boston in 1799 where he remained the rest of his life. He took a commission in the national army, then began a long association with the Massachusetts militia by joining the Boston Light Infantry in 1799. He rose through the ranks and served in the War of 1812, but from 1817 to 1827 his gradually increasing deafness slowly caused him to withdraw from the military. By retiring he was able to devote more time to his painting.

9

The Tea Party, ca. 1821-1825

Oil on canvas

64¼ x 52¼ in. (163.2 x 132.7 cm.)

Museum of Fine Arts, Boston, Gift of

Mrs. Horatio A. Lamb in Memory of

Mr. and Mrs. Winthrop Sargent

Sargent executed many portraits in which he diligently represented the surface texture of fabrics and objects. However, he is better known for his several genre scenes, principally *The Tea Party* in which he depicts social life in a Boston house of the early nineteenth century. The occasion is reputedly a reception at the artist's own home, though the furniture differs from that in the more thoroughly documented *Dinner Party,* a companion painting by Sargent. The date of this painting makes it one of the earliest American genre pictures. Sargent's depiction of a restrained, obviously upper-class party is unusual compared to the work of many genre painters who recorded lively rural scenes.

The elongated proportions of the rooms, furnishings, and people produce an effect of unsubstantiality. By accurately recording the refined manners and lack of dramatic action, Sargent created an atmosphere of restraint and gentility that may have characterized such affairs. Because he was one of the few early artists to depict upper-class society, carefully recording details of costume and setting, his work is important both historically and artistically.

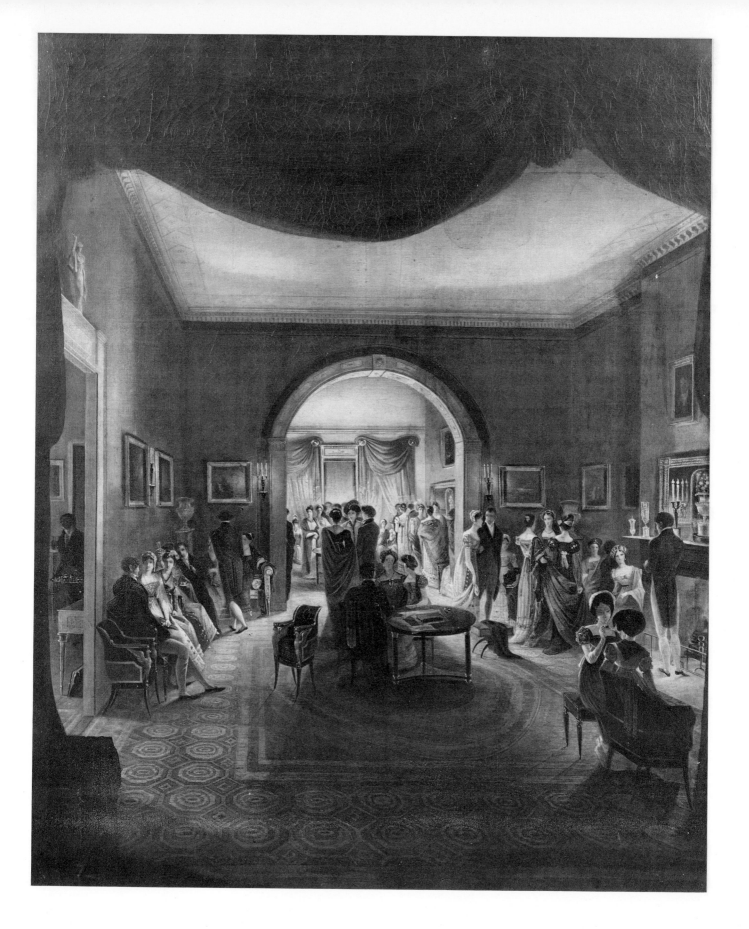

Born in Kingston, New York, Vanderlyn exhibited a childhood interest in drawing. After his graduation from the Kingston Academy at age sixteen, his parents apprenticed him to a seller of colors, glazes, and paintings in New York. He enrolled at the Columbian Academy of Painting where he copied paintings by Gilbert Stuart, and also produced several original portraits.

From 1796 to 1815 Vanderlyn traveled between Europe and the United States, initially supported by his patron, Aaron Burr. For a time he studied with André Vincent in France, learning French academic technique and viewing Old Masters in the museums. He returned to America and painted Niagara Falls before going back to Europe to have some of his works engraved. He spent two years in Rome before again traveling to Paris where he stayed until 1815. After this he settled permanently in America.

Vanderlyn, like his contemporaries Trumbull and Morse, dreamed of painting great historical subjects but found little financial support. He tried to make a profit selling engravings of his paintings, but the project failed as did his idea of making money by exhibiting monumental panoramas. Much of his income came from portraits, though he did complete four notable history paintings: *Marius amidst the Ruins of Carthage, Ariadne, Death of Jane McCrea,* and *The Landing of Columbus on San Salvador, October 12, 1492.*

10

Death of Jane McCrea, 1803-1805
Oil on canvas
26½ x 32 in. (67.3 x 81.3 cm.)
Wadsworth Atheneum, Hartford,
Purchased by Subscription

The *Death of Jane McCrea* depicts an actual incident of the American Revolution. Accompanied by Indian guides, Jane McCrea traveled from New Jersey to Fort Edward, New York, to meet her sweetheart, David Jones, who was an officer with Burgoyne's British army. During the war the British encouraged Indians to attack the colonists by offering them a reward for white scalps, and in the course of her journey, Jane McCrea was killed by the Indians escorting her. They carried her scalp to Burgoyne's camp, and there it was recognized by her lover. The "evil and cruel" massacre of a young and innocent girl was widely publicized as a symbol of American suffering caused by the British, and many Loyalists joined the rebel side because of it.

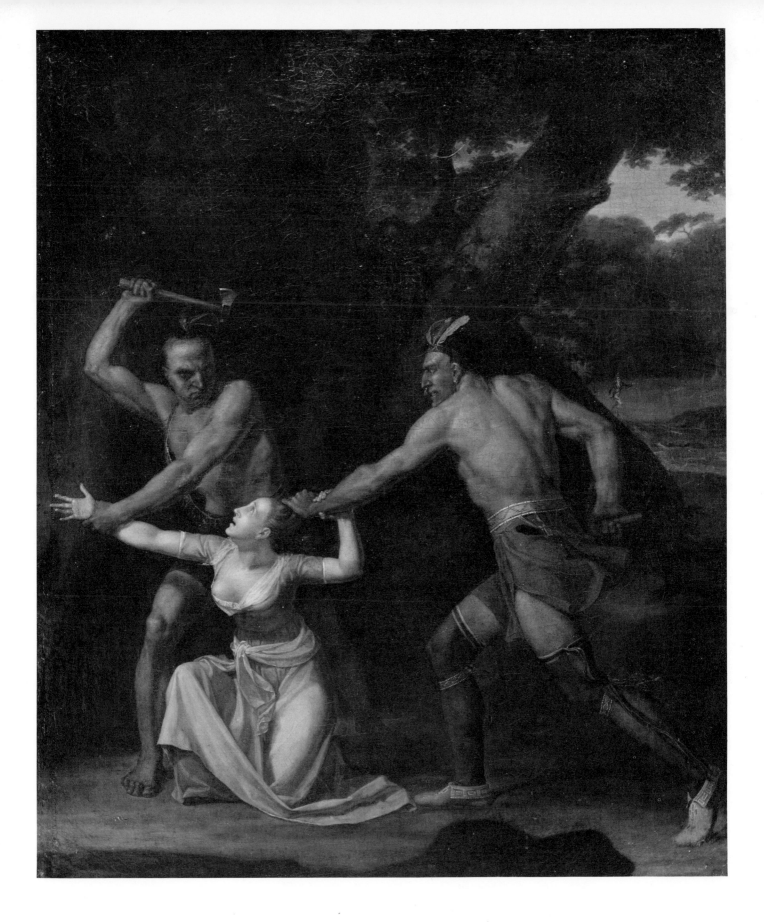

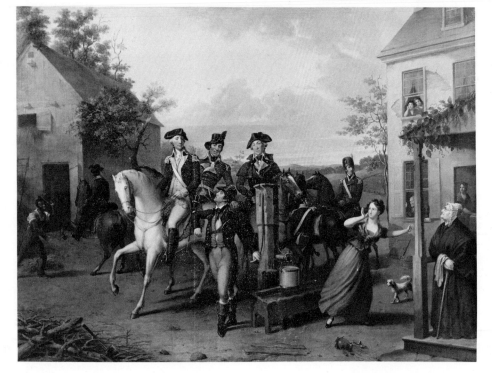

Jacob Eichholtz, portrait painter, was born in Lancaster, Pennsylvania, to a German family of "moderate circumstances." Primarily self-taught in portraiture, he learned the rudiments of art from a local sign painter, and was also given advice by Thomas Sully. He once visited Gilbert Stuart and placed one of his portraits next to one of Stuart's, a comparison he later considered "the best lesson I had ever received."

His father was a practical man and apprenticed him to a copper- and tinsmith. By the time he was twenty-five Eichholtz had attained the rank of journeyman, but his real desire was to paint. Unwilling to abandon the craft that supported his growing family for the insecure income of portrait painting he pursued both careers for a time. "It was not unusual to be called out of the shop, and see a fair lady who wanted her picture painted." Not until he was thirty-five could he make portraiture his main occupation. Though located for most of his career in Philadelphia he also worked in Lancaster, Baltimore, and Washington.

11

An Incident of the Revolution, 1831
Oil on canvas
48½ x 66 in. (123.2 x 167.6 cm.)
Museum of Fine Arts, Boston,
M. and M. Karolik Collection

Eichholtz produced over 300 portraits but probably less than 20 figure pieces and landscapes. Like other artists in the early nineteenth century Eichholtz found that paintings of scenes from the Revolution were popular subjects. At age twelve he painted the *Capture of Major André* and much later *An Incident of the Revolution,* which depicts an amusing anecdote rather than a battle scene. General Charles Lee, although an important military man, was known for his casual attire. Appearing at a farmhouse in advance of General Washington's troops he asked for lunch. The maid, taking him for a tramp, asked him to help her in her chores in exchange for food. While the general was thus employed, Washington rode up and the embarrassed maid fled to the house.

Like his portraits this work is competent but not inspired. The tradition of genre painting begun by painters like Eichholtz was later continued by greater Pennsylvania figure painters like Rothermel, Schussele, and Eakins.

12

The Muses of Painting, Poetry and Music,
ca. 1835
Oil on canvas
38¼ x 33¼ in. (97.2 x 84.5 cm.)
Corcoran Gallery of Art, Gift of
Elizabeth H. E. McNabb in Memory of
Sarah West Norvell Leonard

The Muses of Painting, Poetry and Music is thought to be a group portrait of the Caton sisters from Baltimore who sponsored West while he was in Paris around 1824 or 1825. By painting them in the guise of three of the nine Greek muses, West has adopted the allegorical approach to portraiture favored by such European artists as Sir Joshua Reynolds and Jacques Louis David. The painting is a mixture of old and new elements: the sisters, arranged in a pyramidal grouping, wear modern dress; yet their classically dressed servant pulling aside a curtain to expose them is an old compositional device. The landscape seen through the rear window is reminiscent of renaissance canvases. Like *Leland Stanford's Picnic* (cat. no. 61) by Erneste Narjot, West's *Muses of Painting, Poetry and Music* is a narrative painting that is also a group portrait.

West was born in Lexington, Kentucky, when it was still a frontier city. He began his career as a painter of miniatures, and later studied under Thomas Sully in Philadelphia. After working there until 1818, he moved to Tennessee where he painted portraits in Natchez for a number of years. In 1822, he went to Europe where he won praise for his portrait of Lord Byron and became popular as a painter of Americans abroad. From about 1826 to 1840 he was active in England and exhibited portraits in the important London exhibitions. About 1838 West returned to the United States where he painted in Baltimore, New York, and Nashville until his death.

Although Morse the inventor has long overshadowed Morse the painter, it was a painter he really wanted to be. While studying at Yale he acquired a local reputation for his miniatures on ivory, but his family was reluctant to have him become an artist. He continued painting, however, and after two of his works, *Marius amidst the Ruins of Carthage* and *The Landing of the Pilgrims at Plymouth,* were praised by Washington Allston and Gilbert Stuart, he went to study in England. The four years he spent in London studying under Allston, painting and exhibiting at the Royal Academy, were probably the artist's happiest years for he was surrounded by art and literature. Full of enthusiasm he returned to America and opened a studio in Boston, only to find America was not ready for his artistic concepts. He had to become an itinerant portrait artist to support himself, and thus contradicted his earlier statement, "No, I will never degrade myself by making a trade of a profession. If I cannot live like a gentleman, I will starve like a gentleman."

Morse began his figure paintings about the time genre scenes were becoming popular in America, but his conservative subject matter was less readily accepted than the work of the genre painters. He painted grand and heroic themes from mythology which might have appealed to cultured Europeans but not to middle-class Americans just beginning to appreciate storytelling scenes with contemporary settings. He felt his own paintings were only exercises leading to more accomplished works in the future. Expecting too high a taste from the public he refused to lower his standards.

Despite his financial failure as an artist, the contributions Morse made to the progress of American art are evident in the accomplished works he produced.

13

Judgement of Jupiter, 1815

Oil on canvas

50⅝ x 40¼ in. (128.6 x 102.2 cm.)

Yale University Art Gallery,

Gift of Russell Colgate, B.A., 1896

Benjamin West saw the *Judgement of Jupiter,* painted by Morse as a student in London, as a potential winner of the Royal Academy prize. Unfortunately, Morse could not meet the Academy requirement that he be present at the close of the competition; his parents had demanded he return to America to earn his own living.

The painting's mythological theme is typical of Morse; the god Jupiter arbitrates a dispute between his son Apollo and the mortal Idas over Marpissa, the girl they both love. The picture was accepted in England, but in America few people appreciated its esoteric subject.

14

The Capture of Major André, ca. 1833-1834
Oil on canvas
25⅛ x 30½ in. (63.8 x 77.5 cm.)
Worcester Art Museum,
Worcester, Massachusetts

Durand attempted history painting early in his career with *The Capture of Major André*. His first historical work, the painting represents an incident from the American Revolution in which the spy Major André tried to bribe his American captors into releasing him. Mr. Paulding, looking at the incriminating papers found on André, replied, "No, if you would give us ten thousand guineas you shall not stir one step."

Durand's son, who was also his biographer, records that Durand visited the Tarrytown spot where André had been arrested and conferred with a Mr. J. K. Paulding, a descendant of one of the captors, regarding costume and history. The painting was subsequently engraved, becoming so well known that it served as the standard representation of the subject. The Montclair Art Museum exhibition catalog suggests it may also be an allegory of mid-1830s New York politics in which integrity triumphs over bribery. In any event, though Durand later produced other figural themes such as his *Wrath of Peter Stuyvesant,* he eventually concentrated solely on landscapes and became a leading figure in American scenic painting.

Asher B. Durand was born in Maplewood, New Jersey, and as a youth was apprenticed for five years to an engraver. He succeeded so well he was made a partner in the firm and was sent to New York. Although jealousy severed this relationship a few years later, Durand continued on his own as an engraver, establishing a prosperous career. He grew increasingly interested in portraiture and landscape painting, and by age twenty-six he had exhibited at the American Academy in New York. His activity in art circles increased, and two years later he helped organize the New York Drawing Association. The following year he was one of fifteen founders of the National Academy of Design, and the next a founding member of the Sketch Club. By age thirty-five he had given up engraving entirely and temporarily made his living by portraiture, but his continuing interest in landscape painting soon led him to specialize in it.

Except for a one-year trip through Europe in 1840-1841, Durand spent the rest of his life traveling in the eastern United States looking for suitably picturesque subjects to paint. His "Letters on Landscape Painting," published in *The Crayon,* was the most important formal statement on art theory produced by any artist of the Hudson River school. After serving as president of the National Academy of Design from 1845 to 1861 Durand spent his last twenty years in retirement near Maplewood.

Ariadne, ca. 1829-1834

Oil on canvas

14½ x 18 in. (36.8 x 45.7 cm.)

The Metropolitan Museum of Art,

Gift of Samuel P. Avery, 1897

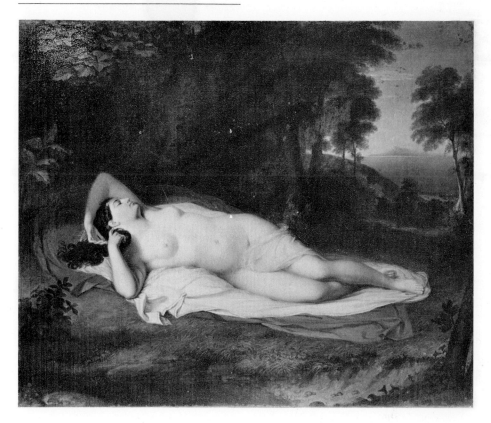

In Greek mythology Ariadne was the daughter of King Minos of Crete. She had fallen in love with the Athenian, Theseus, one of the fourteen victims sent yearly to feed the Minotaur in the Labyrinth on Crete. She helped Theseus slay the Minotaur, then sailed with him and his companions for Athens. On the way they stopped at the island of Naxos where Theseus abandoned Ariadne while she slept.

This painting, a copy of the famous painting of Ariadne by Vanderlyn, was originally thought to be totally by Asher B. Durand. However, recent evidence indicates it may in fact be a painting by Vanderlyn which Durand completed as a basis for an engraving.

After hearing of the profits made by the exhibitors of the painting of a nude Danae, Vanderlyn planned his *Ariadne* with a similar financial success in mind. Pellissier, an expatriate Frenchman living in New York, wrote and produced an opera based on the story of Ariadne at the time Vanderlyn was sent to study in Paris by his benefactor, Aaron Burr. Knowledge of the popular play may also have influenced Vanderlyn in his choice of this subject.

16

The Money Diggers, 1832
Oil on canvas
16¾ x 21½ in. (42.5 x 54.6 cm.)
The Brooklyn Museum,
Gift of Mr. and Mrs. A. Bradley Martin

Born in Tappan, New York, but brought up in New York City where his father was a teacher, Quidor studied briefly with the portraitist John W. Jarvis. By his late twenties Quidor was listing himself in the New York City directory as a portrait painter and soon began exhibiting at the newly founded National Academy of Design. He continued to paint incidents from the stories of Washington Irving and James Fenimore Cooper until the mid-1830s, sending his works to the Academy for exhibition. Around 1830 he took two pupils who were attracted to him because he was "the only avowed figure painter then in New York." However, much of his income came from painting signs, banners, and fire engines.

Few of his pictures painted before 1840 have been located, and no genre scenes from 1840 to 1855 are known to exist, though between 1843 and 1849 he did paint several large Biblical scenes in payment for a farm in Illinois. Quidor was continuously listed as an artist in the New York City directories from 1851 to 1868, and during this time he returned to depicting literary themes. He gave up painting after this last period of creativity and retired to New Jersey, where he died ten years later at the home of his daughter.

Quidor was among the earliest American artists to paint genre scenes, beginning about 1828. Like other figure artists of that time, his work initially found neither public interest nor buyers. Though amusingly presented, his literary subjects had less appeal and relevance to most people than Mount's scenes of farm or rural folk. Nor did Quidor's caricature-like figures fit the public's preconceived ideas of classical models or of closeness to nature.

The Money Diggers, illustrating a story from Irving's *Tales of a Traveller* entitled "Wolfert Webber, or Golden Dreams," is one of Quidor's best-known works. The "diggers" represented are the fortune hunters Wolfert, Dr. Knipperhausen, and their assistant Sam, whose grimacing, mask-like faces are distorted by the firelight. They have been caught by the ghost of the pirate owner as they are robbing his cache: "Wolfert gave a loud cry and let fall the lanthorn . . . The negro leaped out of the hole, the doctor dropped his book and basket and began to pray in German. All was horror and confusion." The theatrically gesticulating figures and wild landscape of the composition evoke a feeling of baroque complexity and movement. In it Quidor uses color vividly, delineating the faces in pure hues of red, blue, green, yellow, and black.

A Battle Scene from Knickbocker's
History of New York, 1838
Oil on canvas
27 x 34½ in. (68.6 x 87.6 cm.)
Museum of Fine Arts, Boston,
M. and M. Karolik Collection

The story represented in this painting is the same as that in Albertis del Orient Browere's *Peter Stuyvesant at the Recapture of Fort Casimir* (cat. no. 37), both based on Washington Irving's *History of New York by Diedrich Knickerbocker,* Book VI, Chapter VIII. At the vortex of this complex tableau of writhing figures are the two protagonists, Peter Stuyvesant and General Risingh. Stuyvesant is shown by Quidor, in Irving's words, ". . . missing his footing, by reason of his wooden leg, down he came on his seat of honor with a crash which shook the surrounding hills." With his style of caricature and baroque composition Quidor probably comes closer than Browere to capturing the spirit of Washington Irving's tales. Quidor's blending of romanticism and fantasy is perhaps unequaled in American art until Albert Ryder's work appears at the end of the nineteenth century.

Thomas Cole was born in England where as a child he displayed interest in music and poetry and received training in engraving patterns for calico fabrics. At the age of seventeen he migrated with his family to Ohio where for a number of years he held various jobs as painting teacher, wood engraver, and designer of floor cloths. He studied briefly at the Pennsylvania Academy of the Fine Arts, then about 1825 moved to New York and began his twenty-year professional career. His paintings won instant recognition, and Cole later became a founding member of the National Academy of Design.

Decaying Greek and Roman ruins, contorted trees, a lone poet or traveler contemplating the majesty of nature are elements that often appear in Cole's work. He had first been inspired by ruins on his trip to Europe in 1829-1832 when he visited England, France, and Italy. He climaxed his second trip in 1841-1842 with a journey to Taormina.

Cole often painted landscapes with people reading poetry and, like his subjects, always carried a volume of Milton, Petrarch, Wordsworth, or Byron on his excursions through Italy.

Although he painted many pictures of the American landscape, Cole's principal interest was in allegorical subjects, for which he found generous patronage. For Samuel Ward he completed a series entitled *The Voyage of Life* (Munson-Williams-Proctor Institute, Utica) and for Luman Reed *The Course of Empire* (New-York Historical Society), which stand as his most important creations in this field.

Cole was not alone in his belief that paintings should instruct. Benjamin West expressed a similar opinion, feeling that historical and religious painting could also be morally instructive. Cole was probably one of the last artists to hold such conservative opinions, for by mid-century genre artists were attracting public attention with pictures that subordinated moral content to a more objective realism.

In January 1832 Cole wrote from Florence to his benefactor J. L. Morton, Esq., that he was painting a scriptural subject, *The Angels Appearing to the Shepherds*. He must have been referring to the study, since (according to Cole's biographer Louis Legrand Noble) the finished painting was executed in New York during two winter months of 1833-1834. Several pencil sketches, now in the collection of the Detroit Institute of Arts, also exist for this work.

This sketch exhibits much of the drama of Cole's romantic paintings. The darkness of the night is shattered by a brilliant light at the upper left which illuminates the shepherds in the opposite foreground. Behind them the radiant star defines the town of Bethlehem.

Religious painting was never of major importance in America; Protestant congregations did not commission paintings as the Catholic church had done in Europe. American painters interested in religious subjects worked primarily in England, where such paintings were generally popular. Though Cole created several pictures of Old and New Testament scenes including *John the Baptist in the Wilderness* and *Moses on the Mount,* these paintings found no patron and were either kept in his studio or given to friends. Cole was the last major American artist to paint Christian themes in the European tradition, using his subjects to instruct and inspire. Later painters such as William Rimmer and Elihu Vedder painted visions which were usually personal or derived from mysticism rather than Christianity.

Study for Angels Appearing to
the Shepherds, ca. 1832
Oil on panel
8½ x 12½ in. (21.6 x 31.8 cm.)
Arthur and Nancy Manella

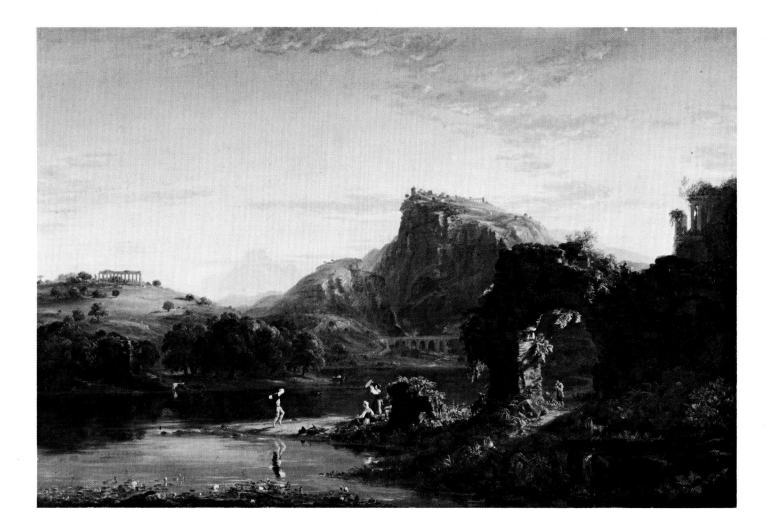

L'Allegro, 1845

Oil on canvas

32 x 48 in. (81.3 x 121.9 cm.)

Los Angeles County Museum of Art,

Art Museum Council and

Michael J. Connell Foundation

L'Allegro was painted in Cole's studio in Catskill, New York, in 1845. Commissioned by Charles Parker, it was originally coupled with a companion work entitled *Il Penseroso*. Of *L'Allegro* Cole said, "I should represent a sunny, luxuriant landscape with figures in gay pastimes . . ." Using the sketches and memories of his two Italian trips of 1831 and 1841, Cole composed a gay pastoral scene enacted in an imaginary Italianate setting. Derived from poetic metaphor, *L'Allegro* illustrates the joys of life expressed in John Milton's poem of the same title. A combination of landscape and allegory painted in Cole's fine, mature style, *L'Allegro* represents a culmination in the art of this outstanding nineteenth-century painter.

20

Sketch for Voyage of Life: Manhood, 1839
Oil on canvas
11 x 16¾ in. (28.0 x 42.5 cm.)
Munson-Williams-Proctor Institute, Utica

In a letter of 1844, Cole wrote:

I have been dwelling on many subjects . . . They are subjects of a moral and religious nature. On such I think it the duty of the artist to employ his abilities: for his mission, if I may so term it, is a great and serious one. His work ought not to be a dead imitation of things without the power to impress a sentiment, or enforce a truth.

Four years earlier, he had developed his great allegorical series, *The Voyage of Life.* In four paintings he showed a symbolic traveler passing from Childhood through Youth and Manhood to Old Age on a "river of life." In each the landscape and mood symbolically express the particular stage of life. The sketch exhibited here depicts Manhood, the third in the series. For the showing of the four, Cole prepared a catalog to describe exactly his feelings and intentions on painting each work. His text for *Manhood* follows:

Storm and cloud enshroud a rugged and dreary landscape. Bare impending precipices rise in the lurid light. The swollen stream rushes furiously down a dark ravine, whirling and foaming in its wild career, and speeding toward the Ocean, which is dimly seen through the mist and falling rain. The boat is there, plunging amid the turbulent waters. The voyager is now a man of middle age: the helm of the boat is gone, and he looks imploringly toward heaven, as if heaven's aid alone could save him from the perils that surround him. The Guardian Spirit calmly sits in the clouds, watching with an air of solicitude the affrighted voyager. Demon forms are hovering in the air.

Trouble is characteristic of the period of Manhood. In Childhood there is no cankering care; in Youth no despairing thought. It is only when experience has taught us the realities of the world, that we lift from our eyes the golden veil of early life: that we feel deep and abiding sorrow; and in the picture, the gloomy, eclipse-like tone, the conflicting elements, the trees riven by tempest, are the allegory; and the Ocean, dimly seen, figures the end of life, to which the voyager is now approaching. The demon forms are Suicide, Intemperance, and Murder, which are the temptations that beset men in their direst trouble. The upward and imploring look of the voyager, shows his dependence on a Superior Power, and that faith saves him from the destruction that seems inevitable.

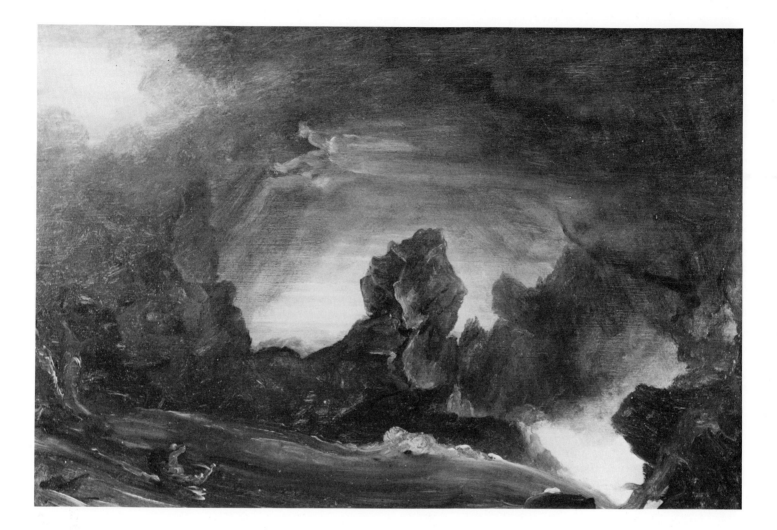

21

The Last March of the Bourbons, 1834

Oil on canvas on masonite

28 x 36 in. (71.1 x 91.4 cm.)

Anonymous loan

Typical of the historical themes illustrated by American artists, *The Last March of the Bourbons* was engraved by James Smillie and appeared as an illustration to a story in the 1835 edition of *The Token, or Affections Gift, a Christmas and New Year's Present.* This publication was issued yearly from the early 1830s to at least the late 1850s and was the "coffee table book" of its day, popularly given as a Christmas present. Publishers of these books sometimes purchased artwork and wrote accompanying stories (as was the case with William Page's *Young Merchants,* cat. no. 26). However, this work was probably commissioned to illustrate a story about Charles III, Duke of Bourbon, which had already been accepted. When the King of France threatened to seize lands the Duke of Bourbon had inherited, the duke raised an army of 10,000 men and made treaties with England and Spain to assist him in an invasion of France. Even though the French king was captured in 1525, the treaty of Madrid (1526) ended the war by giving only Milan to the duke. He was killed during the sack of Rome, which he had initiated to satisfy the soldiers he could not afford to pay.

Robert Walter Weir prepared for a mercantile career but decided to become an artist instead. He managed to obtain instruction in both painting and anatomy after working hours, and when he was about twenty, a patron helped finance his trip to Italy for three years of further study. On his return Weir opened a studio in New York, and was soon made a member of the National Academy of Design. He was appointed drawing instructor at West Point, a position he held for forty-two years while also maintaining an active independent career, illustrating and painting portraits and genre pictures. In addition he fathered two sons—John Ferguson Weir and Julian Alden Weir—who both became artists. Weir has the distinction of being the first artist to produce an oil painting of Santa Claus.

Born in the small town of Leverett, Massachusetts, Field studied only three months under Samuel Morse before becoming an itinerant portraitist in 1824. For several years Field was constantly busy producing portraits of his friends, neighbors, and relatives, as well as painting occasional commissions for people in nearby towns. But when photography became popular, demand for painted portraits began to dwindle, and in 1840 Field moved with his family to New York City. There he studied photography, painted portraits, and exhibited his work until he returned to Leverett in 1848 to help his ailing father with the farm at Plumtrees. Field lived the rest of his life there, supporting himself with a small income from farming.

After the death of his wife in 1859, Field began to concentrate almost completely on Biblical and historical themes which he interpreted as allegories of American life. At the time of his death he was noted primarily for his portraits, but is now obtaining recognition for these symbolic pictures distinctively painted in a naive and colorful style.

22

"He Turned Their Waters into Blood,"

ca. 1865-1880

Oil on canvas

30¼ x 40½ in. (76.8 x 102.9 cm.)

National Gallery of Art,

Gift of Edgar William and

Bernice Chrysler Garbisch, 1964

When he was about seventy-five years old Field painted several works based on the seven plagues of Egypt. Among these were *Death of the First Born, Plague of Darkness,* and *"He Turned Their Waters into Blood,"* which depicts the plague inflicted on Egypt after the Pharaoh's second refusal to free the Israelites. Field had never been to Egypt and the architecture in these paintings may have been based on Bible illustrations by the English artist John Martin. Though most of these works are in an accurate historical context, three are set in nineteenth-century America. Field strongly opposed slavery and possibly used this approach to emphasize the relationship of the Israelites' plight to that of American slaves.

John Russell Bartlett, born at Providence, Rhode Island, was an eminent historian, ethnologist, and bibliographer, as well as an artist. Raised on the frontier in Canada, in his early twenties he worked as a clerk in a dry goods store and later as a bookkeeper and cashier in a bank. About this time his interest in the literature and history of ethnology led him to become a member of the Franklin Society, founded to study the natural sciences, the first of several such societies he joined or helped form. In his early thirties he opened a bookstore in New York which became a meeting-place for leading scholars of the day, and he also began to write scholarly books and papers. At about the age of forty-five he quit his business for a less restrictive life and was appointed commissioner to establish the boundary line between the United States and Mexico after the Mexican-American War. He published a book about this expedition and illustrated it with many drawings. Returning to Rhode Island he was elected Secretary of State. During his seventeen years as Secretary he arranged and classified Rhode Island's public papers and created an index of material on the state's history.

23

The Great September Gale of 1815,

ca. 1835-1840

Oil on canvas

32 x 41⅛ in. (81.2 x 104.5 cm.)

Collection of The Rhode Island
Historical Society

The Great September Gale of 1815 records a destructive storm that occurred when Bartlett was about ten, and the painting thus recreates an incident he recalled from childhood experience. The gale, actually a hurricane, hit Rhode Island on Saturday, September 23, and blew northwesterly through eastern Connecticut, central Massachusetts, and New Hampshire causing destruction in a 150-mile wide path. It was the greatest storm ever to hit New England in the memory of anyone living at the time, and contemporary accounts describe vividly the extensive damage to trees and property. Bartlett's painting of this event, though somewhat primitive in style, forcefully recreates an awesome spectacle of nature.

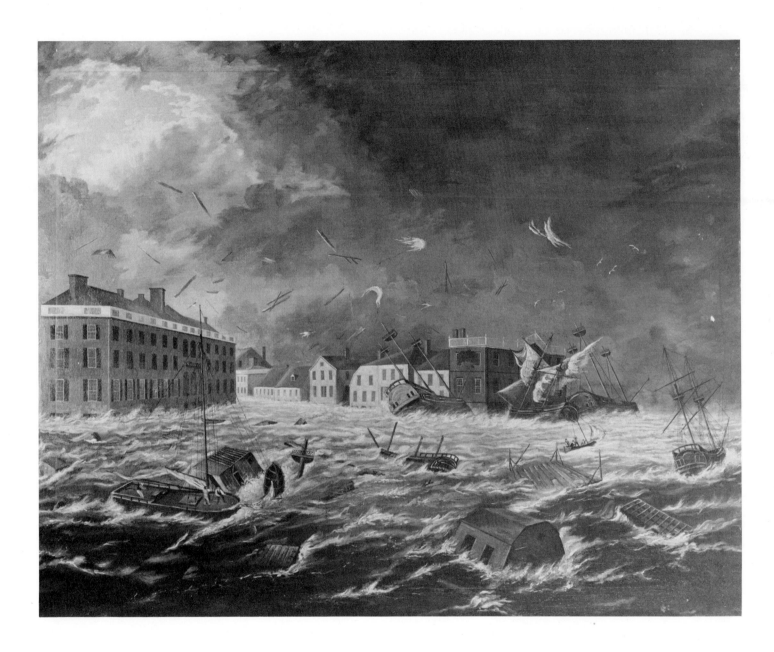

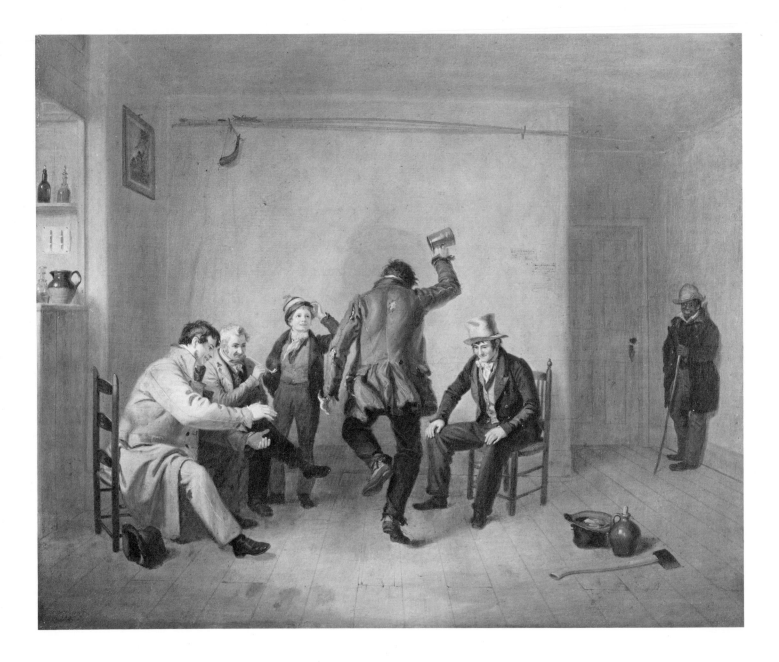

24

The Breakdown, 1835

Oil on canvas

22⅜ x 27½ in. (56.8 x 69.9 cm.)

The Art Institute of Chicago, The William Owen and Erna Sawyer Goodman Collection

One of Mount's earlier paintings, *The Breakdown* (also called *Bar-room Scene*) was painted in Setauket in 1835 at the house of General Satterlee. The humorous good will seen in the faces watching the dancer is characteristic of Mount's jovial types. The only criticism the painting received when it was first shown pertained to the subject; one critic felt Mount should use his superior talents and skills to depict "a subject of a higher grade in the social scale." Although this work does not portray the negative effects of intoxication that John Greenwood had recorded in *Sea Captains Carousing at Surinam* (fig. 1), the critic's comment suggests that by 1835 public sentiment against liquor had begun to emerge. The criticism apparently had little effect on Mount, since his *Loss and Gain,* painted about 1848, shows a drunkard hanging over a fence trying to retrieve his fallen jug.

William Sidney Mount was raised on a farm near Stony Brook, Long Island. At seventeen he was apprenticed to his brother, a sign and ornament painter in New York City, and later studied at the National Academy of Design. Returning to Stony Brook "chiefly from a native preference for its quiet and innocent pleasures," Mount began his professional painting career with landscapes, portraits, and historical paintings. Although he had been offered funds from several sources for European travel and study, he declined them saying, "I have plenty of orders, and I am contented to remain a while longer in our own great country." After briefly revisiting New York City, Mount returned to Stony Brook where he stayed from 1836, painting genre scenes as well as numerous little-known portraits. Besides his art, Mount was interested in politics, phrenology, and spiritualism; he also invented a new type of violin.

Mount's first figural works appeared in New York exhibitions about 1830, when genre paintings were just beginning to be popular. The public had refused to accept Mount's historical works, just as they had rejected those by Samuel Morse. However, instead of refusing to lower his standards Mount began depicting the everyday life of the rural community in which he had grown up, and his subjects became so popular that some of his works were engraved for European distribution by Goupil, Vibert & Co., Paris. His scenes were realistically painted and conveyed a sense of good-natured fun. Mount's paintings, which often show rural farmers playing music and dancing, are very similar to Bingham's depictions of happy frontiersmen, and indeed the two artists were the best-known genre painters of the mid-nineteenth century.

25

The Savoyard Boy in London, 1865

Oil on canvas

54 x 43½ in. (137.2 x 110.5 cm.)

Hirschl and Adler Galleries, New York

The Savoyard Boy in London is typical of Freeman's depictions of street urchins. Domenico, a Roman model Freeman often used, posed for the painting and Freeman mentions in his first book that Domenico entered into the spirit of the masquerade "with great earnestness." Freeman desired to convey the image of a boy from Savona (a province of northwest Italy) who came to London to make his fortune as an organ grinder and who forlornly dreams of his Italian home. To emphasize the contrast between north and south, Freeman has placed nearby a blond-haired, ruddy-faced Irish child, who watches the sleeping southerner with timid pity and wonder. The two children in the composition produce an effect of sentimentality reminiscent of the street urchins by John G. Brown and the children by Joseph Guy and Lilly Martin Spencer. The simple symbolism and easily discernable story are typical of late nineteenth-century Victorian painting, and such important artists as William Woodville and Eastman Johnson also essayed the theme of the "Savoyard Boy." This type of storytelling was much more popular than earlier American works based on historical or classical themes few people knew.

James Freeman was an American expatriate who lived in the American art colony in Rome most of his life. He was born in New Brunswick, Canada, and spent his childhood in Otsego County, New York. Intending to pursue art as a career he went to New York City to study at the National Academy of Design, where his precocious talent was encouraged. In 1833 he was elected to membership in the Academy. Though he painted for a time in western New York, his American career was brief, for he moved to Italy when he was about twenty-eight. Living in Rome he painted portraits as well as sentimentalized genre themes, usually of Italian street urchins. He also produced larger compositions of classical subjects.

His two published books, *Gatherings from an Artist's Portfolio* and *Gatherings from an Artist's Portfolio in Rome,* in which he describes Bohemian life, reveal his genial disposition and the flair for storytelling that is also apparent in his paintings.

Though born in Albany, New York, William Page was raised primarily in New York City. In his mid-teens he was apprenticed to a lawyer but soon changed his mind and began studying art under James Herring and Samuel Morse. He made a second abrupt career change at seventeen when he joined the Presbyterian church and decided to become a minister. Two years later he suddenly returned to painting, which then remained his career for the rest of his life.

Primarily a portrait painter, Page worked in and around New York City except for a sojourn in Rome from 1849 to 1860. His work absorbed many of the qualities of traditional Italian art, and his use of color was strongly influenced by the work of the sixteenth-century Venetian artist, Titian. Page wrote several treatises on proportion and other aspects of painting which he had studied in Italy. During Page's lifetime his work was the subject of much comment, and the opinions of its quality and subject matter varied widely. His paintings evidenced an earnest simplicity and a dignified portrayal of man.

26

The Young Merchants, ca. 1842

Oil on canvas

42 x 36 in. (106.7 x 91.4 cm.)

Pennsylvania Academy of the Fine Arts,

Bequest of Henry C. Carey, 1879

Many of Page's figure compositions were based on classical and religious themes, but his *Young Merchants* is an outstanding contemporary genre scene exhibiting the same qualities of simplicity and human dignity seen in his portraits. The locale is a street corner on Broadway in New York, with City Hall visible in the background. Unlike the popular street urchins by J. G. Brown, the children are not sentimentalized; calmly selling their strawberries and newspapers, they are caught unposed, as if by a camera.

A Philadelphia publisher bought the painting for reproduction in a Christmas annual, and had an engraver add sentimental overtones to make it more appealing to the public. A story was invented about the children's efforts to regain a lost home and was published with the engraving in the 1844 issue of *The Gift*.

Born on a plantation in Virginia, Bingham spent his childhood in Franklin, Missouri. He was first inspired by an itinerant portrait painter to take up art as a career, and, self-taught, began practicing this profession in 1833. He continued to paint throughout his lifetime, working mainly in Missouri and in the Mississippi River region except for four years spent in Washington, D.C. (1841-1844) and three in Düsseldorf (1856-1859). Politics became a second career for Bingham. He was elected to the Missouri State Legislature in 1848, and was a delegate to the Whig National Convention in Washington, D.C., in 1852, as well as State Treasurer from 1862 to 1865 and Adjutant General of Missouri in 1875. In 1877 he was appointed professor of art at the University of Missouri.

Bingham is probably best known for his scenes of Missouri river life which he began painting about 1845. *The Jolly Flatboatmen* chronicles a well-known aspect of Ohio and Mississippi river life of the 1800s. Travelers settling the territories along the Ohio River and upper Mississippi between 1788 and 1840 often went by wagon or pack horse to an embarcation point on the Ohio where they would build or buy a flatboat. Flatboats combined the characteristics of log cabin, fort, and floating barnyard, and they usually only lasted the length of their trip down river. Few were ever used again; most were dismantled for their valuable timbers. Dunbar in his *History of Travel in America* explains, "During a long voyage lasting for weeks or months, the principal diversions of the emigrants were story telling, singing and dancing on the upper deck to the accompaniment of the universal fiddle."

This painting is the second treatment of the subject by Bingham and differs in several ways from the one he had painted two years earlier (Collection Senator Claiborne Pell). Although the arrangement of the figures is very similar in both paintings, here they are smaller, fitting into the landscape rather than acting out their roles in front of a backdrop. The front of the boat is thrown into shadow, concealing the various interesting provisions of the travelers detailed in the first version. In Düsseldorf Bingham painted a third in this series, *Jolly Flatboatmen in Port,* (St. Louis Art Museum), showing even further refinements on this theme according to the standards set by German genre painting.

Though perhaps rigid and classical in their conception, with a weakness in color, Bingham's scenes are honest in detail and give a vivid account of life on the American frontier.

The Jolly Flatboatmen, 1848-1878
Oil on canvas
25¾ x 36 in. (65.4 x 91.4 cm.)
Anonymous loan, Courtesy of
the Fine Arts Gallery of San Diego

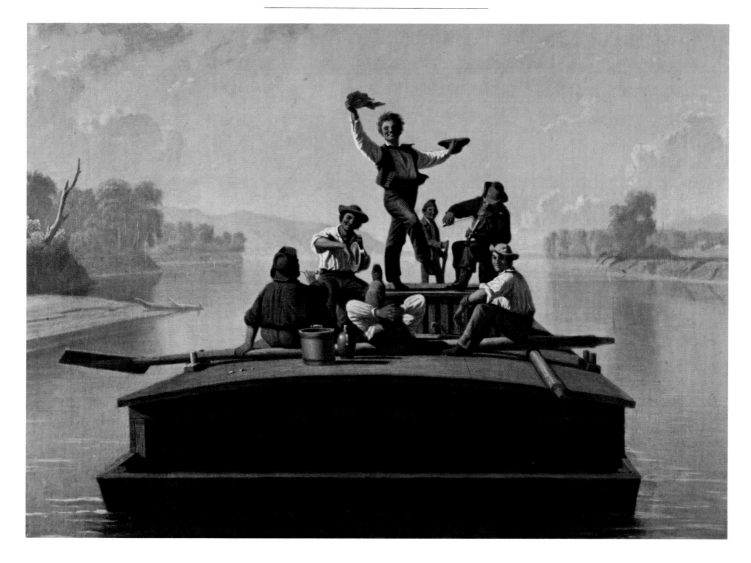

Both James Beard and his younger brother William became painters, and their careers followed a similar progression from portraits to animal paintings. However, James, the more conservative brother, did not receive the popular recognition accorded William who became widely known for his humorous storytelling pictures of animals.

The Beard brothers were raised on a farm near Painesville, Ohio, by their widowed mother. James ran away from home at age seventeen after having taken a few lessons from an itinerant portrait painter. For the next several years he traveled along the midwestern waterways, then settled in Cincinnati about 1834 where he gained a reputation as a portrait painter. During this period he also painted several genre pictures illustrating typical midwestern scenes: *The Long Bill* (a customer astonished at his grocery bill), *The Land Speculator,* and *North Carolina Emigrants.* The work most influential on his later career, however, was probably *A Child and a Dog,* painted about 1836. The child was imaginary but the dog was Beard's own. The painting proved so popular that many people began requesting portraits of their children with dogs, and eventually Beard specialized in painting dogs. After 1870, Beard lived in New York where he was made a National Academician in 1872.

28

Their Master's Tribute, 1884
Oil on canvas
30½ x 40½ in. (77.5 x 102.9 cm.)
Private Collection of Dan H. Russell's Estate

Beard was capable of painting many breeds of dogs, and five are represented in *Their Master's Tribute,* each holding in its mouth the type of game it is known for hunting; for example, the greyhound holds a rabbit, the golden retriever, a duck. The dogs appear to be offering their catches as tribute to the man seated at the left. James' studies always tell a story but without the humor, grotesqueness, and satire that were expressed in William's paintings of animals. For this ability to anthropomorphize animals he has been called the "Landseer of America." The popularity of his paintings reflected the general appreciation of sentimental subjects in Victorian America.

James Goodwyn Clonney (1812-1867)

Sometime before 1830 Clonney arrived in America from England. His teachers are not known but he apparently had some previous experience as an artist because during the next three years his name appears on lithographs issued by the Philadelphia firm of Child & Inman. While he was a lithographer for the firm he designed lithographs of his own as well as printing works by other artists. For the next ten years he exhibited miniatures at the annual exhibitions of the National Academy of Design, also exhibiting at the Art-Union in New York and the Pennsylvania Academy in Philadelphia. By 1841 he was specializing in genre scenes which he painted and exhibited until he stopped abruptly in 1852, possibly for financial reasons. He constantly moved from city to city in New York State during the twenty years he worked as an artist, finally settling at Binghamton where he became a farmer. He died there in 1867, the same year he was elected an Associate of the National Academy.

Clonney specialized in no particular subject. He painted hunting, farming, and military scenes, and even humorous intimate indoor family gatherings. His drawings in the Karolik Collection are lively and expressive, but in his paintings he tends to use a broader, flatter style, particularly in his treatment of children's faces.

29

Militia Training, 1841
Oil on canvas
28 x 40 in. (71.1 x 101.6 cm.)
Pennsylvania Academy of the Fine Arts,
Bequest of Henry C. Carey, 1879

Militia Training is perhaps Clonney's most ambitious painting from the standpoint of actual size and number of figures. It was engraved and reproduced in a Christmas annual, *The Gift*. Painted at the beginning of his genre career it is similar in complexity and handling to Sir David Wilkies' *Pitlessie Fair* of 1804, and suggests Clonney either saw this work in England or knew it through prints. The title *Militia Training* is misleading. Though in the distance miniscule troops are seen practicing, in the foreground friends of the soldiers are making the drill into a pleasure outing.

George Peter Alexander Healy (1813-1894)

Born in Boston, Healy expressed no interest in art until he was about sixteen when he was challenged by a girl friend to paint a better picture than hers. He did, and from that moment was determined to become a painter. After practicing on his own, he showed some of his work to the celebrated portraitist Thomas Sully who encouraged him, and at age eighteen Healy opened a painting studio in Boston.

Though he began by having to pay his rent with portraits instead of money, Healy soon gained a local reputation and had many sitters. In three years he was able to put together funds to study in Paris. This first trip was followed by thirty-four voyages across the Atlantic as well as the Pacific. Healy had a natural facility for likenesses, and countless dignitaries of Europe and America were both his sitters and personal acquaintances. As he was dying, after a successful sixty-year career, he murmured, "Happy, so happy."

Franklin Urging the Claims of the American
Colonies before Louis XVI, ca. 1847
Oil on canvas
25 x 36½ in. (63.5 x 92.7 cm.)
American Philosophical Society, Philadelphia

Besides portraits, Healy occasionally painted landscapes as well as a few compositional groups such as *Franklin Urging the Claims of the American Colonies before Louis XVI*. The idea for this picture came to Healy when he was at Versailles in the 1840s; he remembered stories of Franklin's experiences there and tried to picture his appearance in the palace throne room. Mentioning this to King Louis Philippe, who had commissioned several portraits from Healy, the king replied, "Splendid, Mr. Healy, the very kind of picture I want." To achieve the greatest possible historical accuracy, Healy spent years sketching old costumes and researching interviews and history books for important details on his subject. The work in this exhibition is a study for the full-size painting which was destroyed in a Chicago fire.

Healy came after the period of great American history painters like West and Trumbull; by the 1840s historical subjects were being painted only by such artists as Leutze, Schussele, and Rothermel who vied for patronage from the young United States government. After 1860 large historical compositions had disappeared almost entirely from production.

Duck Shooter's Pony, 1853
Oil on canvas
33 9/16 x 55 in. (85.2 x 139.7 cm.)
Meredith Long & Company, Houston

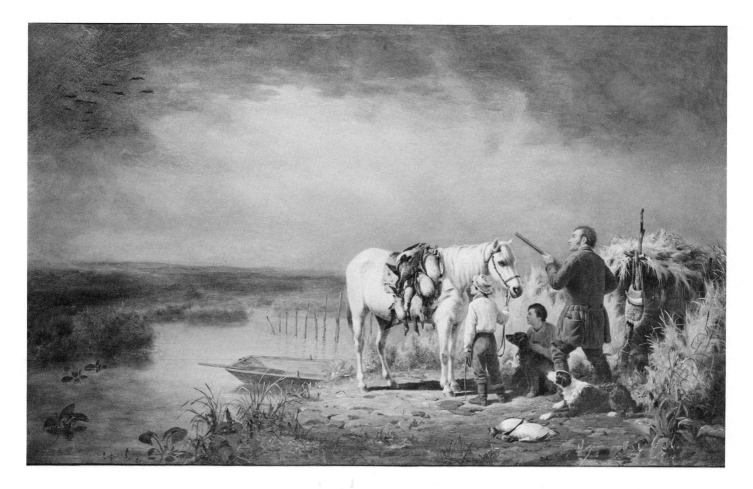

Born in Middletown, Connecticut, at thirteen Ranney was apprenticed to his uncle, a merchant in Fayetteville, North Carolina. Quickly realizing he had little interest in business, he became an apprentice to a local tinsmith with whom he stayed for six years. It was probably this experience with a craft that stimulated his interest in art, for he went to Brooklyn to study soon after his apprenticeship ended. Though in 1836 he was in Texas, fighting for independence, after eight months Ranney returned to Brooklyn and resumed his art studies. By 1838 he was already exhibiting in the National Academy of Design, and from 1842 to 1848 he is listed in the New York City directories as a portrait painter. Soon after Ranney moved to Weehawken, New Jersey; then in 1853 he settled permanently in West Hoboken where he built a house. After living there for only four years, Ranney died of consumption in 1857.

Themes of the Revolutionary War were popular with both early nineteenth-century artists and the public; the same is true of the hunting and sporting pictures Ranney also painted. His own interest in duck hunting probably inspired *Duck Shooter's Pony,* as well as the several other duck hunting scenes he painted. This work which includes only a few large figures is more typical of his usual oeuvre than the complex *Recruiting for the Continental Army.* The large forms, solid painting, simple composition, and attention to detail gave these works a ready appeal to masculine viewers. Along with Arthur Tait, Ranney was one of the few American artists to specialize in hunting scenes.

32

Recruiting for the Continental Army,
ca. 1857-1859
Oil on canvas
54 x 82 in. (137.2 x 208.2 cm.)
Munson-Williams-Proctor Institute, Utica

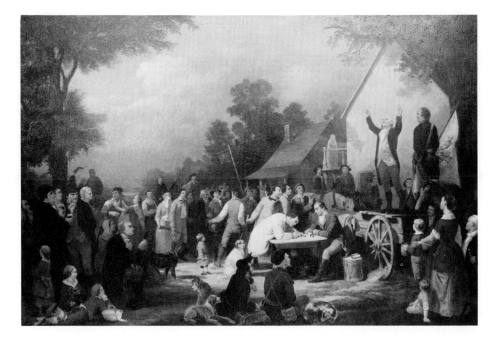

Although Ranney is best known for his works of the frontier based on his experiences in Texas, he executed a variety of other genre scenes. He did several paintings of the American Revolution including *Recruiting for the Continental Army* which resembles in composition some of Bingham's election scenes. The Continental Army consisted mainly of state militia which until 1776 had been supplemented by volunteers who only enlisted for one battle. Because of the difficulty of recruiting soldiers for the duration of the Revolutionary War, enlistment drives were a constant necessity. Since a private in the army was paid less than $7.00 a month, from which the cost of his clothing was deducted, obviously patriotism was the chief recruiting force.

Matteson was born in Peterboro, New York, the son of a sheriff. Various stories of his life mention that he sketched as a child and was even tutored by a talented prisoner of his father. By taking lessons in portraiture in New York, Matteson progressed from the humble profession of itinerant silhouette-limner and worked as a portrait artist in western New York from 1839 to 1841. After achieving success with his painting *Spirit of '76,* he returned to New York City for a decade, painting and actively participating in exhibitions to which he submitted such genre works as *At the Stile* and *Fodder and Cattle.* About 1850 he and his growing family moved to Sherburne, New York, where he produced historical, allegorical, and religious scenes. He became a prominent member of the community and was a state legislator in 1855, president of Chenango Agricultural Society in 1865, a trustee and member of the board of Union School, and chief engineer and foreman of the Sherburne fire department for more than twenty years.

33

Erastus Dow Palmer in His Studio, 1857

Oil on canvas

29¼ x 36½ in. (74.3 x 92.7 cm.)

Albany Institute of History and Art

American sculptor Erastus Dow Palmer is best known for a standing female nude entitled *The White Captive,* but during his career in Albany where he opened a studio in 1846, he was involved mainly in portraiture. Matteson's painting of Palmer's studio is probably quite authentic; nine of the works shown correspond almost exactly to photographs of the pieces themselves, including the Grace Williams Memorial (the child reclining on the floor) and the bust of Moses (seen at Palmer's elbow). The presence of these two sculptures done in 1857 establishes the definite date for this picture. The man with the hammer and chisel may be Launt Thompson, Palmer's best-known pupil, who left for New York that same year.

American neoclassical sculpture had gained a wide audience by 1850. Most sculptors from this country, exemplified by the "purists" Horatio Greenough and Hiram Powers, set up studios in Rome and Florence, but Palmer preferred to work in his native New York.

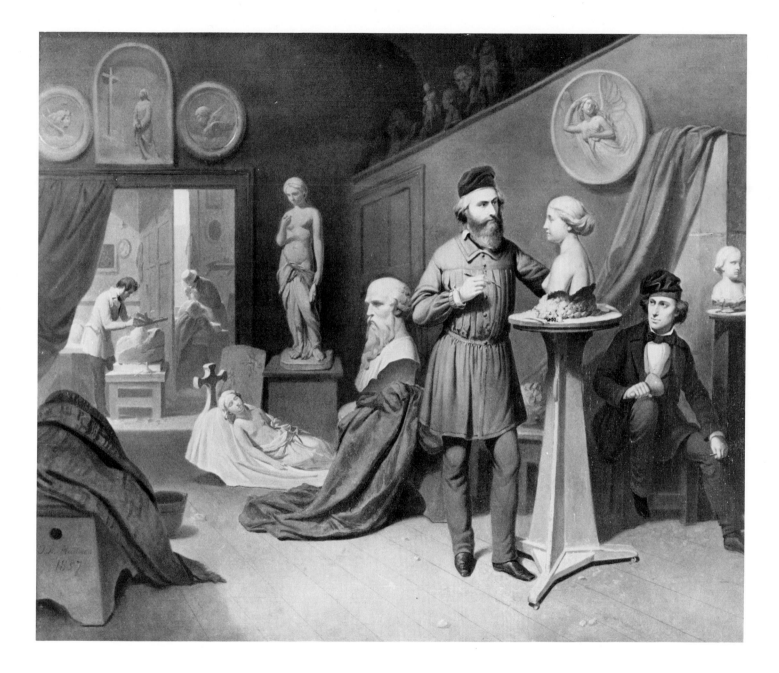

34

The Bible Lesson, 1857
Oil on canvas
24 x 19 in. (61.0 x 48.3 cm.)
Bernard and S. Dean Levy, Inc., New York

The subject of this painting, teaching Christianity to the Indians, was as popular in late nineteenth-century America as the reverence for the "noble savage" had been in the early 1800s. The missionary theme probably reflected Matteson's own Victorian ideas about morality and equality.

Like all his compositions *The Bible Lesson* was produced in a studio. In it he uses a triangular arrangement of the two girls who are so alike physically that only their color distinguishes them. Unlike some of his ethnologist contemporaries, Matteson was not accurate in recording clothing: the Indian girl's dress has been called "pure fantasy," and she sits quite unnaturally like a madonna on a piece of beautiful damask-like material. Matteson painted several scenes inspired by American literature and it is possible that this painting illustrates a story written in the nineteenth century.

John M. Stanley was one of the earliest artists to visit the American West. Born in New York State, at twenty he went to Detroit, which was then a frontier city. He worked first as a house and sign painter there, and then, after a brief training, as a portraitist. His interest in painting Indians dates from about 1838 when he began to travel the frontier as an itinerant portrait painter. For the next several years he roamed throughout the West, painting both landscapes and Indian portraits. In 1843 he was in Oklahoma Territory; in 1845, New Mexico Territory; in 1846, California; in 1847, Oregon Territory; and in 1848, Hawaii. He returned east in 1850 where he painted a gallery of western pictures which toured various cities in the East. Although he made one last major trip from St. Paul, Minnesota, to Puget Sound with the Stevens expedition in 1853, he spent the rest of his life in Washington, D.C., Buffalo, and Detroit painting Indian subjects and portraits and arranging for several chromolithographs to be made of his most popular works. Little of his work is extant today as three major fires destroyed almost his entire oeuvre.

35

The Osage War Dance, 1845
Oil on canvas
40½ x 60½ in. (102.9 x 153.7 cm.)
National Collection of Fine Arts,
Smithsonian Institution

The Osage War Dance, painted in 1845, was one of five paintings by Stanley that survived the Smithsonian fire of 1865. The 1852 Smithsonian catalog of Stanley's pictures explained, "All tribes of wild Indians scalp their captives. . . . On returning from the scene of strife they celebrate their victories by a scalp dance. . . ." The Osage Indians, one of the plains tribes that roamed the area of present day Missouri and Arkansas, finally had to yield to the invasion of their lands by white settlers between 1808 and 1836.

The highly romantic composition depicts a settler and her child, in a central pyramidal grouping, dressed in white and surrounded by menacing savage dancers. Stanley made numerous notes on the individuals he later portrayed, and the posed, unnatural arrangement of figures in this scene suggests it was composed from field sketches. He was apparently reasonably accurate in reproducing clothing and other details, but does not compare with the scientific realism of the artist Karl Bodmer. Compositions like *The Osage War Dance* were extremely popular in eastern cities with Americans who both expounded the concept of the "noble savage" and supported the government's program of exterminating the Indians.

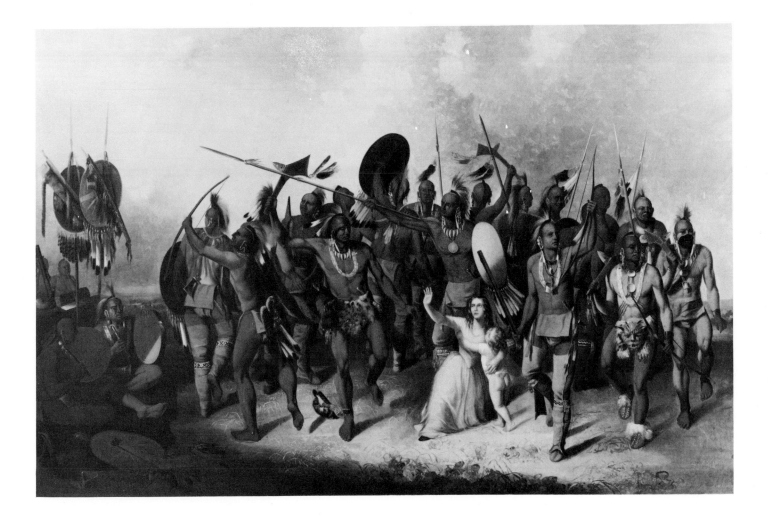

Born in Tarrytown, New York, Browere spent most of his life in Catskill, New York, but is best known for his paintings of early California. Though primarily self-taught, he was probably given some instruction by his father, who also taught him to make life masks of plaster. Prior to his move to Catskill in 1841 Browere received some minor acclaim for the technically primitive paintings of literary subjects he sent to exhibitions in New York City. He supported himself in Catskill with various occupations before becoming a sign and carriage painter. Circumstances forced him to relegate landscape painting, his real love, to a hobby. Browere developed from a painter of such literary and historical themes as *Peter Stuyvesant at the Recapture of Fort Casimir* and *Recruiting Peter Stuyvesant's Army for the Recapture of Fort Casimir* to a competent, realistic genre artist who recorded views of Catskill in his mature years. He remained in Catskill until his death except for two sojourns in California: one from 1852 to 1856 when he prospected for gold and sketched, the other from 1858 to 1861. The scenes he recorded there were painted on his return to Catskill. Because Browere painted in the shadow of such greats as Frederic E. Church and Thomas Cole, he is considered to be of comparatively minor importance among Eastern painters. He is, however, one of the outstanding chroniclers of early California.

36

Recruiting Peter Stuyvesant's Army for the
Recapture of Fort Casimir, 1838
Oil on canvas
24 x 29 in. (61.0 x 73.7 cm.)
M. Knoedler & Co., Inc., New York

Between 1623 and 1664 the Dutch ruled the area of New Amsterdam which included the land that bounds present day New York Harbor and the Hudson River. It is not so well known that between 1638 and 1655 the Swedes established New Sweden in an area along the Delaware River between present day Wilmington and Philadelphia. Fort Casimir, now New Castle, Delaware, was established in 1651 by the Dutch and was captured through trickery by the Swedes around 1654. The Swedish governor Risingh was entertained at the fort by the Dutch general Van Poffenburg who got drunk while Risingh stayed sober and captured the fort. Furious at the loss, Peter Stuyvesant, governor of New Amsterdam, sent out recruiting agents to raise an army which he planned to lead against the Swedes. This painting shows the departure of a recruit for the war.

37

Peter Stuyvesant at the Recapture of

Fort Casimir, 1838

Oil on canvas

27 x 34 in. (68.6 x 86.4 cm.)

M. Knoedler & Co., Inc., New York

The artist best known for subjects drawn from early American writers is John Quidor. However, the exhibition records of the National Academy of Design show that Browere rivaled him in the number of literary subjects painted, exhibiting *Rip Van Winkle* in 1833 and, contemporary with Quidor, in 1838 the *Peter Stuyvesant at the Recapture of Fort Casimir* (or as Quidor titled his painting, *A Battle Scene from Knickerbocker's History of New York,* cat. no. 17). During the battle Risingh knocked Stuyvesant down, who retaliated by striking the Swede over the head with his wooden leg. Risingh fell and the Dutch won the battle. Both Quidor and Browere chose the same comic episode to record.

38

A "Pic Nick," Camden, Maine, ca. 1850

Oil on canvas

41 x 62 in. (104.1 x 157.5 cm.)

Museum of Fine Arts, Boston,

M. and M. Karolik Collection

The origin of picnics is untraceable but the French word *picque nique* first appeared at the end of the seventeenth century, and by the first half of the nineteenth the picnic was a popular pastime in England and America as well.

Thompson was one of several artists to paint such outings, and his picture, like Henry Sargent's *Tea Party* (cat. no. 9), contrasts with the numerous depictions of farm life popular in the mid-nineteenth century. However, unlike the formal elegance of Sargent's *Tea Party,* Thompson's *"Pic Nick"* portrays the relaxed and more diversified behavior that is also seen in some contemporary rural scenes. His approach reflected the general American optimism of the period that ended with the Civil War.

Son of the portrait painter Cephas Thompson, Jerome was born in Middleboro, Massachusetts. His father, who wanted only one son to become an artist, encouraged Jerome's brother Cephas, but forbade Jerome to paint. Continuing to study art secretly, Jerome left home in his teens for Barnstable, Massachusetts, where he established himself as a sign and ornamental painter. As early as 1835 he was listed in the New York City directories, and he remained in that city for about seventeen years. Though apparently completely self-trained he had considerable success, first painting portraits, then rustic scenes. He exhibited at the National Academy of Design in the early 1860s and again in the 1880s and several of his works were lithographed. In 1852 he went to England where he studied the works of Hogarth and Turner and painted portraits of the nobility. On his return he operated a farm at Mineola, Long Island, where he gained a reputation as an able farmer and continued his painting. He sketched in the Massachusetts Berkshires and in Vermont, and his several paintings of western subjects indicate that he traveled west at some time.

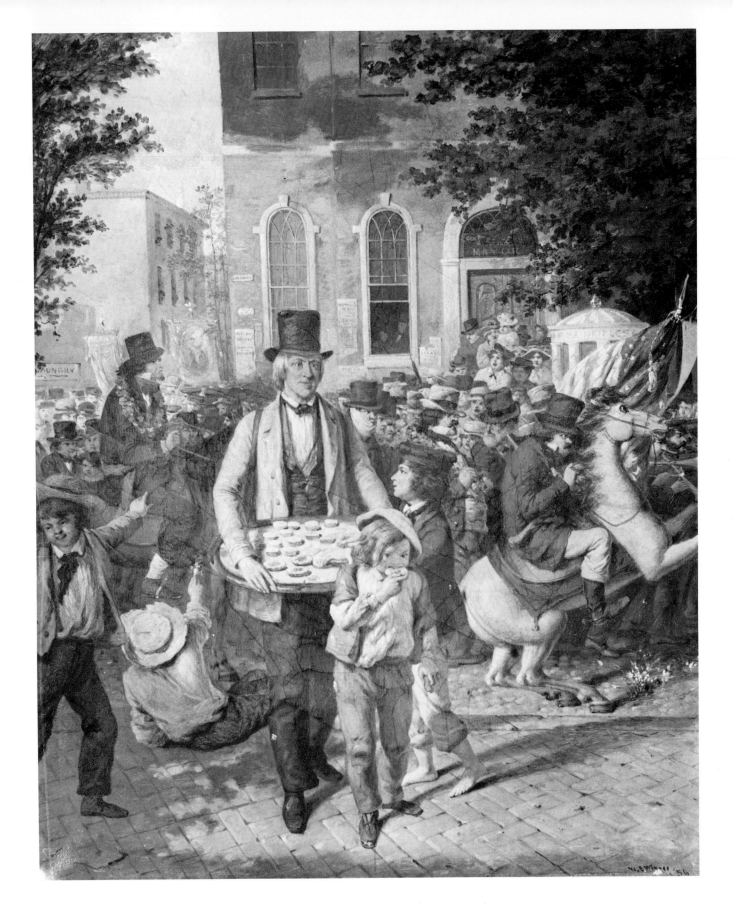

39

The Pie Man, 1856

Oil on canvas

24 x 20 in. (61.0 x 50.8 cm.)

The Historical Society of Pennsylvania

The Pie Man and its companion work, *Crazy Nora,* were painted within a year of each other and represent two well-known Philadelphia figures of the mid-nineteenth century. Though set out-of-doors, the paintings are basically portraits. Hermann Williams in his book, *Mirror to the American Past,* says, "Both Nora and the Pie Man were simple-minded individuals who were permitted by the authorities to roam the city streets as was then the practice throughout the country." The pictures are additions to the long line of popular images of street vendors that have been represented in prints from as early as 1475. As portraits they are basically realistic with none of Winner's usual sentimentality or humor. His reason for painting them remains a mystery.

Born in Philadelphia, Winner lived and painted there throughout his life. Although nothing is known of his artistic training, exhibition records at the Pennsylvania Academy indicate that he was exhibiting portraits by 1836. He continued with portraiture, but by the early 1840s he had also begun to exhibit Biblical and genre scenes. This transition from portraits to narrative works occurred in the careers of many artists now known primarily for their genre subjects. Winner painted prolifically, showing an average of ten works in each annual exhibition. He is known to have made only one trip outside Philadelphia when he went to Charleston in 1848 to paint several portraits.

Born in East Liverpool, Ohio, as a child Blythe amused himself and his friends by sketching caricatures of local people. At sixteen he went to Pittsburgh where he spent four years learning woodcarving with Joseph Woodwell. During much of his life he worked as an itinerant painter and woodcarver traveling first along the Mississippi and Ohio Rivers and later in the eastern United States. From 1846 to 1851 he settled in Uniontown, Pennsylvania, where he was most productive. In addition to satirical painting, at which he excelled, and portraits, he carved a statue of Lafayette, painted a panorama of the Allegheny mountains, and wrote verse. Widowed around 1849 after a brief marriage, he recommenced his travels until he returned to Pittsburgh in 1856. There he lived in a bleak room on Third Avenue, where he continued his painting until his death nine years later.

40

Lawyer's Dream, ca. 1858-1860

Oil on canvas

24¼ x 20¼ in. (61.6 x 51.4 cm.)

Museum of Art, Carnegie Institute, Pittsburgh

Financially insecure and an alcoholic most of his life, Blythe probably had many unfortunate encounters with the courts. In a bitter poem written in 1856 he states, "Our courts with few exceptions are fit subjects for . . . objections. Public opinion first, Blackstone second . . ." (Sir William Blackstone wrote extensively on English law in the eighteenth century.)

Blythe painted three pictures satirizing law and justice while in Philadelphia. In the first, *Lawyer's Dream,* a lawyer dozes; he has obviously been reading the two newspapers lying on the table and ignoring the books, *Modern Justice* and *Blackstone,* which lie discarded and padlocked. He is dreaming of attaining a legislative post to crown his eminent law career. In the second work, *The Courtroom Scene,* the incompetence of the jury is emphasized, and in the third, a mob rules the court. In his use of art to satirize human corruption Blythe can be compared with the French artist Honoré Daumier and the Englishman William Hogarth.

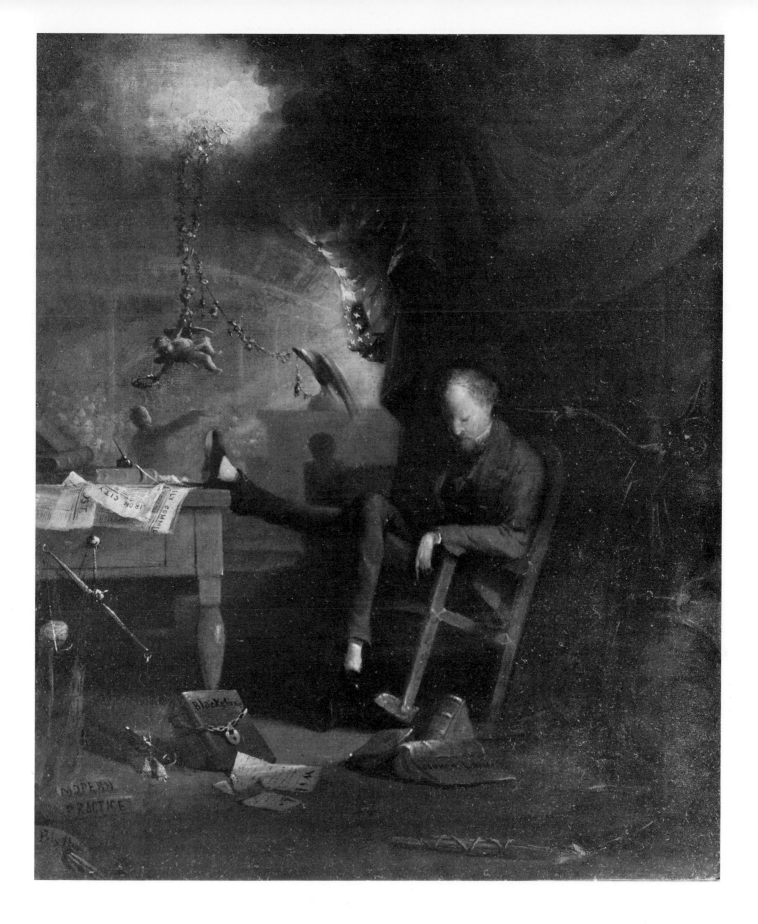

Libby Prison, 1863
Oil on canvas
24 x 36 in. (61.0 x 91.4 cm.)
Museum of Fine Arts, Boston,
M. and M. Karolik Collection

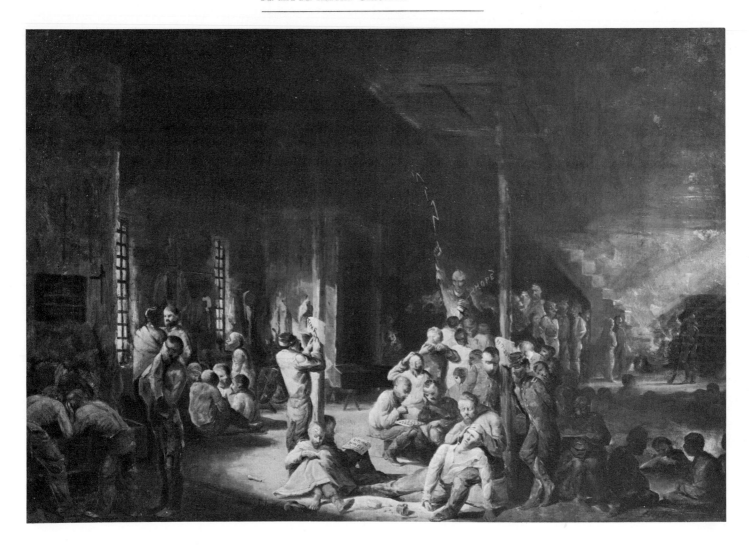

This is one of Blythe's greatest Civil War pictures. The building had been a brick tobacco warehouse until it was made into a prison to hold Union troops. The crowded, vile conditions there made it notorious during the war and Blythe, who followed Union troops to obtain subject matter, probably painted it from descriptions of escapees. His images of the war can be contrasted with those of Homer and Bierstadt, who saw it from the respective views of illustrator and landscapist.

42

Philosophy and Christian Art, 1868

Oil on canvas

40 x 50 in. (101.6 x 127.0 cm.)

Los Angeles County Museum of Art,

Gift of Will Richeson

The scientific discoveries of the eighteenth and nineteenth centuries challenged the long accepted ideas of the Bible and religion. In *Philosophy and Christian Art* Huntington visually portrays the philosophical dialogue between Reason, represented by the sage with his book of mathematical symbols, and Intuition, represented by the young woman holding a picture of the Nativity. Though painted in the style of post-renaissance Italy, Huntington's canvas is entirely nineteenth century in its theme—the conflict between the new science and traditional religious beliefs.

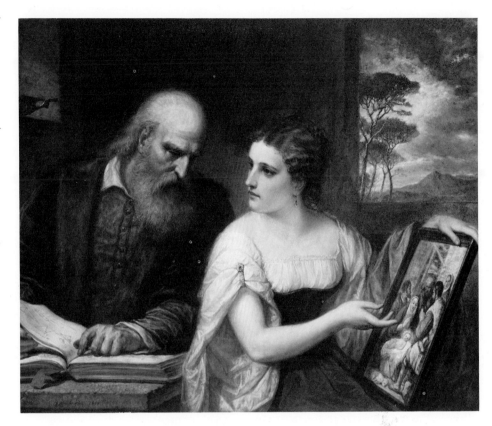

Daniel Huntington was born in New York City and, though he had made sketches as a child, did not decide to become a painter until his second year of college when he met the artist Charles Loring Elliott. Huntington returned to New York where he studied with Samuel Morse and Henry Inman and later worked at the National Academy of Design. He progressed so rapidly he was soon exhibiting and within three years of his career decision he was in Italy studying art.

Huntington was a deeply religious man who found inspiration for his composition, color, and subject matter in the paintings of the early Italian school. Though primarily a portraitist, he was one of the few American painters in the late nineteenth century to paint religious or moral themes inspired by his own deep religious feeling. His conceptions, more in keeping with European taste of one hundred years earlier, were never really "American" and form a unique category in American art.

Emanuel Gottlieb Leutze (1816-1868)

Leutze was born in Germany and immigrated with his family to Philadelphia in 1825. Showing an interest in art, he received some instruction in portraiture from a local artist, John Rubens Smith, and by age twenty was exhibiting locally. He worked as an itinerant portraitist for the next three years, leaving America in 1841 to study at the Academy in Düsseldorf with C. F. Lessing. After traveling to Venice and Rome, Leutze returned to Düsseldorf and remained there until 1859, becoming its most important American artist in residence. He returned to the U.S. in 1859 to paint a mural for the House of Representatives in Washington, D.C., and spent the last ten years of his life in New York and Washington.

Ferdinand Removing the Chains
from Columbus, 1843
Oil on canvas
39 x 52 in. (99.0 x 132.1 cm.)
Mann Galleries, Miami

See color reproduction, page 105.

Though Columbus' discovery of America in 1492 is well known, few people are aware of his three subsequent trouble-filled voyages to explore and colonize the Caribbean. In 1499 on his third trip he found his colony at Santo Domingo, Hispaniola (present day Haiti), in open revolt. The hungry and disillusioned settlers had earlier complained to Spain, causing the king and queen to appoint Francisco de Bobadilla as the new governor. Upon his arrival Bobadilla seized Columbus and sent him back to Spain in chains. Columbus was gravely insulted and insisted on wearing the fetters during the entire journey, swearing he would remain chained until the king and queen who had ordered him bound should command his release. He planned to keep his chains "as relics and as memorials of the reward of his service."

After his return and a reversal of royal favor, Columbus was not only unfettered, but, richly apparelled and surrounded by friends, was honored in court on December 17, 1500. Nonetheless, his son revealed that Columbus kept the chains "always hanging in his cabinet, and he requested that when he died they might be buried with him."

Ferdinand Removing the Chains from Columbus, probably painted in Munich, was the third and final painting based on episodes from the life of Columbus that Leutze executed. The first, *Columbus before the High Council of Salamanca,* was Leutze's first historical painting of importance and brought him immediate recognition. The second, *The Return of Columbus in Chains to Cadiz,* painted within about a year of the first, was purchased and distributed by the American Art-Union. These large, historically accurate works were the direct result of Leutze's Düsseldorf training.

Leutze was referred to as the "new Allston" because of his interest in history painting, and the composition of *Ferdinand Removing the Chains from Columbus* has many affinities with that used by Washington Allston in his famous unfinished painting, *Belshazzar's Feast* (fig. 2). However, it is improbable that Leutze had seen Allston's work before painting his own. With its historical accuracy, sophisticated color, strong composition based on a triangular arrangement of figures, and controlled use of light, Leutze's picture is a skillfully realized tableau.

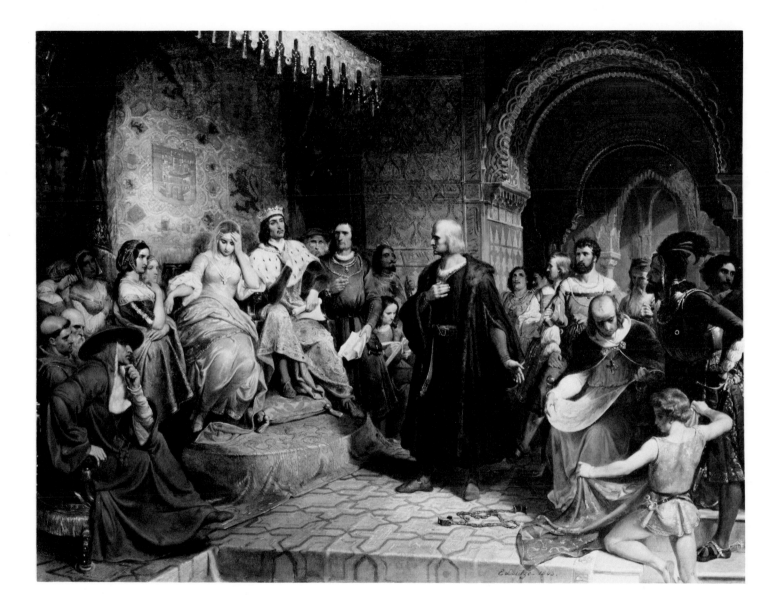

44

Washington Crossing the Delaware,
ca. 1851-1852 (attributed to Leutze)
Oil on canvas
27 x 40½ in. (68.6 x 102.9 cm.)
The Los Angeles Athletic Club

Washington Crossing the Delaware, the picture for which Leutze is best known, was produced in Düsseldorf. Leutze hoped it would be purchased by the American government for display in the Capitol, and he returned to this country in 1851 to arrange the sale. To his disappointment the work was sold privately instead, but it became well known through engravings. The painting depicts Christmas night, 1776, when Washington crossed the Delaware River with his troops on the way to Trenton to surprise the encamped Hessians. It was this successful battle that turned the tide of the Revolutionary War in favor of the Americans.

According to Worthington Whittredge, an American painter and a friend of the artist in Düsseldorf, Leutze found the German models "either too small or too closely set in their limbs" to be models for Americans. He asked Whittredge (who sat for both the steersman and Washington) and a number of American visitors to pose for him. Whittredge wrote of his experience, "Clad in Washington's full uniform, heavy chapeau and all, spyglass in one hand and the other on my knee, I was nearly dead when the operation was over. They poured champagne down my throat and I lived through it." The work shown here is one copy of the original which was irreparably damaged in a studio fire in 1850. This small copy was one of several made by Leutze; one was sent to America and exhibited in New York and Washington, D.C., and another was used as a model for the widely distributed engraving by Goupil and Company, Paris.

Though Leutze took great care to make the work accurate by ordering replicas of Washington's uniform and by painting Washington's portrait from the cast of Houdon's bust of him, it is filled with historical errors. Washington never stood in the boat, nor were the horses brought across the river with the men; the condition of the uniforms is far too good and the actual boats were larger; the flag shown was adopted in 1777 and was not the one used in 1776. Despite these factual inaccuracies the work is a stirring representation of a vital event in America's history.

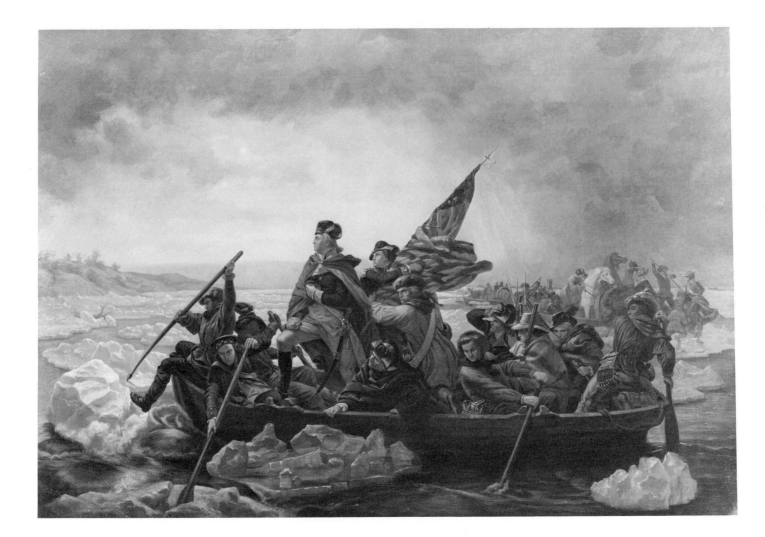

William Rimmer (1816-1879)

William Rimmer was a man of three careers; he worked as a doctor, a sculptor, and a painter. Raised in Boston, he was educated by his father and served several apprenticeships, including one in lithography. In his youth he began painting historical and religious pictures, and by his mid-twenties he was working as an itinerant portrait artist in Massachusetts. His interest in anatomy led him to study medicine, and after receiving his degree, Rimmer practiced medicine as well as shoemaking and painting to help support his family. In 1855 when he was about forty he moved to East Milton, Massachusetts, where he met Stephen H. Perkins, a patron who encouraged him in his painting and sculpture. Perkins commissioned the sculpture of the Martyrdom of St. Stephen for which Rimmer received his first recognition in 1860. From this time his sculpture brought him increasing attention. He received offers to teach art anatomy in Boston and for two years successfully headed a private art school there. He gave frequent and popular lectures; he wrote *Elements of Design*; and from 1866 to 1870 he directed the School of Design for Women, Cooper Institute, New York. He then resumed his work as an artist in Boston, continuing to lecture and teach. In 1877 he produced *Art Anatomy* which included reproductions of nearly 900 of his pencil drawings.

Flight and Pursuit, 1872
Oil on canvas
18 x 26¼ in. (45.7 x 66.7 cm.)
Museum of Fine Arts, Boston,
Bequest of Miss Edith Nichols

Rimmer's father was an eccentric who believed himself to be the lawful heir to the French throne, and who felt he had to hide his family in America to escape assassination by Louis XVIII. He filled his son's head with visions of equestrian battles, falling angels, and thundering demon wings, motifs that appear in many of Rimmer's drawings.

Flight and Pursuit holds the variant title *"Oh for the Horns of the Altar,"* a quote from the Old Testament referring to the tradition of seeking sanctuary by clasping the horns on the temple altar. Since most of Rimmer's paintings have a symbolism with a personal meaning relating to his life, this image of seeking refuge from a shadow may relate to his father's fears of assassination. The fact that Rimmer used sound anatomical forms in painting scenes from his imagination links his work to that of Elihu Vedder.

46

The Progress of America, 1875

Oil on canvas

72 x 102½ in. (182.9 x 260.3 cm.)

The Kahn Collection, The Oakland Museum

In San Francisco Tojetti painted several portraits and decorated the walls of many Catholic churches. His most outstanding canvases from this period are large allegories or illustrations of romantic literature. These paintings are reminiscent of works created by American painters of the late eighteenth and early nineteenth centuries after they studied in Europe. *The Progress of America* is an allegory illustrating Bishop Berkeley's famous line, "Westward the course of empire takes its way." The central figure represents America standing in a chariot decorated by an American eagle above a shield of stars and stripes; she is being drawn westward by white chargers while two cupids with horn and torch herald and guide her journey. A third cupid approaches to crown her with laurel. The four women accompanying her represent medicine, art and architecture, music, and agriculture, while the two robed men to the right symbolize learning. In the background to the left, several Indians react to the entourage with amazement. The setting for this allegorical pageant is a prosaic California landscape with a railroad engine chugging across the background.

Tojetti was both criticized and praised by San Francisco reviewers during his career, and decidedly this painting displays the eclecticism of which it was accused. But it also stands as a magnificent memorial to Tojetti's nouveau riche patrons who evidently had more money than taste.

Tojetti was born in Rome to wealthy and distinguished parents who encouraged his artistic talent. He studied with Camucini and Nurandi and later said that the severe and arduous training of his youth contributed greatly to his success. Tojetti became well known in Rome where he executed many church commissions including a series of portraits of the popes for the Vatican. His secular work is exemplified by the frescos of mythological and historical subjects he painted for the palace of Prince Torlonia of Naples.

Tojetti was a familiar figure in court and diplomatic circles, and this was undoubtedly one reason he was chosen to establish an Academy of Fine Arts in Guatemala when that government petitioned Italy for help. Though he spent four years there, the climate affected his health, and he was compelled to travel northward. He stayed in Mexico for a time but by 1871 had moved to San Francisco where he remained until his death.

47

State House on the Day of the Battle
of Germantown, ca. 1870
Oil on canvas
35 x 48 in. (88.9 x 121.9 cm.)
Pennsylvania Academy of the Fine Arts,
Bequest of Henry C. Gibson, 1896

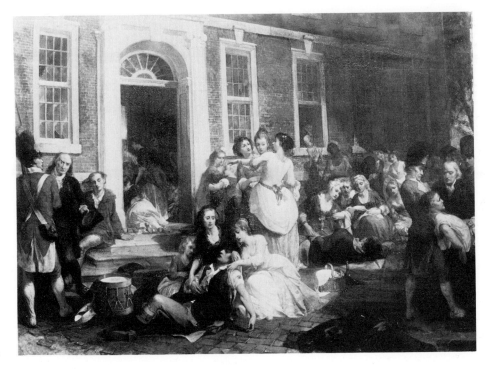

Philadelphia was the national capital during the Revolutionary War, and was occupied by the British in September 1777 under General William Howe. The State House, now Independence Hall, was used as British headquarters; and prisoners of war were held on the second floor, where several years later Charles Willson Peale was to house his museum. On October 4, 1777, following the Battle of the Brandywine, Washington's army attacked the core of the Anglo-German advance troops under Howe in the nearby town of Germantown. The Americans advanced in four columns down Germantown pike, Washington himself commanding. The main column at first met with success, driving the British advance troops back. Then meeting with unexpected opposition, the Americans were thrown into confusion and compelled to retreat. Washington went into winter quarters at Valley Forge, forty miles west of Philadelphia, while the British wintered in and around the city. This painting shows the State House after the battle; the wounded are being treated and most of them appear to be captured rebels; British guards and gossiping housewives are also a part of the scene.

Rothermel was born in rural Pennsylvania and at the age of twenty went to Philadelphia to become a sign painter. A few years later he began to study drawing and soon enrolled at the Pennsylvania Academy of the Fine Arts, where he later had a short but distinguished career as director. Although first specializing in portraits, he eventually became known as a figure painter whose reporting of details had an almost photographic accuracy. The titles of his works painted both in Pennsylvania and on his one trip to Europe from 1855 to 1859 reflect subjects ranging from religion to mythology and battle scenes. He exhibited frequently and his narrative works became well known to his contemporaries. His last eighteen years were spent at his country home in Montgomery County, Pennsylvania.

43

Ferdinand Removing the Chains
from Columbus, 1843
Oil on canvas
39 x 52 in. (99.0 x 132.1 cm.)
Mann Galleries, Miami

See text, page 96

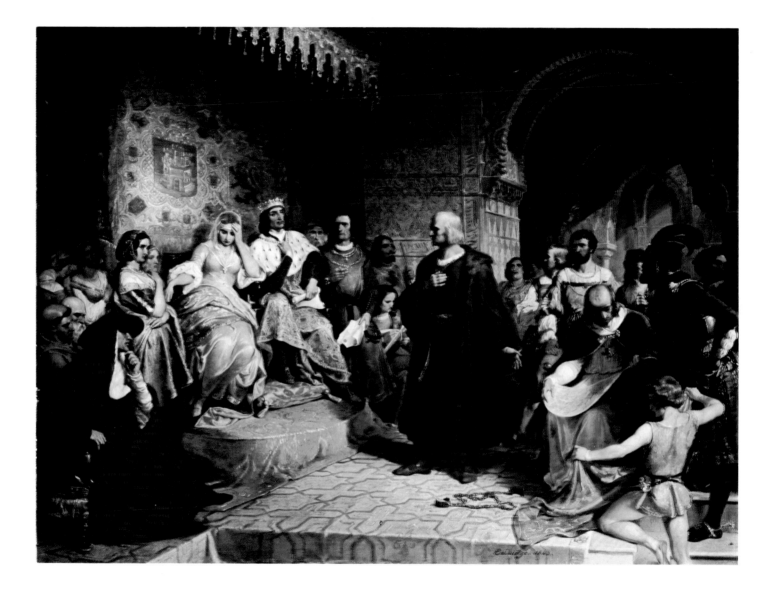

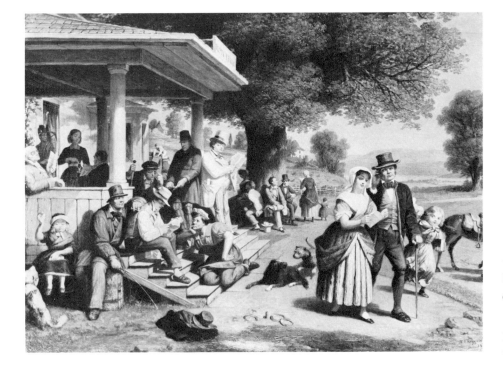

48

Rural Post Office, 1857

Oil on canvas

19½ x 27½ in. (49.5 x 69.8 cm.)

IBM Corporation, New York

Rossiter was born in New Haven, Connecticut, where he later studied drawing and set up a portrait studio. He traveled to Europe with his artist friends Asher B. Durand, John F. Kensett, and Thomas Casilear, and spent five years working in England, Scotland, Paris, Rome, Germany, and Switzerland. Returning to America, he helped design a studio building in New York where he and his friends worked from 1851. However, he soon went back to Europe, remaining in Paris for almost three years. When he finally returned to America to stay, he worked for a time in New York before moving to the house he designed and built in Cold Spring, New York. Though he also painted portraits, Rossiter became best known for his large figural compositions. Specializing in American history, he depicted several scenes from the life of George Washington.

Rossiter's *Rural Post Office* is a complicated scene of activity, a counterpart to his *City Post Office* painted the same year. It has been suggested that the painting of the country post office represents an actual locale in New York State, possibly near Rossiter's house in Cold Spring. The contrast of the springtime atmosphere with the wintry scene of the *City Post Office* further indicates that he painted one on his summer vacation and the other at his winter residence in New York City. Post offices were meeting places that attracted the entire community, and as such offered Rossiter an intriguing variety of subjects and activities. Though the dress and architecture differ in the two scenes, he repeats the same loiterers, philosophers, and playful children.

49

Market Scene at Night, 1859

Oil on canvas

36 x 50 in. (91.4 x 127.0 cm.)

Jack Frost Fine Arts, Santa Monica, California

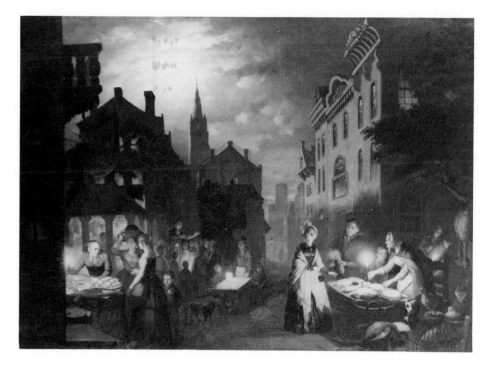

Beginning with his earliest American exhibitions Culverhouse specialized in genre themes with subjects influenced by Dutch paintings: village peasants, ice skaters, marketplaces, and scenes of men drinking in beer halls. In many of his works the light source is the moon or a candle, and often the two are used together to illuminate his numerous market scenes. The locales of the markets range from Amsterdam and Rotterdam to Syracuse, New York, but the colors, composition, and activity in these paintings are very similar. The architecture in most is usually specific enough to identify the location, but the site of *Market Scene at Night,* a work just recently rediscovered, has not yet been established. In it the glow of individual candles highlights various storytelling scenes that resemble the intimate genre compositions favored by American artists. However, Culverhouse's integration of these several scenes into a larger unit links him with artists born and trained in Europe who delighted in portraying diverse, methodically organized activities of small figures in a large background. Other continental artists who brought this style to the United States include William Hahn, Frederic Rondel, Thomas P. Rossiter, and Christian Schussele, whose works are represented in this exhibition.

Very little is known about the life of this artist. Clark S. Marlor indicates in *A History of the Brooklyn Art Association with an Index of Exhibitions* that Culverhouse was born in Rotterdam, Holland. However, during an investigation of the American Art-Union in 1853, a New York art dealer testified that the German-speaking artist had been born in England and moved to Germany at an early age. He received instruction at the Düsseldorf Academy, then came to America, exhibiting at the American Academy of Fine Arts as early as 1849. His address is listed as New York in exhibition records through 1867, except for 1851 when he was in Boston. Recent research establishes that he was living in Syracuse from 1871 to 1872, and that in 1877 and 1878 he exhibited at the Brooklyn Art Association, but gave no address. In 1877, nearly thirty years after his first exhibition here, Culverhouse was still exhibiting such Dutch scenes as *Market Scene in Amsterdam* at the Brooklyn Art Association. Because of this and the fact that he died in Rotterdam, it is possible that he made periodic trips to America from Rotterdam rather than settling here from 1849 to 1891, as had been previously believed.

Charles Christian Nahl (1818-1878)

Charles Christian Nahl was born in Cassell, Germany, into a family whose members had been artists for several generations. After studying at the Academy in Cassell, in 1846 he traveled with his mother and stepbrother to Paris. He continued his education under Vernet and Delaroche, acquiring a desire for technical perfection and a predilection for heroic themes and classical subject matter. A year after the French Revolution of 1848, the Nahls left for New York and the following year traveled to California via the Panama Canal.

The gold rush was in its peak years when they arrived, and Nahl worked some mines in Nevada for a few months. However, he soon returned to art for his income. During his long career he made illustrations and ran a photography studio in addition to painting portraits and large genre pieces. One of his particular interests was in depicting the colorful scenes of early California, especially those of the mining camps.

50

Fire in San Francisco Bay, 1856

Oil on canvas

26 x 40 in. (66.0 x 101.6 cm.)

Fireman's Fund American Insurance Companies, San Francisco

In 1848 San Francisco was a small village of 800, one of several California ports visited by ships picking up hides and other local products. Two years later, after the discovery of gold, its population was 35,000 with shiploads of newcomers arriving every day. Many of these ships were abandoned in the bay by crews rushing off to try their luck in the mines; some were then drawn up on the mud where, connected by piers to the land, they became hotels, shops, or warehouses. Others remained at anchor awaiting crews to sail them back east. Though the bay is fifty miles long, there were areas where the anchored ships were so tightly packed that their combined masts looked like a forest.

Certainly the most famous San Francisco fire was the one started by the earthquake of 1906, but fire had been common in that city since the time of the gold rush. Between 1849 and 1852 four major fires swept through San Francisco, and ships in the bay did not escape such conflagrations.

Some were set by captains or owners to collect insurance, others started accidentally; the average was about one fire a day. The fire represented in this painting was on an unnamed ship moored near the Abernethy, Clark & Co. ship chandlery. Since the ship, considerably older than the clipper moored at the dock, has no name and is missing the top of its masts, it may have been one of the many vessels used only for storage. The barrels and boxes floating in the water possibly had been salvaged from it. Firemen on board the burning ship direct water at the fire, while other firemen operate the pumps on the pier.

California, with its pervasive Spanish influence and burgeoning population, offered genre painters a rich variety of vivid subjects: the gold camps, the ranchos, San Francisco. Though most people were originally lured to California by their desire for gold, many stayed there to create a stable society, and painters like Nahl chronicled the colorful life around them.

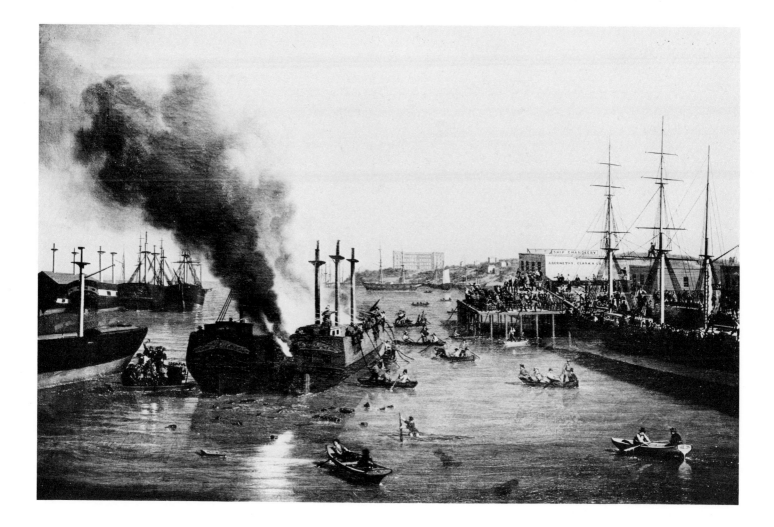

Charles Deas was born in Philadelphia to a distinguished family who had planned a military career for him. Surrounded by his father's collection of copies of Old Masters he grew up with an active interest in art. Failing to be admitted to West Point, he readily turned his attention to becoming an artist and first studied at the National Academy of Design in New York. On a visit to Philadelphia in 1837-1838 he saw an exhibition of George Catlin's Indian paintings, and, though he spent two more years working in the East, these works eventually inspired him to visit the West in 1840. The first year his activities were centered around Fort Crawford, Wisconsin, where his brother was an officer, but he soon established a permanent studio in St. Louis. There he painted western scenes, until he returned east in 1847. In June 1849 he was placed in an asylum, suffering from melancholia, and apparently remained there the rest of his life.

51

The Devil and Tom Walker, 1838

Oil on canvas

17 x 21 in. (43.2 x 53.3 cm.)

Hermann Warner Williams, Jr.,

Washington, D.C.

Like several other artists of his day Deas found Irving's writings a fertile source of subjects. *The Devil and Tom Walker* is based on a Washington Irving story in which Tom Walker unsuccessfully uses various wiles to try to escape from his pact with the devil. It was painted before Deas' trip west in 1840.

In this picture, as well as in several other works he painted before his illness, there is a feeling of pursuit or threat. The devil chases the frightened Tom on a stormy night; in another painting, *Death Struggle,* a pursuing Indian has caught a trapper and they destroy each other falling from a cliff; in *The Prairie Fire,* frightened figures race from approaching flames. Little is known of Deas' illness but its general nature can be inferred from the themes of his paintings. The titles of three works he painted after his admittance to the asylum are *The Lord, The Maniac,* and *The Vision.* ". . . The last . . . represented a black sea, over which a figure hung, suspended by a ring, while from the waves a monster was springing. . . ."

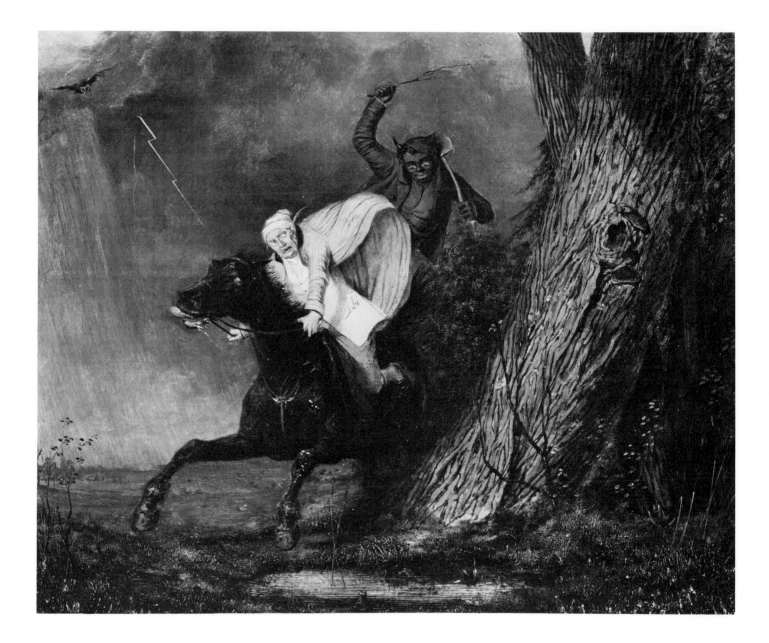

James Hamilton (1819-1878)

Hamilton was born in Ireland and was one of several of America's marine painters to come from the British Isles. When he was fifteen his family came to Philadelphia and after brief study in a drawing school he began work in an accounting house. On the advice of the engraver Sartain, Hamilton soon turned to an art career and studied with two or three teachers in Philadelphia. Though he was basically self-taught his work was greatly influenced by the style of the English painter William Turner. At twenty-one Hamilton began exhibiting and soon attained success with *A Scene on the Delaware* which one reporter labeled the "best marine picture until then painted in this country." He was an avid traveler along the eastern coast between Massachusetts and Delaware and painted the views he saw with dramatic atmospheric effects.

52

Naval Engagement between the Monitor

and the Merrimac, 1874-1875

Oil on canvas

20 x 40 in. (50.8 x 101.6 cm.)

The Historical Society of Pennsylvania

The Naval Engagement between the Monitor and the Merrimac depicts the famous Civil War battle between the first two ironclad fighting ships. The Monitor on the Union side and the Merrimac for the Confederacy met on March 9, 1862, and for four hours they attacked each other at close quarters without much damage to either side. Finally, unable to continue fighting in the shallow water of the falling tide, the Merrimac returned home. This encounter marked the end of the era of wooden warships.

In 1874, twelve years after the actual battle, Hamilton painted two scenes of the fight from sketches made on the spot by Colonel Samuel Wetherill. One of his paintings shows the fight in the morning, the other, at noon when the battle ended. A third painting of this subject, exhibited here, was inscribed by Hamilton, "Action between the Merrimac and Monitor (;) Crany Island in Middle Ground (;) Fogg clearing off . . ." Unlike Hamilton's other two paintings, there is no additional inscription on the back of this one specifying that it was directly inspired by Wetherill's sketches, but it may have used them as a source. The churning water and the emphasis on fog and the smoke from battle typify Hamilton's romantic style. His vibrant marine views with their dashing and picturesque images contrast vividly with the works of another American marine painter, Fitz Hugh Lane, whose scenes are characterized by mirror-like surfaces and precise detail.

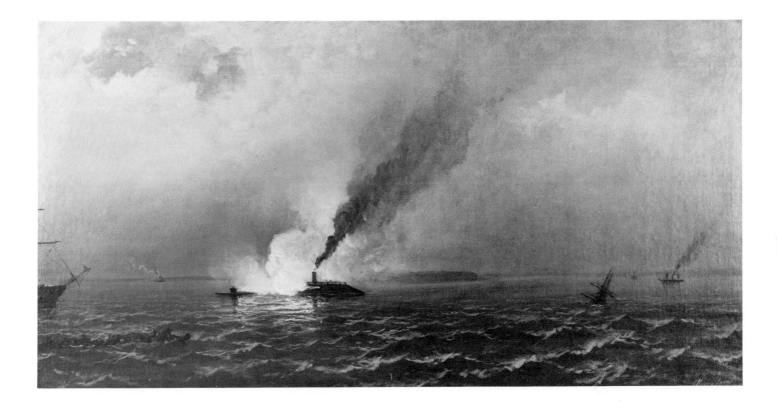

113

Angelique Marie Martin was born in Exeter, England, to French parents who emigrated to the United States when she was about eight. Three years later they moved to a farm in Ohio where Lilly grew up. Her parents encouraged her in her art from the first, despite the fact that it was a difficult career for a woman, and after she had some success in her home town her father moved to Cincinnati with her so she could pursue her art there. Though primarily self-taught, her brief contact with the work of Cincinnati artist James Beard may later have influenced her to paint children.

Lilly was married in 1844 to Benjamin Spencer. After trying various professions he turned totally to assisting his wife in her career, helping her with her painting and acting as her business agent. Lilly Spencer was certainly one of the earlier "modern women," combining her career which was the sole support of her family with her domestic career as mother of thirteen children. She and her husband moved to New York in 1848 and though they had various residences in and out of the city, New York was their base until her death. There she exhibited her works; many were sold to the art unions and some were reproduced in lithographs. Her work was characterized by its sentimentality and by her choice of such familiar subjects as children and domestic scenes. She also painted several pictures inspired by literary themes and executed many portrait commissions.

53

Shake Hands, 1854

Oil on canvas

30⅛ x 25⅛ in. (76.5 x 63.8 cm.)

Ohio Historical Center, Columbus

Shake Hands was one of Spencer's most popular paintings; it was purchased by the Cosmopolitan Art Association and engravings of it sold widely. It embodies all of the artist's characteristics as well as including a fine still life. The scene is her own kitchen and the girl, identified from a drawing titled *Our Servant,* was the Spencer's maid. Here, in the midst of making bread the girl extends her floured hand with a big grin; this warm-hearted humor was one of the most appealing facets of Spencer's genre painting.

54

Mother and Child, 1858
Oil on canvas
16 x 12 in. (40.6 x 30.5 cm.)
Jo Ann and Julian Ganz, Jr.

In the 1850s the two subjects Spencer painted most often were humorous kitchen themes like *Shake Hands* and nursery scenes like *Mother and Child.* The latter painting of a young mother waiting to put shoes and socks on her playful child has affinities to another work by Spencer, *This Little Pig Went to Market.* Both are small canvases representing a mother and child in an arched setting. Since they were painted within a year of each other the identification of the mother as the artist and the child as her two-year-old son Charles in *This Little Pig* may likewise identify the figures in *Mother and Child.* The chair in the latter picture evidently belonged to the Spencers as it also appears in a memorial portrait of Nicholas Longworth by Lilly Spencer.

Spencer delighted in painting details, and was in fact one of the finest still life painters of her day; here she delineates the eyelets of a petticoat, the border decoration of the mother's dressing gown, and the delicate lace cap. Many of Spencer's nursery themes show mother and child in such informal dress, with the mother in her gown and petticoat and the child in a shirt which is often falling off one shoulder in a disarming manner. Her Victorian subjects project the same secure domesticity of upper-middle-class Americans that Seymour Guy represented in his *Story of Golden Locks.*

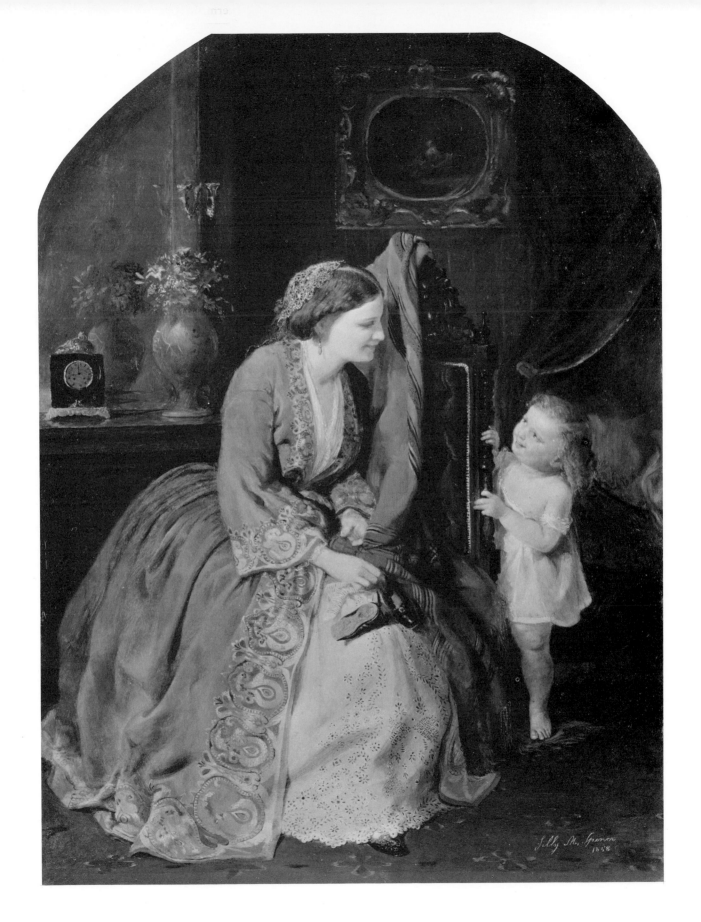

Wood was a genre artist whose career somewhat resembles that of Eastman Johnson. He specialized in portraits at the beginning and end of his career, but the genre painting for which he is best known was concentrated in a middle period of twenty years.

His interest in art was inspired by an itinerant portrait painter and Wood's first works date from about 1844. He was primarily self-taught, sketching from nature and from book illustrations, although he did receive some instruction in Boston. From 1852 to 1866 Wood painted portraits in New York, Quebec, Washington, D.C., Baltimore, Nashville, and Louisville. For a short time in 1858 he was in Paris, where he studied the Old Masters.

In 1866, having been given encouragement on several genre pictures Wood moved to New York and for the next twenty years specialized in genre painting. His best works were executed in the first ten of these years; by the second decade his pictures had become overly sentimental and anecdotal. As vice-president of the National Academy of Design and president of the American Water Color Society his duties diverted his attention from painting during the latter half of this period, and the quality and quantity of his production diminished.

With financial backing from John W. Burgess, in the mid-1890s Wood established the Wood Gallery in Montpelier. He had been born in that town and summered there each year throughout his life. Until his death Wood devoted much of his time to obtaining works by his contemporaries and to copying Old Masters for the Gallery collection.

55

The Critical Moment, 1882
Oil on canvas
32 x 21 in. (81.3 x 53.3 cm.)
Mrs. Bradley King Criley

Wood was eclectic in his choice of subjects and a survey of his works would provide an interesting and comprehensive study of American life in the later nineteenth century. Wood painted several studies of farm life in the early 1880s probably modeling them on farms located near his summer home in Montpelier, Vermont. Two of these works are *Jump* (1883), showing a little girl about to jump from the hayloft of a barn into the arms of a man below, and *The Critical Moment;* both are typical of the story-telling canvases that characterized his later genre work. Both paintings feature an idealized child with a white dress, golden hair, and blue eyes, a sentimental element that was also typical of his later work. In *The Critical Moment* this sentimentality is reinforced by the child's appealing attempt to reach the bonnet filled with eggs by standing on her tiptoes.

For Wood, as for Henry Alexander and Lilly Spencer, the background is as important as the main action, and he has filled this barn with a rich autumn still life of pumpkins and drying corn. The piece of harvesting machinery on which the little girl stands offers a hint that the industrial revolution has invaded the late nineteenth-century farm.

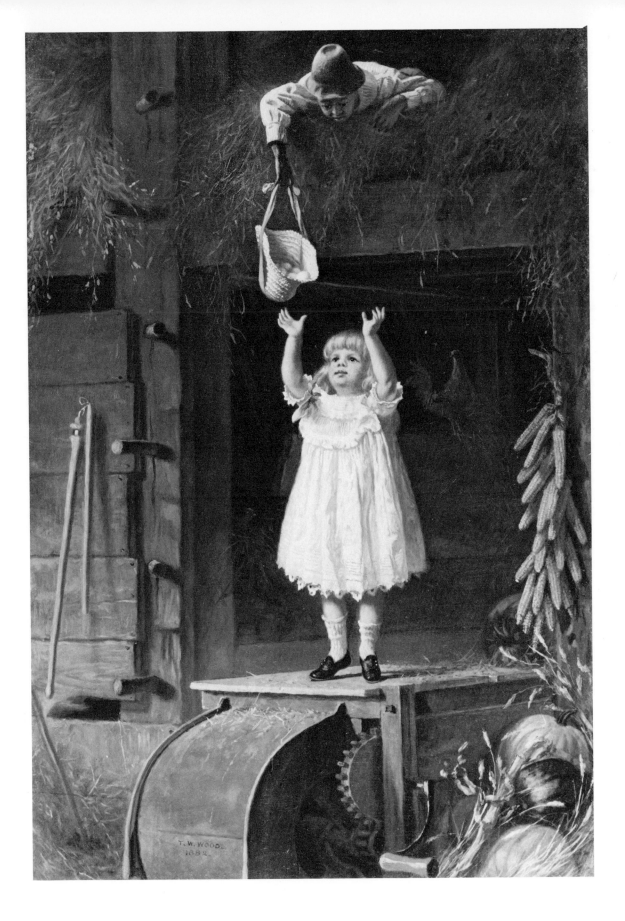

Eastman Johnson was born in Lovell, Maine, and by age twenty was a competent self-trained portraitist working in crayons. After spending the next five years working in Washington, D.C., and Cambridge, Massachusetts, he decided to study art abroad. He went first to Düsseldorf where he studied genre and the technique of oil painting. Three years at The Hague led him to appreciate Rembrandt and the Dutch masters, and his last year in Paris under Thomas Couture taught him systematic technique. The death of his mother forced him to return to America. In 1858 he moved to New York where he remained for the rest of his career, spending his summers on land he owned in Nantucket.

Though Johnson is now best known as a genre painter, he was primarily a portraitist, producing all his genre work between 1851 and 1887. His genre paintings used several general themes: Indian subjects (all painted on the frontier in the summer of 1857); Civil War studies (made at the front during the summers of the war); maple sugar camp scenes (produced during the first half of the 1860s in the maple groves of Fryeburg, Maine); farm scenes, including barn scenes and corn husking (done throughout his career); cranberry pickers (from the cranberry fields on Nantucket duing the mid and late 1870s); and various indoor studies of women and family life.

Some of Johnson's figures are lighted in the same way and have the same solidity as those by Winslow Homer. Like Homer, he believed in the integrity of man and avoided sentimentality, never caricaturing his genre figures or exaggerating their gestures and expressions. Situated between the mid-century genre painting of Bingham and Mount and the late century realism of Homer and Eakins, Johnson's work extols the American virtues of hard work, honesty, and satisfaction with simple pleasures.

In the spring when the sap in sugar maple trees begins to rise, small shallow holes are drilled a few feet from the base of the trunk to collect it. By the nineteenth century this annual "harvest" had become a tradition, and, like quilting bees or corn huskings, it was as much a social gathering as a work party. Audubon describes such a sugar harvest:

As I approached [the fire] ... bursts of laughter, shouts and songs apprised me of some merry-making. I thought at first that I had probably stumbled upon a camp-meeting; but I soon perceived that the mirth proceeded from a band of sugar-makers... With large ladles the sugar-makers stirred the thickening juice of the maple; pails of sap were collected from the trees and brought in by the young people; while here and there some sturdy fellow was seen first hacking a cut in a tree, and afterwards boring with an auger a hole, into which he introduced a piece of hollow cane.... (Delineations of American Scenery and Character, 1835)

Though this subject had precedents in American art before Johnson's various studies of it, he is probably the artist most identified with its depiction. He had a special studio built with wheels and a stove which he moved from camp to camp. In this way he was able to work in comfort and make accurate and careful studies of all details of the sugar camp.

The Rendering Kettle, Sugaring Off is one of his unfinished studies showing the boiling-down process; the sap was reduced in a potash kettle suspended from a horizontal pole over a fire. Though the human subjects were of importance to Johnson, he also seems to have delighted in the subtle color harmonies he observed in such camps: the red fire, the gray spring skies, the snowy floor, and the smoke-filled forest.

The Rendering Kettle, Sugaring Off,

ca. 1861-1866

Oil on canvas

17 x 21 in. (43.2 x 53.3 cm.)

Anonymous loan

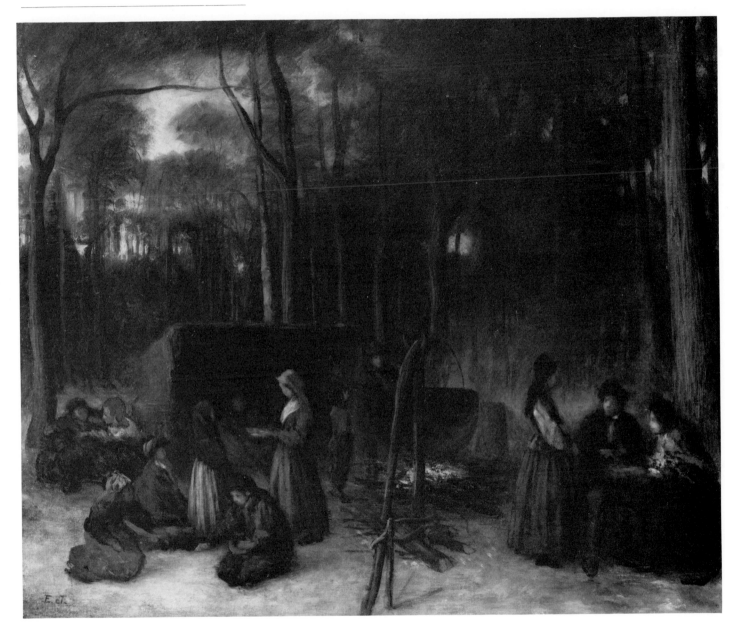

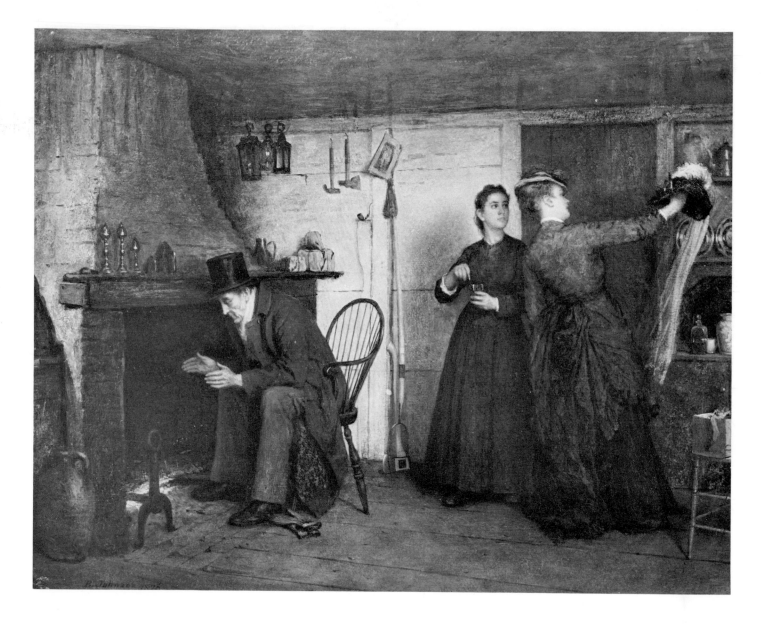

57

The New Bonnet, 1876
Oil on cardboard
20¼ x 27 in. (52.7 x 68.6 cm.)
The Metropolitan Museum of Art,
Bequest of Collis P. Huntington, 1925

Toward the end of his genre career, before he returned to painting portraits, Johnson turned his attention to interiors, often using Nantucket people as models. He painted several scenes of girls and women engaged in private activities at home, modeling some of his subjects on the family of his sister Harriet in Kennebunkport, Maine. Others may have been influenced by his marriage in the early 1870s, which would have made it more likely for him to witness such scenes. *The New Bonnet* was painted in Nantucket and the fireplace, candlesticks, and lanterns are the same as those in Johnson's *Nantucket Sea Captain.*

The New Bonnet, contradicting traditional rules of composition, is actually two scenes in one, divided by the tools at the center of the canvas. On the right is a fine example of Johnson's interior studies with women, on the left an equally fine example of his studies of Nantucket men. It is successful in spite of the deliberate central division and the fact that attention is focused away from the center of the canvas. Theoretically, nothing holds the composition together; yet the division is neither obvious nor disturbing.

The painting is typical of late nineteenth-century genre works in which artists recorded many scenes of simple domesticity. Though this painting has a central object—the new bonnet—the man ignores it and the woman stirring something in a glass gives it only a casual glance. Such scenes capturing intimate moments became popular, foreshadowing the work of the impressionists who often portrayed the daily activities of ordinary people.

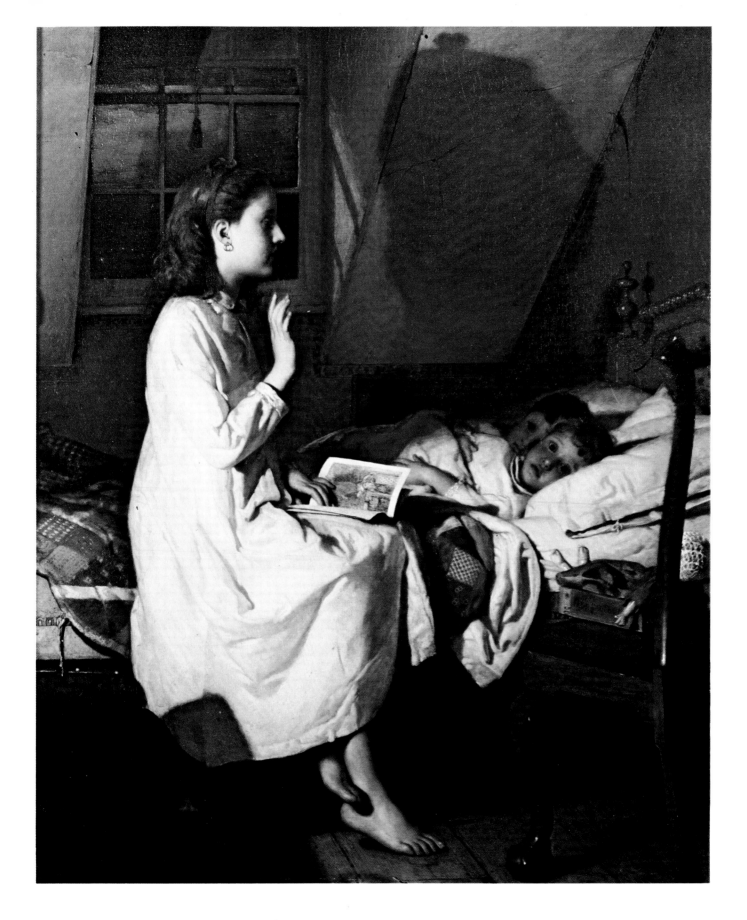

58

The Story of Golden Locks, ca. 1870
Oil on canvas
34 x 28⅛ in. (86.4 x 71.4 cm.)
Jo Ann and Julian Ganz, Jr.

In Guy's *The Story of Golden Locks* two small boys are listening to an older girl read a story illustrated in the book the reader holds. The two children nestle snugly between white sheets, projecting a Victorian image of middle-class comfort and security. They are the complement to the popular Victorian idealization of ragged street gamins who, despite their poverty, embodied the ideals of honesty and industry. The painting's composition resembles that of another work by Guy, *The Bed Time Story,* but there are differences in details such as the coverlet and the reader's dress. The style is similar to his most famous work, *Making a Train* (Philadelphia Museum of Art), and probably dates from about the same time.

Guy's paintings are skillfully drawn and in several of them he uses a hidden candle as a light source; in this case a candle illuminates the figures from the left side of the picture. Though this pictorial device was utilized by several artists in both Europe and America, Guy's direct source may have been the work of the English artist Joseph Wright of Darby.

Seymour Joseph Guy was born in Greenwich, England, and orphaned at the age of nine. At thirteen he wanted to be either a civil engineer or an artist; he decided on the latter and took up sign painting. With his earnings he purchased art materials which he used for studying on his own, and in 1839 he was apprenticed in the oil and color trade for seven years. Articled in 1847 to Ambrose Jerome, a London portraitist, he also studied with an artist named Buttersworth. He painted portraits and made copies of Old Masters until he went to New York in 1854. There, though his portraits were well received, he soon began painting genre scenes and specialized in themes involving children. These works are very similar in technique and mood to those of J. G. Brown, another popular Victorian artist.

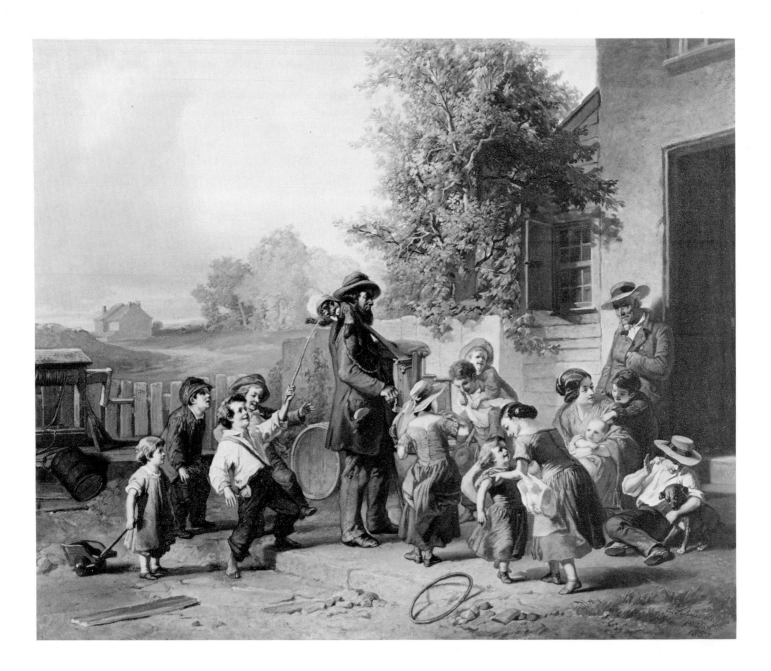

59

The Organ Grinder, 1857

Oil on canvas

29 x 36¼ in. (73.6 x 92.1 cm.)

Ira Spanierman, Inc., New York

The *Organ Grinder,* painted at the midpoint of Schussele's career, was exhibited the year after its completion at the Pennsylvania Academy of the Fine Arts, and it represents a favorite theme of nineteenth-century genre artists. A *Scribner's Magazine* article of 1893 describes such an event in New York. "Suddenly there is an explosion of sound . . . and a hand-organ starts off with a jerk like a freight train on a down grade . . . its harsh high-pitched metallic drone makes the street ring for a moment. Then it is temporarily drowned by a chorus of shrill, small voices. . . . The street is filled with children of every age, size, and nationality . . . the women are coming out. . . . Some male passers-by line up at the edge of the sidewalk. . . . The children are dancing."

Like the dance scenes by Mount and Bingham, Schussele's picture portrays the enthusiasm of the public's response to popular diversions. Such subjects were characteristic of American genre painters who generally preferred lighthearted scenes of country or city people enjoying whatever amusements were available to them.

Though Christian Schussele was born in Guebwiller, Alsace, and educated in France, the subjects of his paintings were distinctly American. As a child he demonstrated a talent for art, but when his father determined he was to be a banker, he ran away to Paris. He found work in a printing house and studied art with Paul Delaroche, Godefroy Engelmann I, and Franz Graff, before finally entering the Versailles studio of Adolphe Yvon, a painter of battle scenes. Escaping the French Revolution of 1848, Schussele came to Philadelphia where he was first employed as a chromolithographer. Three years later his first painting was exhibited at the Pennsylvania Academy of the Fine Arts. During the next eleven years he achieved a sizeable reputation painting, exhibiting, and selling genre and historical pictures.

Schussele's short career ended in 1862 when he was stricken with palsy. No longer able to paint, he went to Paris and Strasbourg for operations and cures which proved unsuccessful. His friend, the engraver John Sartain, found him in Strasbourg in 1868 and persuaded him to return to Philadelphia. There he became the first professor of the art school of the Pennsylvania Academy, a position he held until his death in 1879.

Little is known about Rondel today except that he seems to have avoided publicity and that he was briefly the teacher of Winslow Homer. Frederic Rondel was born in Paris where he studied under Auguste Jugelet and Théodore Gudin. He came to Boston before 1855 and in 1858 moved to South Malden, Massachusetts, before finally settling in New York City two years later. Except for a trip to Europe in 1868 and brief residences in Poughkeepsie and New Rochelle, he remained primarily in New York City until moving to Philadelphia in 1890.

National Academy of Design exhibition records show that he had three children —Frederic, Jr., Miss J. Rosa, and Louis—who exhibited their works along with their father in annual exhibitions from the 1860s to the 1880s.

60

The Picnic, ca. 1865

Oil on canvas

19½ x 34 in. (49.5 x 86.4 cm.)

The Butler Institute of American Art, Youngstown, Ohio

Rondel was known as a landscape painter, but because his paintings generally show several small figures active within a larger landscape, they can also be considered genre works. Though he was born and educated in France, the subjects of his compositions, such as *The Picnic,* seem to be totally American. A popular contemporary subject, two other paintings on the theme appear in this exhibition. Rondel's work differs in approach from Narjot's *Leland Stanford's Picnic* (cat. no. 61), really an informal group portrait, but resembles Jerome Thompson's treatment of the *"Pic Nick,"* (cat. no. 38) in which an unidentified group of people simply enjoy an outing. In Rondel's painting the people also seem to have gathered for another event, possibly the dance across the lake which may be part of a larger festivity as well. The painting's action is complex, including an amorous couple, a man smoking, children delving into hampers and carpetbags, someone preparing food, and a child trying to wrest itself free from an affectionate older sister. Rondel's works are characteristically serene, and unlike some of his contemporaries he makes no particular attempt at humor, sentimentality, or storytelling. His approach is that of an uninvolved spectator who quietly observes and records the individual activities of a variety of people.

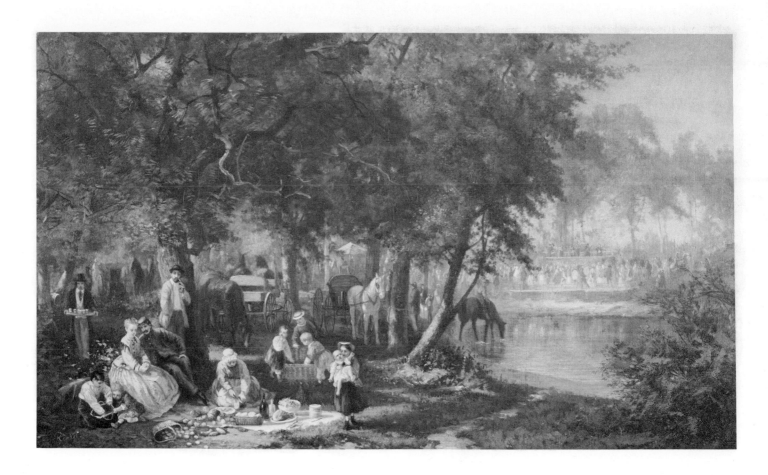

Narjot was born into a family of painters in Saint Mâlo, France. He studied painting in Paris, but, infected with "gold fever," he sailed for California at the beginning of the rush. He stayed there only until 1852, finding little work as a painter and may have had even less success with his diggings. Hearing of a rich strike he went down to Sonora, Mexico, where he married and must have witnessed some of the scenes of Mexican life he later painted. Forced from Mexico during the war in 1866, he returned to San Francisco with his family and stayed there until his death.

Specializing in large genre compositions, he painted subjects from his own experience, such as *The Chinese Procession* (depicting San Francisco's Chinatown before the fire of 1906) as well as literary subjects like *The Druid's Sacrifice* of which he was particularly proud. In addition he also painted portraits and landscapes as well as frescos for churches, theaters, and public buildings. He was a prominent member of San Francisco's art community in the 1870s and 1880s, the most vital years for art in that city during the nineteenth century. Unfortunately, most of his paintings, like those of other San Francisco artists, were destroyed in the fire of 1906.

The culmination of Narjot's career was a commission to decorate the Leland Stanford, Jr., tomb on the Stanford University grounds. Ironically, it was this commission that destroyed him, for the paint falling from the ceiling as he worked severely injured his eyes. After many operations for which the family spent their entire savings, only one eye was saved and Narjot died destitute a few years later.

61

Leland Stanford's Picnic, Fountain Grove, Palo Alto, California

Oil on canvas

30 x 25 in. (76.4 x 63.5 cm.)

Dr. and Mrs. Carl S. Dentzel

This painting of Leland Stanford's family and friends having a picnic combines Narjot's talents as a genre, portrait, and landscape painter. Leland Stanford, a major figure in California history, came to the state in 1852; he later became governor and served as president and director of both the Central Pacific Railroad and the Southern Pacific Company. He founded Stanford University on his ranch, "Palo Alto," in memory of his son, Leland Stanford, Jr., who died at the age of sixteen.

This picnic took place in "Fountain Grove," the Stanford vineyard located on his ranch thirty-two miles southeast of San Francisco. Among the picnickers are Leland Stanford and his wife; the naturalist John Muir; Josiah Royce, philosopher and teacher; Joseph LeConte, geologist and teacher at the University of California, Berkeley, from 1869; and Charles Warren Stoddard, author in San Francisco from 1855.

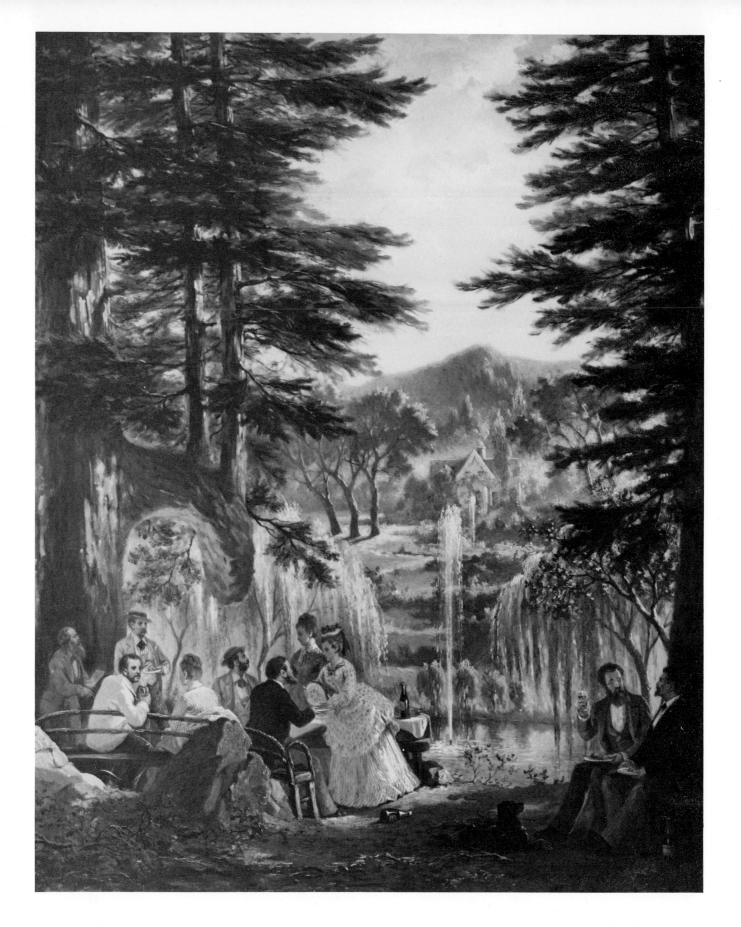

Wimar was born in Germany and came to America with his family when he was in his mid-teens. They settled in St. Louis at a time when Indians still camped nearby, and the boy's interest in these native Americans came from his frequent visits to their camps. He received his first art training from a local painter, Leon Pomarede, with whom he stayed for four years, and it was with him that Wimar made his first trip up the Mississippi. When he went to Düsseldorf to study in about 1852, he was able to combine his two interests. In his four years there he painted seventeen known paintings based on subjects of the frontier, earning the title "Indian painter" from his fellow students.

After returning to St. Louis he continued to paint Indian themes. To get closer to his subjects he made trips up the Mississippi and Missouri rivers in the summers of 1858 and 1859, taking along sketch pads as well as an ambrotype apparatus. Once back in St. Louis he expanded his sketches into large compositions. He also painted portraits, did decorative work, and exhibited at the local fairs. In 1861 he received his most important commission—to paint the rotunda of the new dome of the old St. Louis courthouse. He managed to finish it just before he died of consumption at the age of thirty-four.

62

The Buffalo Dance, 1860
Oil on canvas
24⅞ x 49⅝ in. (63.2 x 126.0 cm.)
The St. Louis Art Museum,
Gift of Mrs. John T. Davis

The Buffalo Dance depicts the Mandan tribe's ceremony to insure the coming of the buffalo and good hunting. The scene is illuminated by a fire and highlighted by touches of moonlight. The spectators, arranged in distinct, well-ordered levels, sit in the shadows watching the dancers. Wimar tended to romanticize his compositions, often showing heavily muscled Indians on horses with flying manes and flaring nostrils, but this scene is probably relatively similar to the original. Much of the regalia seen here and in his other pictures Wimar bought or received in trade from Indians he met on his river excursions.

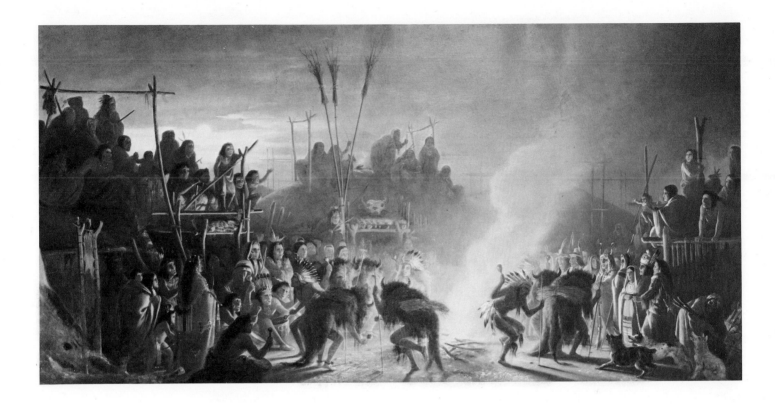

63

The Ambush, ca. 1870-1875
Oil on canvas
30 x 50½ in. (76.2 x 128.2 cm.)
Museum of Fine Arts, Boston,
M. and M. Karolik Collection

The Ambush, probably painted in San Francisco about 1870-1875, is one of Bierstadt's numerous subjects based on his experiences in the West. More a re-creation of a classic incident than an actual event, this encounter between Indians and a wagon train lacks authenticity. The road seems too level and graded for the wilderness and the dog is reminiscent of his city kin who flee fire engines in eastern genre scenes. The presence of the soldiers already settled alongside the path of the oncoming wagons suggests that both the wagon train and the Indians are being ambushed. The picture exemplifies the overly dramatic style criticized by Bierstadt's contemporaries; he dramatizes the story with a theatrical treatment of the brooding, cloudy skies, the light falling on the front of the wagon, and the men's excited faces and gestures. His characterizations typical of the romanticized images of Indians and the West often conveyed by artists to easterners, images that inspired many of the popular misconceptions of the West.

Bierstadt was born in Düsseldorf and brought to New Bedford at the age of two, but he returned to his birthplace in 1853 to study art. He specialized in landscapes at a time when historical painting was the dominant art form at Düsseldorf and he composed his final paintings from sketches made out-of-doors. After studying in Italy for a year he returned to the United States in 1857 to continue his career. Two years later he made his first journey to the American West and saw the picturesque landscapes that were to inspire some of his greatest works. He took various trips west: with the Landers party he went to Wyoming and South Pass in the Wind River Mountains (1859); he traveled with Fitz Hugh Ludlow from Kansas to San Francisco, visiting Salt Lake, Lake Tahoe, Yosemite, and Oregon (1863); he stayed in San Francisco for two and a half years; and he took a trip by rail through Canada (1889). The sketches he made there often served as the basis for grandiose studio compositions in which he exaggerated the drama of the western landscape to achieve a monumental effect.

Although Bierstadt achieved almost instant recognition for his paintings at the beginning of his career, the critics began to comment negatively on his style of painting, and by the time of his death in 1902 he was almost forgotten. The reappraisal of his works over the last two decades has shown him to be one of America's greatest painters of the western landscape.

64

Resurrection, ca. 1860
Oil on canvas
28 x 34 in. (71.1 x 86.4 cm.)
Robert C. Vose, Jr.

Born in Watertown, New York, where he lived all his life, Kip was inspired to paint by Salathiel Ellis, a little-known artist who lived in Watertown between 1828 and 1835. Kip began as a portrait painter, and later designed frescos and murals in local churches; eventually his decorative projects encompassed the ornamentation of railroad cars and steam presses. Though he had no formal schooling Kip produced a quantity of prose and poetry, composed and delivered eulogies on the death of his friends, and preached sermons at his local Universalist Church. Little was known of his life or work until 1961, when a cache of his works in oil and watercolor, both portraits and landscapes, was discovered in the attic of his home in Watertown. The diaries and scrapbooks accompanying these works provide information that is just now bringing his name out of obscurity.

Resurrection reflects Kip's early interest in religious subjects, themes common to primitive painters. The composition for Christ's appearance before Mary Magdalene on Easter morning was probably copied from a Bible illustration, for Kip could not have been familiar with the jagged peaks and palm trees seen in the distance. Though certainly primitive, the painting shows fine sensitivity and skillful copying in the head of Christ, and there is an appealing, sympathetic expression on Mary's face. Like *Christ and the Woman of Samaria* (cat. no. 2) this picture is typical of the work of a vast body of minor painters who have only recently been appreciated for their contributions to the history of American art.

65

Pulling for Shore, 1878

Oil on canvas

32½ x 48½ in. (82.5 x 123.2 cm.)

The Santa Barbara Museum of Art,

Museum Exchange

Though Brown's style combined realism with sentiment, in *Pulling for Shore* he has fortunately avoided sentimentality. The picture of a boat overloaded with eight occupants has the basic elements of Winslow Homer's painting, *Lost on the Grand Banks* (cat. no. 69); yet the two works are completely different in character. Homer's painting grasps the universal concept of man's struggle against nature, while Brown's appears to be a group portrait of a fishing party. Use of the outdoors as a backdrop for such a portrait makes this work similar to Narjot's *Leland Stanford's Picnic* (cat. no. 61). Though several of the people in the Narjot picture can be identified, unfortunately no one in the fishing party has yet been identified.

Born in England to poor parents, Brown was early apprenticed to a glass cutter. He practiced painting as a sideline, and when he was twenty-two went to London where he supported himself by painting portraits. After moving to the U.S. around 1855 he temporarily returned to the glass cutting trade in Brooklyn. When he later began to paint again he specialized in paintings of street urchins. In addition to a love of children, he felt akin to those whose poverty reflected that of his own youth. His depiction of the poor and of the working class in America foreshadowed the social realists of the early twentieth century, but without their critical social comment. He saw the poor with Victorian eyes, as nostalgic and sentimental objects, although he recorded them with an American love of realism. The paintings he did in America proved very popular with the public and Brown achieved great financial success in his later years.

66

Waiting for a Partner, 1872
Oil on canvas
24 x 44 in. (61.0 x 111.8 cm.)
Jo Ann and Julian Ganz, Jr.

In contrast to Brown's numerous renditions of street urchins he has painted this party scene of obviously affluent children. The girl circled by a ring of playmates is thought to be Brown's daughter, and because of this the scene may represent an outing once taken by Brown's family. Paintings of outings like this, as well as scenes of picnics, skating, camping, and camp meetings, were popular among Victorian city dwellers. Americans, influenced by their poets and writers as well as by painters of the Hudson River school, had gained an appreciation of the American landscape. In 1877 William Cullen Bryant had written "Thanatopsis," a poem urging people to "go forth, under the open sky, and listen to nature's teaching." The year *Waiting for a Partner* was painted, Bryant edited a new magazine called *Picturesque America* that in pictures and words conveyed the beauties of the American countryside.

Though *Waiting for a Partner* is not Brown's original title (now lost) it was suggested by the various references to couples in the painting. This picture may actually have been planned as an allegory of the transitoriness of life, with various figures ranging from infancy to old age. The children encircle a girl who seems to be considering a decision; a slightly older boy helps a young lady climb a rock; a courting couple talk in the shadows to the far left; a newly married couple with a baby stand grouped to the right. Though the scene is not overtly sentimental the obviously pleasant, rather idealized portrayal has overtones of Victorian feeling.

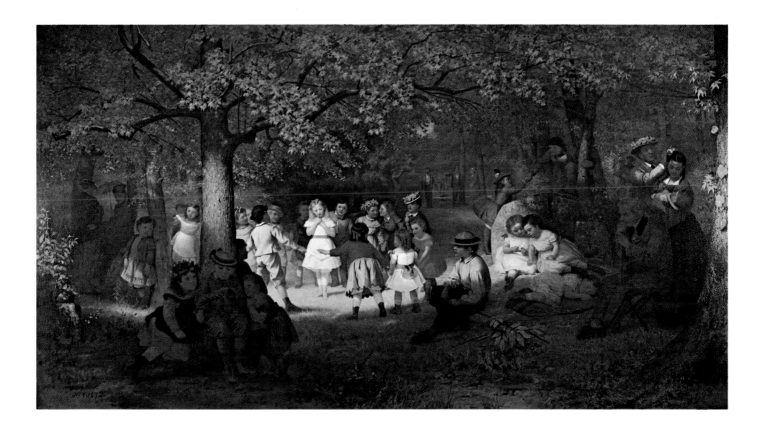

Horace Bonham was born in West Manchester, Pennsylvania, in 1835, and very little more is known of his life. He studied with Léon Bonnat in Paris and specialized in genre painting, exhibiting at the Pennsylvania Academy and at the National Academy of Design from 1879 to 1886. His actual painting career predates his known exhibitions since *Nearing the Issue at the Cockpit* is dated 1870. There are no other known works by him in contemporary collections.

67

Nearing the Issue at the Cockpit, 1870

Oil on canvas

20¼ x 27⅛ in. (51.4 x 68.9 cm.)

Corcoran Gallery of Art, Washington, D.C.

Nearing the Issue at the Cockpit records the spectators rather than the two fighting cocks. While it avoids the bloody spectacle of the birds the excitement of the coming climax is conveyed by the various expressions on the spectators' faces.

The practice of fighting specially bred gamecocks originated in the Orient, was brought to Europe in the fifth century B.C., and eventually to America by the English. Birds matched by weight fought in a pit until a victor was obvious or until one bird was killed. Heavy betting usually accompanied the matches. This sport, still popular in some areas of the world, has been illegal in most of the United States for some time. The diverse social classes among the spectators show the wide popularity of this sport in nineteenth-century America. Bonham seems to delight in representing varied ethnic types and expressions. The area surrounding the figures is evidently of little importance to him: the men's trousers and the roof are delineated as briefly as possible. Bonham's style provides an interesting contrast to that of Henry Alexander (see *Laboratory of Thomas Price,* cat. no. 86) who concentrated his attention as much on the background as on the main subject.

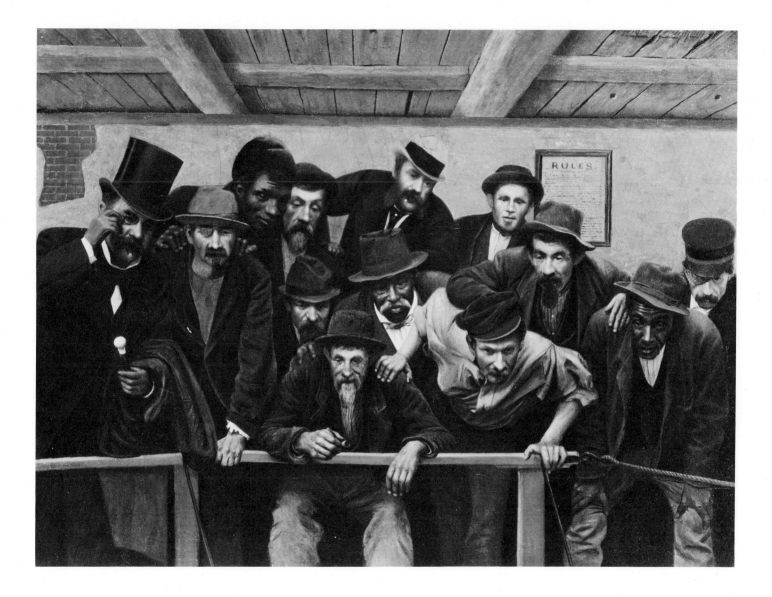

Born in Boston, Homer grew up in Cambridge, then a rural village. Evidencing talent for drawing he was apprenticed to a lithographer and publisher of prints, and after a few years established himself as a freelance illustrator. His first work in Boston was drawing for *Ballou's Pictorial* and *Harper's Weekly,* and after moving to New York he continued to work for Harper and Brothers and other publishers.

Several times during the Civil War Homer went to Union troop encampments and battlefields as an artist-correspondent to make sketches, and he was far superior to his contemporaries in authentically depicting views of the war. Though successful as an illustrator, he began to seek new means of artistic expression, and it was during the Civil War years that he first experimented with painting in oil. After the war he went to Paris where he painted for about a year and by 1875 he had ceased illustrating entirely. After a year's stay at Tynemouth, England, where he painted the fishermen and the sea, he settled in Prouts Neck on the coast of Maine. This became his home, and the starting point for his various hunting, sketching, and fishing trips. In summer he visited the Adirondacks or Canada and in winter chose the warmer climates of Nassau, Cuba, Florida, and Bermuda. During these trips he painted watercolors and from some of them later produced larger compositions in oil. At home in Prouts Neck he recorded the sombre moods of the sea that dominated the work of his later years. He led a progressively more solitary life, never marrying, devoting himself to his garden and his painting.

Homer's paintings document human activity without becoming anecdotal or excessively involved with detail. His simple, realistic, and boldly painted statements on American life of the late nineteenth century often show man interacting with nature. Homer's monumental compositions give man a quiet dignity, seeing him as a forceful opponent of nature and thus in balance with it.

The Civil War inspired numerous paintings with subjects ranging from historic battles to the war's effects on the people at home. Homer was sent to the front by *Harper's* to illustrate aspects of the war; his many sketches seldom showed actual fighting for he concentrated instead on everyday life in camp. Before the war's end Homer had decided to become a painter and his first works in oil were of Civil War scenes, sketched at the front and completed on canvas in his studio. *Prisoners from the Front,* his most famous war painting, depicts Confederate captives brought to a Union camp where they are scrutinized by an officer. The drama is subtle, consisting mainly of expressions rather than physical action. The confident, well-groomed northern officer faces a shabby but defiant Confederate professional soldier, an old man anxious about his fate, and a raw young recruit who quietly awaits a verdict. A comparison of *Prisoners from the Front* with John Trumbull's *Battle of Bunker's Hill,* a detail of which is in this exhibition (cat. no. 8), shows how painters' views had changed from a time when heroism and gallantry were standard elements in scenes of war. During the Civil War there was a change in the public attitude toward war. More sophisticated than their eighteenth-century ancestors who continued to value patriotism and the outmoded chivalric code, Homer's contemporaries could see a work like this, painted in the heat of war, and feel sympathy with the enemy. Homer's approach and the public's sentiments fell midway between the old concept of heroic battle and the bitterness of the early twentieth century exemplified by George Bellows' *Return of the Useless* (cat. no. 87). By 1918 war was viewed as a necessary, but hated, phenomenon in which the average man was less a hero than a victim of government and society.

Prisoners from the Front, 1866

Oil on canvas

24 x 38 in. (61.0 x 96.5 cm.)

The Metropolitan Museum of Art,

Gift of Mrs. Frank B. Porter, 1922

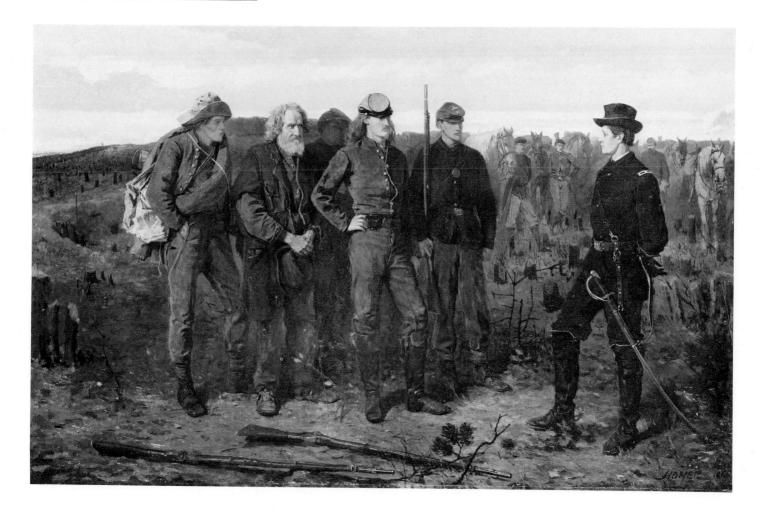

69

Lost on the Grand Banks, 1885

Oil on canvas

30½ x 49⅜ in. (77.5 x 125.4 cm.)

Mr. and Mrs. John S. Broome

Drawings dated 1884 of men in dories on the high seas, hauling in nets and baiting trawls, suggest that Homer took a trip with a fishing fleet sometime that year. In any event, over the next two years he produced four major canvases of deep sea fishing subjects: *The Fog Warning* (The Metropolitan Museum of Art), *The Herring Net* (Art Institute of Chicago), *Lost on the Grand Banks,* and *Eight Bells* (Addison Gallery of American Art). Displaying his artistic development, these paintings had a greater naturalism, broader handling, and more sophisticated subject matter than his former works. *Lost on the Grand Banks* is probably the most successful of the four; intensely dramatic, it reduces details, concentrating instead on the wild motion of the waves and the fury of the gale. Referring to this painting, Lloyd Goodrich, one of Homer's biographers, states that "among all his sea pieces there is no more moving expression of nature's force and man's helplessness in face of it."

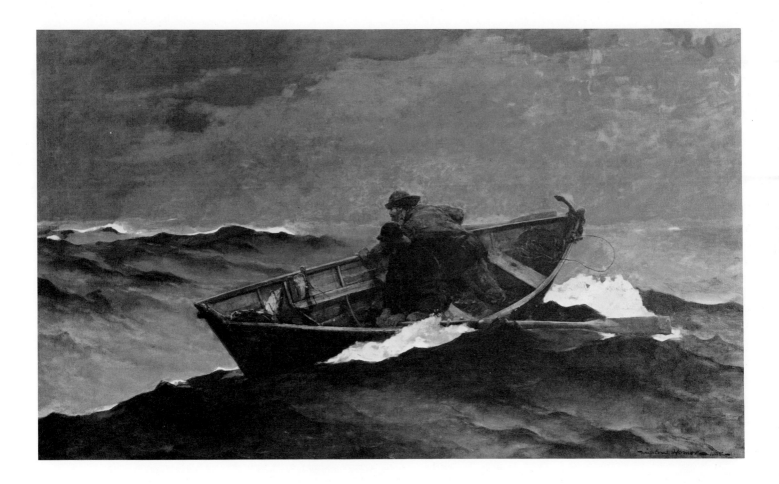

70

The Questioner and the Sphinx, 1863

Oil on canvas

36 x 41¾ in. (91.4 x 106.0 cm.)

Museum of Fine Arts, Boston,

Bequest of Mrs. Martin Brimmer

The Questioner and the Sphinx is probably Vedder's best-known painting and was one of the first mystical works he painted while in New York during the Civil War. His only comment on these paintings was that he tried to record in them his first impressions of the strange beings he encountered in his imagination. In *The Questioner and the Sphinx* Vedder has reversed the Greek myth of the creature who sat by the road to Thebes propounding riddles to passers-by; instead he shows a traveler asking a riddle of the Egyptian Sphinx at Gizeh.

The novelty of the strange combination of real and mythical images in Vedder's paintings must have contributed to their immediate appeal, but they also express a deeper philosophic questioning of reality itself.

Born in New York City, Vedder spent much of his childhood in Schenectady, though he made several trips to Cuba where his father was engaged in a number of business transactions. He was interested in art from an early age and studied briefly with Tompkins H. Matteson. In Europe from 1856 to 1860, he studied under François Picot in Paris and later associated with the Macchiaioli group in Florence. From one of those artists, Nino Costa, he acquired an appreciation of landscapes; from another, Raffaello Bonaiuti, he learned to draw in a classical manner and to appreciate Tuscan art of the early renaissance.

When Vedder returned to New York City at the beginning of the Civil War, he rented a little room with a view of plain brick walls and iron shutters. Unhappy with his surroundings, he turned inward for inspiration, putting on canvas the forms he saw when "wandering in the little world of . . . [his] imagination." By the end of the war he had completed several important works, including *The Lair of the Sea Serpent, The Fisherman and the Genii,* and *The Questioner and the Sphinx,* which established his reputation. After the war Vedder returned to Europe and spent a short time in France. By 1867 he was in Rome, where he remained until his death except for occasional trips to America. His work gained recognition, and in addition to his illustrations and paintings he executed several important mural commissions toward the end of his life.

71

Memory, 1870

Oil on mahogany panel

21 x 16 in. (53.3 x 40.6 cm.)

Los Angeles County Museum of Art,

Mr. and Mrs. William Preston

Harrison Collection

A drawing for this picture dated March 19, 1867 (his wife's birthday) suggests that the model for the head in this work was Vedder's wife, Carrie. The work was evidently inspired by Tennyson's poem "Break, Break, Break" quoted below, for Vedder's penciled notes of 1866 mention "A mixture of Tennyson's break, break, break and memory of those left behind. Idea used afterwards several times." *Memory* was finished in 1870 and he repeated the theme of faces in clouds in several other works, including *Break, Break, Break*, dated 1871, and *Memory*, dated ca. 1876-1878 (with the face of the dead son of Mr. J. S. Dumaresq).

Though Vedder was inspired by Tennyson's emotional poem and his painting inspired in turn a sentimental sonnet (1895) by Florinda Browne, the painting is untouched by Victorian emotionalism.

Break, break, break,
* On thy cold gray stones, O Sea!*
And I would that my tongue could utter
* The thoughts that arise in me.*

O, well for the fisherman's boy,
* That he shouts with his sister*
* at play!*
O, well for the sailor lad,
* That he sings in his boat on the bay!*

And the stately ships go on
* To their haven under the hill;*
But O for the touch of a vanish'd hand,
* And the sound of a voice that is still!*

Break, break, break,
* At the foot of thy crags, O Sea!*
But the tender grace of a day that is dead
* Will never come back to me.*

Born in Scotland, Keith came to the United States as a youngster in 1850. After being schooled in New York he was apprenticed to a wood engraver, and then went to work for *Harper's* which sent him to California in 1858. Keith returned to San Francisco after a brief visit to Scotland, and in the early 1860s while he worked as an engraver he began painting. Determined "to be a good (artist) or die in the attempt" he went to Düsseldorf in 1869, where he studied not at the Academy but with Albert Flamm. On his return he spent two years in Boston, then moved to California where he remained the rest of his life. He was a great friend of the naturalist John Muir, who encouraged him in his art, and they made many trips into the Sierras together. Best known for his depictions of the California countryside Keith painted landscapes of two distinct types. In his first works he sought to record the views he saw, creating large panoramas filled with majestic peaks, rolling hills, and crystal-clear lakes. Later he was inspired by the Reverend Joseph Worcester, a Swedenborgian minister to whom he wrote while studying in Munich in 1883. Through Worcester's influence he became interested in a subjective interpretation of the California landscape. His works became more intimate and poetic as he tried to express his concept of nature's inner meaning through the use of darker colors and a greater virtuosity of brushstrokes.

The Discovery of San Francisco Bay, painted in 1896 for a competition, is one of the masterpieces of Keith's later period. When Spanish officials heard rumors in the 1760s that California was to be taken over by other nations they dispatched a party of explorers to establish Spain's right to the land. Led by Gaspar de Portola, governor of Baja California, the party traveled north along the coast in the summer of 1769. In late October they camped on the lower San Francisco peninsula and the chief scout, José Francisco Ortega, was sent to explore the country ahead. This advance group reached a crest of hills on November 2, 1769, and saw the bay spread out below it. Keith's painting records the planting of the cross (the Spanish method of claiming land) on what is now known as Sweeney's Ridge.

Though Keith was principally a landscape artist, he also painted historical subjects and a series on the California missions. Despite its historical theme, however, *Discovery of San Francisco Bay* is basically a landscape populated by small figures. The brushwork, the dramatic effects of the sun's rays, and the sword pointing to the cross exhibit the emotionalism and subjectivity that characterize Keith's second period. The painting's beautiful and effective blond tones are unusual for Keith. This work was originally purchased by Mrs. Phoebe Hearst for $25,000, the highest price paid for a Keith painting during his lifetime.



72

Discovery of San Francisco Bay, 1896
Oil on canvas
40 x 51 in. (101.6 x 129.5 cm.)
Dr. and Mrs. Carl S. Dentzel

153

Bacon was born in Haverhill, Massachusetts. During the Civil War he enlisted in the Union Army and served as field artist for *Leslie's Weekly* until he was disabled by injuries. He studied at the Ecole des Beaux-Arts under Gérôme, Edward Frère, and Cabanel, remaining in Paris until about 1895. There he painted large genre pictures in oil which he frequently exhibited at the Salon Champs Elysées and the Salon des Beaux-Arts. Several of these received widespread popularity through reproductions by Goupil and Braun.

From 1895 until his death in Cairo, Bacon spent most of his time traveling in Egypt, Greece, Sicily, Ceylon, and Italy. He recorded his impressions of these countries in pure washes of color with virtuoso watercolor technique.

73

Quilting Party, 1872

Oil on canvas

22¼ x 35½ in. (56.5 x 90.2 cm.)

Jo Ann and Julian Ganz, Jr.

Throughout his career Bacon continued to send back to the United States exhibition canvases that retained both the subject matter and sentiment of his native land. The *Quilting Party* is a fine example of the genre scenes he produced in his Paris years. In 1872 Bacon sent the small study of this work (now in the collection of the Shelburne Museum, Shelburne, Vermont) to Mr. S. P. Avery of New York. He wished Mr. Avery to handle the large painting when it arrived and arrange to hang it at the National Academy of Design exhibition of that year. He wrote, "I send with this [letter] a sketch of a picture . . . [which I] wish to send . . . to the Spring exhibition of the N.Y. Academy. The subject is a New England quilting party about 50 years ago . . . I think it my best picture. . . ." Quilting parties like corn huskings and maple sugar gatherings were one of the social events of nineteenth-century America. Showing the interrelationship between individuals in large groups like this was a particular interest of American genre painters. The portrait of George Washington in the upper right is copied from the earliest painting of him done by Charles Willson Peale exactly one hundred years before the *Quilting Party* was finished.

William Hahn (1829-1887)

Very little is known about this artist who was born in Dresden. He studied under Julius Huebner at the Academy there from 1848 to 1855 and later was active in Düsseldorf. By 1871 he had arrived in New York from Germany and he exhibited at the National Academy of Design. In Boston he met William Keith, the California landscapist, who may have been instrumental in Hahn's trip to San Francisco in 1872. Since most of his extant works are of northern California scenes, Hahn is considered a California artist. However, though he lived in San Francisco for approximately fifteen years, he did make frequent trips abroad, probably to Dresden and Berlin where he exhibited in the Academies. While in San Francisco he was an active member of the art community and his work, displayed in local stores and exhibitions, was very popular. He also traveled throughout California sketching the landscape of locales that included Yosemite, San Gabriel, Placerville, and the Russian River.

74

Sacramento Railroad Station, ca. 1874
Oil on canvas mounted on wood panel
53¾ x 87¾ in. (136.5 x 222.9 cm.)
The Fine Arts Museums of San Francisco

The Sacramento Railroad Station is an outstanding example of an American scene painted with the detailed accuracy of nineteenth-century German technique. The work is a study in the organization of a multitude of details; filled with groups engaged in a variety of activities, the painting has no real center of interest. However, analysis of the composition reveals that small pyramids are built on larger ones to unify the otherwise unrelated action. A contemporary reviewer noted that the unusual activity around the station, located on the main line of the transcontinental railroad, gave the artist scope for the illustration of character at which he excelled. Both the style and the approach of Hahn's *Sacramento Railroad Station* differ strikingly from E. L. Henry's treatment of *The Camden and Amboy Railroad* (cat. no. 75), though both works record similar subjects. Henry's painting recreates an historical view and is weakened by his preoccupation with detail. By contrast, Hahn's picture was painted on the site (according to *Overland Monthly* he finished it in Sacramento during the winter of 1874), and captures the complexity of the activity without undermining the masculine and boisterous qualities of the scene.

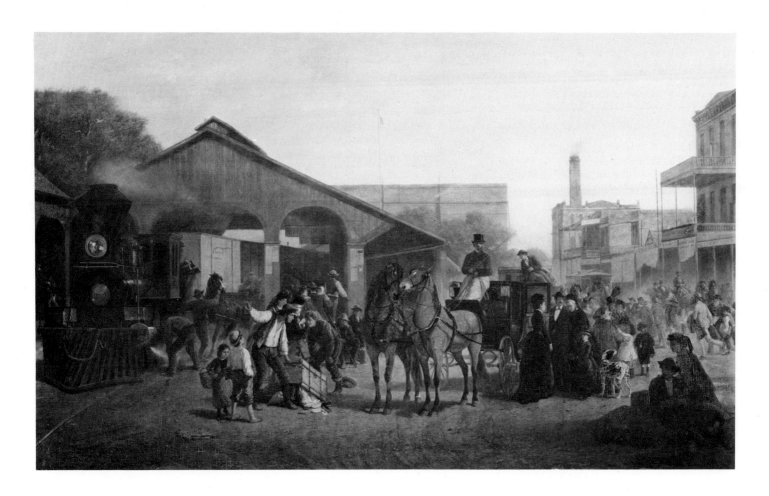

Born in Charleston, South Carolina, Henry was orphaned early and then raised
in New York by his cousins. He exhibited a childhood fondness for drawing and
against opposition from his family chose an art career. He studied with W. M. Oddie
(1805-1865) and at the Pennsylvania Academy of The Fine Arts. From 1860 to 1862
he was in Europe, traveling to London and Paris where he studied with Suisse, Gleyre,
and Courbet and sketched in the Louvre. He also toured Rome, Florence, Germany,
England, and Ireland, making numerous sketches.

On his return Henry began to paint genre scenes. He was intrigued by all forms
of transportation—the horse, oxcart, bicycle, steamboat, train, and eventually by the
automobile—and by architecture, much of which he drew from photographs he took
himself. Though he painted some scenes from his European travels and from his war
experience (he served as a captain's clerk in the Union Army in the fall of 1864)
most of his works were of southeastern New York State.

Henry achieved prosperity almost immediately and many of his works were sold
even before they were hung in the annual exhibitions at the National Academy of
Design. He worked in New York at the Tenth Street Studios and later at a more
commodious studio in Washington Square. After his marriage he had a house built in
about 1885 at Cragsmoor in southeastern New York. There he began to paint during
the summers, relying more and more on those surroundings for subject matter. His
meticulous paintings of the locale provide a historically important record of rural life
in that area of New York. The collections of costumes and buggies he had accumulated
provided him with accurate sources for many of his details. Having once developed
his style Henry stayed with it, continuing his nineteenth-century approach into the
early twentieth century when younger artists of the Ashcan school were painting genre
scenes of New York's lower East Side.

75

The Camden and Amboy Railroad
with the Engine "Planet" in 1834, 1904
Oil on canvas
16 x 32½ in. (40.6 x 82.5 cm.)
Graham Gallery, New York

The Camden and Amboy Railroad,
opened in 1832, came within a couple of
years of being the first railroad in America.
Holding the exclusive right-of-way be-
tween New York and Philadelphia, for
many years it was America's most profitable
railroad. Its first steam engine, im-
ported from England, was known as the
"John Bull." In 1834, stagecoach-like
bodies on railroad wheels were still in use,
but were soon to be supplanted by regular
railway cars. The train first ran between
Amboy (on New York Bay) and Borden-
town (across the Delaware from Phila-
delphia). Lloyd's Register of Shipping
records that the ferry "Wm. Penn" (center
of painting) was registered in Philadelphia
in 1835, therefore this scene may be
located at Bordentown.

Since Henry did not begin his career
in art until 1858, this is obviously one of
his historical paintings. Henry used the
photographs and prints in his considerable
collection to make the details as accurate
as possible. In addition, his sketchbooks
refer to *History of the First Locomotive of
America,* by William H. Brown, and he
may have used it and other texts to recreate
the myriad details in this picture.

See color reproduction, next page.

75

The Camden and Amboy Railroad
with the Engine "Planet" in 1834, 1904
Oil on canvas
16 x 32½ in. (40.6 x 82.5 cm.)
Graham Gallery, New York

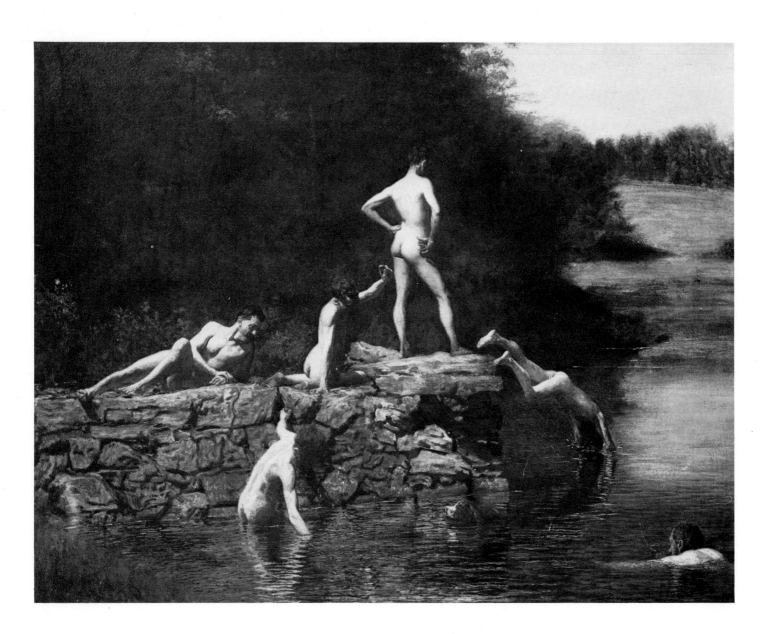

76

Swimming Hole, 1883
Oil on canvas
27 x 36 in. (68.6 x 91.4 cm.)
Fort Worth Art Museum, Texas

Another work showing Eakins'
interest in anatomy is the *Swimming Hole.*
His models were pupils or friends; Eakins
is the swimmer in the lower right corner
and the red setter in the water is his dog
Harry, who figured in many of his pictures
and was one of his numerous pets. This
painting may record an experience in
Eakins' life, for swimming on the New
Jersey shore of the Delaware River was
one of his favorite pastimes. It is con-
sidered the culmination of his outdoor
work because of the complex organization
of space, overall design, and rhythmic
progression of the bodies which gives a
sense of pictorial unity to the painting.
Sensitive to critics who considered him
overly fond of nudes, this is one of Eakins'
last compositions studying the nude figure;
from the mid-1880s he dealt mainly with
portraiture. The genre career of a fine
artist was thus compromised by prudish
hostility, but Eakins turned his genius
elsewhere and continued painting portraits
which were more acceptable to the
society of his day.

Born, raised, and educated in Philadelphia, Eakins attended the Pennsylvania
Academy of the Fine Arts. He studied there for six years, at the same time studying
anatomy at nearby Jefferson Medical College. He continued his education at the Ecole
des Beaux-Arts where he was especially influenced by his instructor J. L. Gérôme and
by the Spanish realists Velásquez and Ribera whose work he saw on a trip to Spain. In
1870 Eakins returned home to live with his family, using them and his friends as
models for his paintings.

Eakins was trained at a time when genre artists like William Sidney Mount and
George Bingham achieved great popularity with their depictions of jovial rural Amer-
icans. Instead of emulating them Eakins independently pursued a diligent study of
anatomy, striving for scientific accuracy in his work. His genre work had none of the
storytelling quality of Bingham and Mount, nor did his portraits rely on the facile
brushstrokes of such realist painters as Chase and Duveneck. Instead he recorded
physical objects and persons on canvas as a camera would and even made photographic
studies of human movement in 1884-1885.

Unappreciated most of his life, Eakins eventually gained some recognition for his
achievements. In 1902 he was admitted to the National Academy of Design by
unanimous vote, and he received the gold medal from the Pennsylvania Academy of
the Fine Arts in 1904. The year after his death he was further honored with a retro-
spective exhibition at The Metropolitan Museum of Art, and his position as America's
greatest realist painter has since become generally accepted.

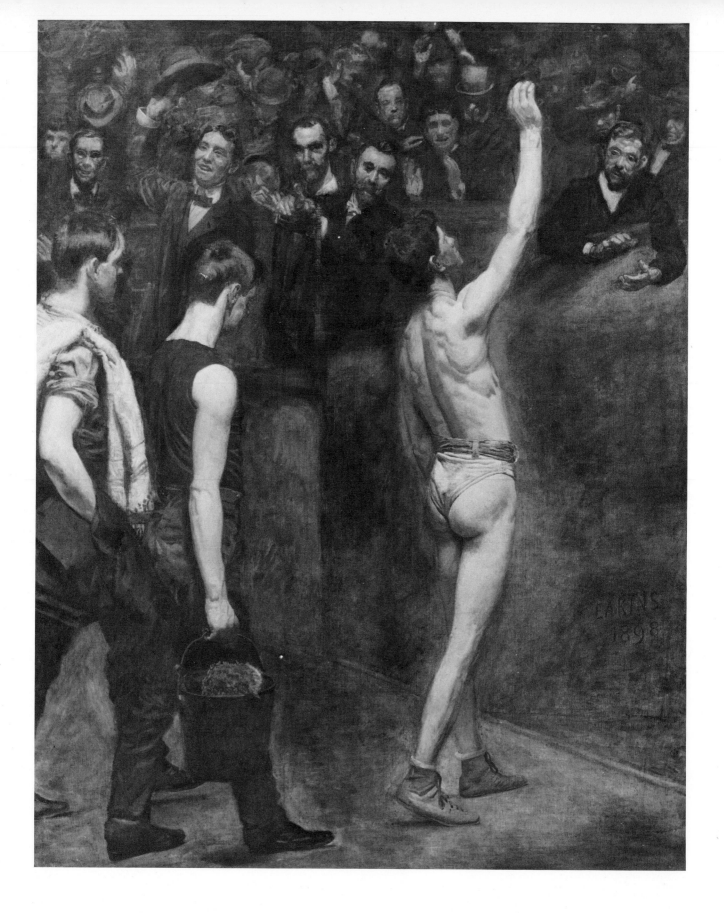

77

Salutat, 1898

Oil on canvas

49½ x 39½ in. (125.8 x 100.3 cm.)

Addison Gallery of American Art,

Phillips Academy, Andover, Massachusetts

Many of Eakins' works were the portraits from which he derived his income, but he also painted several important larger compositions involving numerous people. Because of his interest in the human body and in sports many of these include wrestlers, oarsmen in sculls, baseball players, swimmers, and sailors.

Eakins painted several works of wrestlers in 1898 and 1899, possibly be-cause wrestling was a subject that justified the studies of nude bodies. *Salutat* represents the well-known fighter, Billy Smith, leaving the ring victorious and giving the traditional *salutat* of the winner. The setting is probably an arena once situated at Broad and Cherry Streets near the Academy in Philadelphia, and the men in the audience are portraits of well-known people.

Millet, about whom relatively little is known now, was a familiar figure of his own time. He distinguished himself not only as an easel and mural painter but also as a writer, a war correspondent, and an administrator. He was born in Mallapoiset, Massachusetts, and graduated from Harvard with a master's degree in modern languages and literature. Through his job on the *Boston Advertiser* he learned lithography, which started him toward a career in art. He then studied art at the Royal Academy in Antwerp for two years, winning every prize the Academy offered. His delight in representing the surface textures of old silver and wood and his use of costumes from the period documented by Ter Borch, De Hooch, and Metsu reflect the influence of his education.

In the span of four years he served as Secretary of the Massachusetts commission to the Vienna Exposition, toured the Near East, studied painting in Rome and Venice, and acted as correspondent for the *Boston Advertiser.* Later he was publicly crowned by the King of Belgium; awarded the Cross of St. Stanislaus in the name of the Czar; made a Chevalier of the Legion of Honor by France; and given the First Class Order of the Sacred Treasure by Japan. He was director of the American Academy in Rome when he went down with the Titanic in 1912.

78

Reading the Story of Oenone, ca. 1880?

Oil on canvas

30 x 57⅞ in. (76.2 x 147.0 cm.)

The Detroit Institute of Arts,

Detroit Art Loan Fund, 1883

Millet's *Reading the Story of Oenone* may have been inspired by his art training in Rome or his travels in Greece. The four women in classical dress who relax in various positions are aligned on a single plane in a style similar to Greek bas-reliefs. The reader is placed exactly in the center of the picture but a purely symmetrical composition has been avoided by balancing the two listeners to the left with the one to the right.

In Greek mythology Oenone was a nymph Paris married in his youth and later deserted for Helen of Troy. After being wounded in the battle of Troy, Paris thought kindly of his abandoned wife and asked her to heal his wound. At first she refused, but quickly repenting Oenone rushed to him with remedies. Paris died before she reached him, and she hanged herself in grief.

Millet's work is characterized by precise drawing, fine balance and arrangement of individual parts, and a mood of tranquility: classic qualities that seem unusual for a man so excessively energetic.

Born in New York City, Blashfield displayed a precocious talent for art and was encouraged by the painter William Morris Hunt, with whom he worked for two months. Around 1866 he left the Massachusetts Institute of Technology, where he was preparing for a career in engineering, to study art in France. From 1866 until he returned to the U.S. in 1881 his life revolved around the studio of Léon Bonnat, a rigid disciplinarian who strengthened Blashfield's draftsmanship. He exhibited at the Paris Salon, first with historical canvases and later with contemporary scenes, decorative subjects, and portraits. He was especially interested in the renaissance and with his wife wrote and illustrated several magazine articles on medieval and renaissance art. They also produced an abridged edition of Vasari's *Lives of the Painters*.

The turning point in Blashfield's career came after his return to America when he painted the mural *The Arts of Metal Working* for a dome of the Manufacturers' and Liberal Arts Building at the Chicago World's Fair of 1893. He had previously concentrated on easel painting, but this commission established his reputation as a muralist, and for the next thirty years he helped fill the constant demand for murals in both public buildings and private residences in America.

79

Suspense, the Boston People Watch from the Housetops the Firing at Bunker Hill, ca. 1880
Oil on canvas
25 x 35¼ in. (63.5 x 89.5 cm.)
The Home Insurance Company, New York

The second battle of the American Revolution was fought on June 17, 1775, on Bunker Hill and Breed's Hill just north of Boston. Though the outnumbered Americans were finally driven from their fortifications, their ability to hold the hill for three attacks gained them a great moral victory.

Blashfield's biographer, Royal Cortissoz, explains that until he became a muralist, "Blashfield thought of himself as a painter of easel pictures. He painted them well. He was a good craftsman, excellent in drawing and composition and . . . he had an imaginative drift. . . ." Blashfield studied under Bonnat in Paris, as did Horace Bonham, and it is interesting to note that *Suspense* uses the same approach as Bonham's *Nearing the Issue at the Cockpit* (cat. no. 67): the action is suggested by the expressions on the spectators' faces rather than directly represented.

Though Blashfield's reasons for painting this particular subject are not known, the work is typical of his later Paris period, when he turned to subjects from American history. Signed "Paris" the painting was exhibited in the National Academy of Design in 1882, the year after Blashfield's move to America, so it must be dated in the late 1870s. Blashfield prided himself on his historical accuracy, as did many of the other painters of historical subjects from the time of Benjamin West, but none of their re-creations can rival the authenticity and realism of Winslow Homer's on-the-spot record, *Prisoners from the Front* (cat. no. 68).

Born and raised in Newport, Kentucky, an Ohio River town, Anshutz' first study of art was at the National Academy of Design in New York. There he rebelled against the tradition of drawing from antique casts and was determined to investigate anatomy and nature directly. He soon found a teacher more to his liking in Thomas Eakins in Philadelphia where Anshutz remained the rest of his life. After completing his studies he became a teacher in 1881 at the Pennyslvania Academy of the Fine Arts and then served as director for a short time. Dedicated to his painting he resigned the director-ship of the Academy to take additional studies in Paris at the Julian Academy where he studied for a year under Doucet and Bouguereau. He felt a man should be taught to "reproduce all the facts of nature that he can see" and then should be given "the power to choose his own road." Although teaching became his principal activity later in life, he painted well and was equally competent in oil, watercolor, crayon, and pastel. His landscapes, figures, and portraits were conventional but based on sound principles of correct drawing and harmonious color.

80

Dissecting Room, ca. 1879

Oil on canvas

10 x 12½ in. (25.4 x 31.7 cm.)

Pennsylvania Academy of the Fine Arts

Gift of the Artist, 1879

In September 1879 *Scribner's Monthly* published an article on the advanced state of education in the newly built Pennsyl-vania Academy of the Fine Arts. To illustrate it, Anshutz and other students from the Academy painted various scenes experienced by students there, including Anshutz' contribution, *Dissecting Room.* This was painted in grisaille, tones of greys and blacks, so it could easily be transferred into a wood block engraving and repro-duced as an illustration in the magazine. Anshutz' family still possesses study photographs he took in the school, and though none of them resembles this paint-ing in composition, one includes a head similar to one in the painting.

By 1879 there was a total of 230 students on the rolls of the Academy, including women, all of whom attended sketching, life drawing, and modeling classes. However, instruction emphasized the understanding of anatomy. Dr. Keen, a medical doctor who had originally given private instruction to artists at the Phila-delphia School of Anatomy, was appointed professor of artistic anatomy, and Thomas Eakins, who had studied and painted the human body in motion, was chosen assist-ant professor of painting and prosector in anatomy. Their students were required to attend lectures on anatomy and to dissect animal and human cadavers. *Scribner's* explained, "When the muscles are demon-strated, a cadaver is dissected and all studies are corrected and enforced at the moment by study of the living model. . . . The dissections for the lectures are all done by the class of advanced students, numbering some six or eight . . . under the direction of Dr. Keen and of Mr. Eakins. Every day during the dissections, the life classes are admitted to the dissecting room to study the parts already lectured upon and to make drawings of them for reference and guidance."

Asked whether such detailed non-art instruction would enable a pupil to draw a body better, Thomas Eakins replied, "Knowing all that will enable him to observe more closely, and the closer his observation is the better his drawing will be . . . the whole point of such instruction is there." The emphasis on the direct study of anatomy rather than drawing from antique casts was one more step away from artists' dependence on traditional styles and techniques.

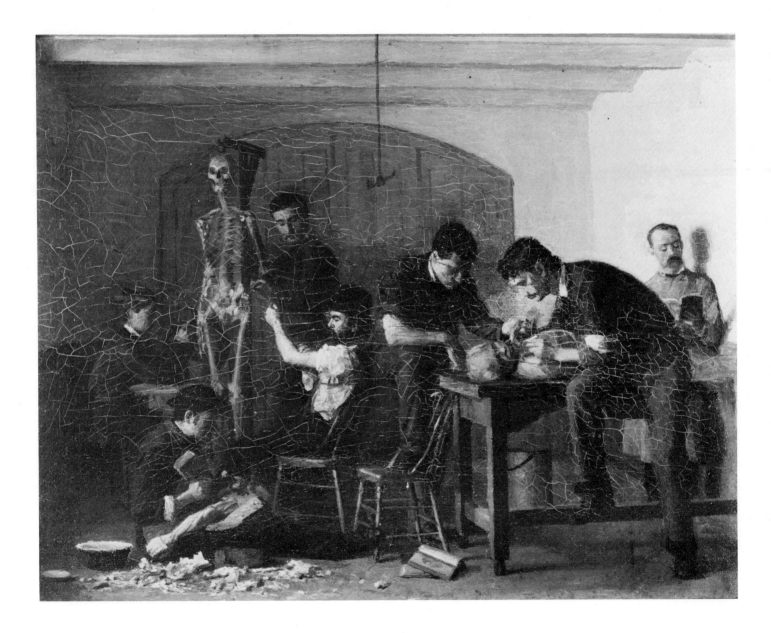

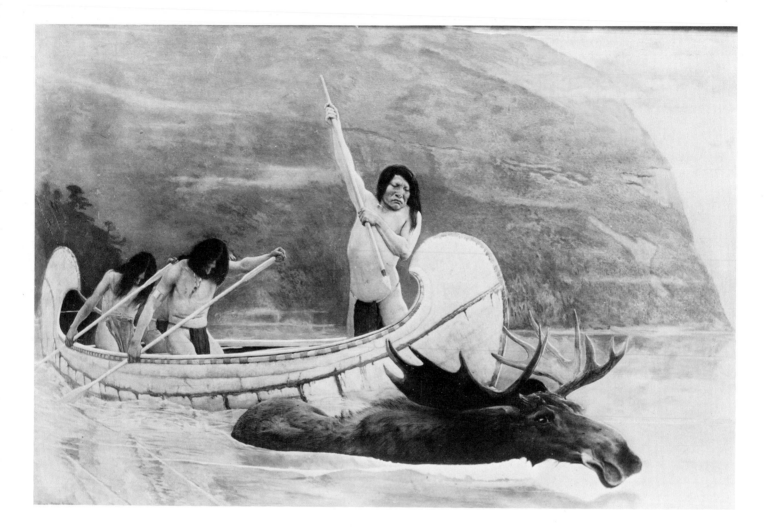

81

The Moose Chase, 1888

Oil on canvas

36⅜ x 56⅛ in. (92.4 x 143.8 cm.)

National Collection of Fine Arts,
Smithsonian Institution

The Moose Chase probably depicts the Indians of the Canadian Great Lakes area where, shortly after his western trip, Brush spent his honeymoon. While there, he sought (and found in a traveling circus) a live moose to sketch, presumably for this picture. The canoe may have been modeled on the one Brush traveled in for several days on that same trip. His paintings of Indians are unlike those of Remington and Russell which center around fast action, and they are different also from the scientific records of ethnologist-artists. In Brush's Indian paintings there is an atmosphere which, intentionally or not, intimates the downfall of the race. *The Moose Chase* achieves a poetic overtone from the monumental, classically formed figures gliding through the water in their canoe. Even the action of the foremost Indian with the lance does not destroy the calm of the scene.

Raised primarily in Danbury, Connecticut, Brush received some preliminary instruction in art from his mother, an amateur painter, before enrolling in the National Academy of Design at age sixteen. Three years later he was attending the Ecole des Beaux-Arts, where he was greatly influenced by the style of his master, Gérôme, whose work was characterized by carefully drawn and modeled forms and a totally smooth paint surface. Soon after returning to America in 1879, Brush accompanied his brother on a trip to Wyoming. Living in a log cabin and traveling in southern Montana, he visited and made sketches of Indians at a time when they were popular subjects among artists. His first success in painting was with Indian subjects, though he later became famous for his paintings of mother and child themes using his own family as models.

82

Whittling, 1881

Oil on canvas

15 ⅜ x 21 in. (39.0 x 53.3 cm.)

Jo Ann and Julian Ganz, Jr.

Whittling, with its strong brush-strokes and objective approach to the subject matter, is a genre scene with none of the sentimentality that characterized the work of Gaul's teacher, J. G. Brown.

Like many artists of the period, Gaul earned his living as a writer and illustrator, gathering material from his experiences during his travel throughout the western United States and abroad. Artists of the period habitually filled their studios with costumes and regalia used in their paintings, and *Whittling,* painted in 1881 but posed in the costume of about 1840, seems to be authentic.

Gilbert Gaul was renowned for his scenes of military life though he began his career as an artist of genre and historical scenes and continued painting non-military scenes throughout his life. Born in Jersey City, Gaul could trace his ancestry back to the Revolutionary War. He received some early education at the Claverack Military Academy, an experience that may have contributed to his later affinity for military subjects. Having studied with the genre artist J. G. Brown he concentrated on genre paintings until the early 1880s, when military themes began to dominate his work. When the Art Students League was organized he enrolled there, and in 1872 he began exhibiting at the National Academy of Design. Achieving a widespread reputation at the end of the nineteenth century as a painter of military scenes, Gaul continued to exhibit until the year he died.

83

Ball at the Art Students League, 1910
Oil on canvas
47 ½ x 59 in. (120.7 x 149.8 cm.)
Victor D. Spark

Several American artists of the early 1900s have identified the subject of this painting as a dance at the Art Students League of New York. An art school founded in 1875, the League still exists today. The ball shown here was an unofficial student affair, similar to other masquerades held all over the country in the early twentieth century when fancy dress balls were very much in vogue. The lavish costumes were probably either borrowed from models' wardrobes or designed by the artists themselves in a competitive spirit. The uninhibited Bohemian atmosphere of the artists' masquerade balls undoubtedly made them even more inviting.

Several of the dancers in this painting have been identified: Walter Pach, painter (toward the left); Ernest Lawson, painter (with cap and Van Dyck beard and moustache, right of center); and the artist's wife (wearing a black dress, just to the right of the girl in white). The costumes are varied, with people dressed as Indians, ranchers, and gypsies, but with an emphasis on Spanish attire. Mora delighted in depicting women in shawls and mantillas and exhibited several pictures with Spanish themes in the major annual exhibitions of the early twentieth century. The majority of his studies included only one or two people, and the complicated tableau of the *Ball at the Art Students League* is unusual for him.

Mora was born in Montevideo, Uruguay, and spent his childhood there and in Spain. He came to America with his father, a Spanish sculptor who taught at various times in New Jersey, New York, and Massachusetts. Mora's natural inclination to art was encouraged by his father, and he studied at the School of the Boston Museum of Fine Arts and at the Art Students League of New York. By 1892 he was already illustrating magazines. His commission in 1900 to paint a decorative panel for the Lynn, Massachusetts, public library established Mora as a muralist, and he began receiving important commissions for murals throughout America. In addition, he became well known for his portraits in oil and for the watercolors, etchings, and drawings he frequently exhibited in important annual exhibitions. Except for visits to western Europe in 1906-1907, 1913-1914, and 1934, Mora remained in the United States. Though he was a member of many clubs and the winner of numerous awards, very little has been written about him.

Ulrich is one of several painters at home both in Europe and the United States. Born in New York City, he studied at the National Academy of Design before traveling abroad. He was profoundly influenced by his study in Munich where for eight years he worked with Lofftz and Lindenschmidt. When he returned to this country he exhibited, at the National Academy, American genre subjects which critics praised for their sincerity, thoughtfulness, insight, and strength of character. Avoiding the portrayal of the "fashionable upper crust" so popular with his contemporaries, Ulrich instead painted immigrants (in *The Land of Promise*) and the working class (in *The Village Print Shop*). This use of urban subjects foreshadowed the work of the social realists.

Ulrich lived in New York until around 1887 when he listed his address as Paris. During 1889 and 1890, when he sent works to the Royal Academy exhibition in London, he was living in Venice. The titles of his paintings of this period, such as *The Dancing Faun* and *Spanish Letter Writer,* suggest that his themes were changing to appeal to a continental audience. From 1899 to 1902 he lived in Rome, and when he died at the age of fifty he was residing in Berlin.

84

The Village Print Shop, ca. 1885
Oil on panel
23 x 23 in. (58.4 x 58.4 cm.)
Mrs. Norman B. Woolworth

Unlike more traditional painters who might have concentrated on the printer and the activity of his press, Ulrich magnified a peripheral action in *The Village Print Shop* and made it the painting's subject. Though full of detail the work is not overcome by it; the detail is subdued, producing an effect of overall richness. The fact that the composition is highly successful despite the obvious central split attests to Ulrich's skill. The painting projects a sense of immediacy, suggesting that the viewer has chanced upon an unposed situation; it evokes an empathy usually untouched by sentimental contemporary works.

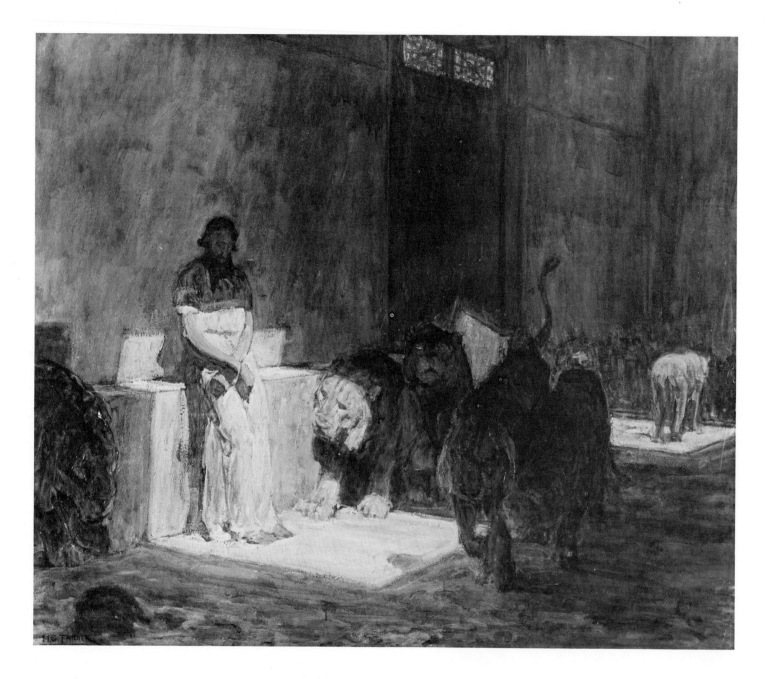

Tanner was born to educated Afro-American parents; his father was a minister in the African Methodist Episcopal Church. As a child he showed interest in sketching in school and decided on an art career after watching an artist work in Fairmount Park, Philadelphia. For two years he studied with Thomas Eakins at the Pennsylvania Academy, then after a brief career as photographer and teacher he went to Paris. He studied at the Académie Julian in the 1890s and exhibited in the Salons, where he received his first critical recognition.

Tanner remained in France until his death, though he made two trips to the Mediterranean in 1898 and 1910 and was in England during World War I.

85

Daniel in the Lion's Den, ca. 1916
Oil on paper on canvas
41¼ x 50 in. (104.8 x 127.0 cm.)
Los Angeles County Museum of Art,
Mr. and Mrs. William Preston
Harrison Collection

In the mid-1890s Tanner turned from genre scenes of Afro-American life to religious subjects. One of his first such works was *Daniel in the Lion's Den* which received an honorable mention when it was exhibited at the Salon of 1896. Tanner had painted lions while still in America and had sold the painting *A Lion at Home* from a National Academy of Design exhibition. Encouraged by the sale he planned an Androcles which he did not complete, but it apparently suggested to him the subject of Daniel. "For this picture," he wrote in his autobiography, "I modeled lions in the Jardin des Plantes, and also worked in the summer class of Fremiel." The original *Daniel in the Lion's Den* is now lost, though the one at the Los Angeles County Museum of Art is often mistaken for it. However, the Los Angeles painting is entirely different in shape and in such details as the light from the window and the position of some of the lions. It is painted in oil on paper glued to canvas and since the glazing technique and color resemble his work of the mid-teens it may be that he made this second painting over his original cartoon.

One evening while he was riding in an omnibus in Paris, Tanner marveled at the beauty around him. "Inside, the figures dimly lighted with a rich cadmium; outside, the cool night with here and there a touch of moonlight." He portrays such a moonlight effect in many of his religious canvases, including *Daniel,* using layers of glazes to emphasize depth. Like other spiritual painters of the late 1800s, Tanner's desire to paint religious scenes came from his personal faith rather than church commissions, and he expressed his own mysticism in these canvases.

Very little is known of this nineteenth-century genre and *trompe l'oeil* painter. Born in San Francisco, at age fourteen he went to Munich to study art. Chase and Duveneck were there using the bold brushstroke technique of the new realism under Wilhelm Leibl, but Alexander's masters taught him a more delicate and conservative technique. He learned to paint as an academic realist and to create still lifes that verged on *trompe l'oeil*. Returning to San Francisco in the early 1880s, he remained there until 1887 when he went to New York, already considered the artistic center of the United States. He resided at the famous Tenth Street Studios until death cut his career short at the age of thirty-three.

Alexander's obscurity is due to two occurrences—an early death before his reputation had been established and the almost total destruction of his artistic output in the San Francisco fire of 1906. In February 1973 the M. H. De Young Memorial Museum exhibited the few works of his that have survived, and they reveal that Alexander was a perceptive genre painter almost more interested in the clutter of objects surrounding his subject than in the subject itself.

86

The Laboratory of Thomas Price, ca. 1886
Oil on canvas
36 x 30 in. (91.4 x 76.2 cm.)
The Metropolitan Museum of Art,
Alfred N. Punnett Endowment Fund, 1939

The Laboratory of Thomas Price was probably painted sometime between 1880 and 1887 in San Francisco. Price, who was California State Mineralogist and Chemist, is shown surrounded by his assaying equipment, and the individual objects are treated in such detail that the composition almost becomes a still life. Alexander has even included the sign of the What Cheer House, one of the most popular California hotels, which stood across the street from the laboratory. Such careful detail is typical of Alexander's work and his other extant paintings record the clutter in a business office, a taxidermist's shop, a cobbler's shop, and several Chinese restaurants. Alexander was a gifted genre artist; however, in his painstaking attention to background he is also a still life painter of the highest capability. The fascination of Alexander's painting lies in discovering each minutely recorded object; like a visit to an antique shop, there is always the feeling that some treasure is waiting to be discovered in the clutter.

Bellows was born in Columbus, Ohio, and attended Ohio State University. He graduated in 1903 and worked briefly as a newspaper cartoonist in Columbus. A year later he was in New York where he began studying art under Robert Henri. In 1908 he received a second Hallgarten Prize for his work exhibited at the National Academy of Design; and a year after that he became the youngest associate member of the Academy. Bellows was one of the early twentieth-century painters who found inspiration in the lives of working class people and his work is closely related to that of the Ashcan group. He expressed the energy of his times in canvases depicting prize fights, the circus, people on the beaches, and scenes of his own family life. He exhibited in the Armory Show of 1913 and was a founding member of the Society of Independent Artists organized by John Sloan. He died at forty-three but in his short career had not only produced a vast body of work but had re-established lithography as a respected art form.

87

Return of the Useless, 1918
Oil on canvas
59 x 66 in. (149.8 x 167.6 cm.)
Mrs. C. Ruxton Love, Courtesy of
Hirschl and Adler Galleries

The *Return of the Useless* was painted in autumn 1918, just before the Armistice was signed ending World War I. It shows northern French peasants being returned through Allied lines by the Germans who found them no longer fit to work. In the early part of the war Bellows had dismissed reports of German atrocities as rumors, but after reading eyewitness accounts of the atrocities in the Bryce Reports, he issued a series of seventeen anti-war lithographs in the spring of 1918. That summer he put his name on a list of volunteers for the newly organized Tank Corps and towards fall began to make paintings inspired by his series of lithographs. He was completing the *Return* when the war ended. Though the subject is not "American" it reflects Bellows' recognition of social injustice and the plight of the common man.

ALEXANDER, Henry

Frankenstein, Alfred. *After the Hunt.* Berkeley and Los Angeles: University of California Press, 1969. pp. 145-146.

Frankenstein, Alfred. "S.F. Realist's Reputation." *San Francisco Chronicle,* 4 February 1973. "This World," pp. 37-38.

ANSHUTZ, Thomas

Bowman, Ruth. "The Artist as Model: a Portrait of David Wilson Jordan by Thomas Anshutz." *The Register of the Museum of Art* (University of Kansas, Lawrence) 4 (Fall 1973): 4-34.

Bowman, Ruth. "Nature, the Photograph and Thomas Anshutz." *Art Journal* 33 (Fall 1973): 32-40.

Cournos, John. "A Great Art Instructor: His Methods and Ideas." *Philadelphia Record,* 29 May 1910.

Graham Gallery. *Thomas Anshutz, 1851-1912, a Retrospective Exhibition* (exhibition catalog). New York: 1963.

Katz, Leslie. "The Breakthrough of Anshutz." *Arts* 37 (March 1963): 26-29.

"A Maker of Painters." *Boston Evening Transcript,* 10 February 1912.

Pennsylvania Academy of the Fine Arts. *Thomas P. Anshutz . . .* (exhibition catalog). Philadelphia: 1973.

Ziegler, F. J. "An Unassuming Painter—Thomas P. Anshutz." *Brush & Pencil* 4 (1899): 277-284.

BACON, Henry

City Art Museum of St. Louis. *An Exhibition of Paintings . . . of Egypt & Greece . . . in Water Color by . . . Henry Bacon* (exhibition catalog). St. Louis: 1913.

"Henry Bacon." *Panorama* 1 (May 1946): 95.

National Gallery of Art. *Catalogue of a Memorial Exhibition . . . Water Colors of Egypt, Greece, France, Italy and England . . .* (exhibition catalog). Washington, D.C.: 1931.

BARTLETT, John Russell

Bartlett, John Russell. *Personal Narrative of Explorations and Incidents in Texas, New Mexico, California, Sonora and Chihuahua.* New York: D. Appleton & Co., 1854.

Hine, Robert V. *Bartlett's West.* New Haven: Yale University Press, 1968.

BEARD, James Henry

"James Henry Beard." *Dictionary of American Biography.* New York: Charles Scribner's Sons, 1964.

Smith, S. Winifred. "James Henry Beard." *Museum Echoes* 27 (April 1954): 27-30.

BELLOWS, George Wesley.

Bellows, Emma Louise, comp. *George W. Bellows: His Lithographs.* New York: A. A. Knopf, 1927.

Braider, Donald. *George Bellows and the Ashcan School of Painting.* Garden City: Doubleday, 1971.

The Metropolitan Museum of Art. *Memorial Exhibition of the Work of George Bellows* (exhibition catalog). New York: 1925.

Morgan, Charles Hill. *George Bellows, Painter of America.* New York: Reynal, 1965.

National Gallery of Art. *George Bellows; a Retrospective Exhibition* (exhibition catalog). Washington, D.C.: 1957.

BIERSTADT, Albert

Amon Carter Museum. *A. Bierstadt* (exhibition catalog), Gordon Hendricks. Fort Worth: 1972.

Hendricks, Gordon. "The First Three Western Journeys of Albert Bierstadt." *Art Bulletin* 46 (September 1964): 333-365.

Santa Barbara Museum of Art. *Albert Bierstadt, 1830-1902* (exhibition catalog). Santa Barbara: 1964.

Spieler, Gerhard G. "A Noted Artist in Early Colorado: The Story of Albert Bierstadt." *American-German Review* 11 (June 1945): 13-17.

Trump, Richard Shafer. "Life and Works of Albert Bierstadt." Ph.D. dissertation, Ohio State University, 1963.

BINGHAM, George Caleb

Bloch, E. Maurice. *George Caleb Bingham.* 2 vol. Berkeley and Los Angeles: University of California Press, 1967.

Christ-Janer, Albert. *George Caleb Bingham of Missouri. . . .* New York: Dodd, Mead & Co., 1940.

McDermott, John Francis. *George Caleb Bingham, River Portraitist.* Norman: University of Oklahoma Press, 1959.

National Collection of Fine Arts. *George Caleb Bingham, 1811-1879* (exhibition catalog), E. Maurice Bloch. Washington, D.C.: Smithsonian Institution Press, 1967.

Rusk, Fern Helen. *George Caleb Bingham, the Missouri Artist.* Jefferson City: Hugh Stephens Co., 1917.

BLASHFIELD, Edwin Howland

Blashfield, Edwin H. *Mural Painting in America (The Scammon Lectures).* New York: Charles Scribner's Sons, 1913.

Whitworth, Grace. "The Work and Workshop of Edwin Howland Blashfield." *Fine Arts Journal* 23 (November 1910): 284-290.

The Works of Edwin Howland Blashfield. Introduction by Royal Cortissoz. New York: Charles Scribner's Sons, 1937.

BLYTHE, David Gilmour

Abraham, Evelyn. "David G. Blythe, American Painter and Woodcarver." *Antiques* 27 (May 1935): 180-183.

Columbus Gallery of Fine Arts. *Works by David Blythe, 1815-1865* (exhibition catalog). Columbus: 1968.

Miller, Dorothy. *The Life and Work of David G. Blythe.* Pittsburgh: University of Pittsburgh

O'Connor, John, Jr. "David Gilmour Blythe, 1815-1865." *Panorama* 1 (January 1946): 39-45.

BROWERE, Albertis del Orient

Conkling, Roscoe P. "Reminiscences on the Life of Alburtis Del Orient Browere." *Los Angeles Museum Quarterly* 8 (Spring 1950): 2-6.

Smith, Mabel P. and MacFarlane, Janet R. "Unpublished Paintings by Albertis del Orient Browere." *Art in America* 46 (Fall 1958): 68-71.

Wright, Charles G. *Alburtus D. O. Browere. . . .* Paper presented to Greene County Historical Society, 1971.

BROWN, John George

Benjamin, S. G. W. "A Painter of the Streets." *Magazine of Art* 5 (April 1882): 265-270.

"John George Brown." *Dictionary of American Biography.* New York: Charles Scribner's Sons, 1958.

Sheldon, G. W. *American Painters.* New York: D. Appleton & Co., 1879. pp. 141-144.

BRUSH, George de Forest

Bowditch, Nancy Douglas. *George de Forest Brush; Recollections of a Joyous Painter.* Peterborough, N.H.: Noone House, 1970.

CLONNEY, James Goodwyn

Museum of Fine Arts. *M. and M. Karolik Collection of American Paintings, 1815-1865.* Cambridge: Harvard University Press, 1949. pp. 166-185.

COLE, Thomas

Baltimore Museum of Art. *Studies on Thomas Cole, an American Romanticist.* Baltimore Museum of Art Annual II. Baltimore: 1967.

Bryant, William C. "Eulogy." *Orations and Addresses.* New York: G. P. Putnam's Sons, 1873.

Memorial Art Gallery, University of Rochester. *Thomas Cole* (exhibition catalog), Howard S. Merritt. Rochester: 1969.

Noble, Louis Legrand. *The Life and Works of Thomas Cole.* Cambridge: Belknap Press of Harvard University Press, 1964.

Wadsworth Atheneum. *Thomas Cole, 1801-1848, One Hundred Years Later* (exhibition catalog), Esther Isabel Seaver. Hartford: 1948.

COPLEY, John Singleton

Adams, Charles Francis, *et al.,* eds. *Letters and Papers of John Singleton Copley and Henry Pelham.* Massachusetts Historical Society Collections 71. n.p., 1914.

Amory, Martha Babcock. *Domestic and Artistic Life of John Singleton Copley.* Boston: Houghton Mifflin Co., 1882.

Bayley, Frank W. *The Life and Works of John Singleton Copley.* Boston: Taylor Press, 1915.

Flexner, James T. *John Singleton Copley.* Boston: Houghton Mifflin Co., 1948.

The Metropolitan Museum of Art. *An Exhibition of Paintings by John Singleton Copley* (exhibition catalog). New York: 1936.

National Gallery of Art. *John Singleton Copley, 1738-1815* (exhibition catalog). Washington, D.C.: 1965.

Parker, Barbara N. and Wheeler, Anne B. *John Singleton Copley: American Portraits. . . .* Boston: Museum of Fine Arts, 1938.

Perkins, Augustus Thorndike. *A Sketch of the Life and a List of Some of the Works of John Singleton Copley.* Boston: Privately printed, 1873.

Plate, Robert. *John Singleton Copley: America's First Great Artist.* New York: McKay, 1969.

Prown, Jules David. *John Singleton Copley.* Cambridge: Harvard University Press, 1966.

CULVERHOUSE, Johann Mongles

Groce, George C. and Wallace, David H. *The New-York Historical Society's Dictionary of Artists in America, 1564-1860.* New Haven: Yale University Press, 1957.

Marlor, Clark S. *A History of the Brooklyn Art Association with an Index of Exhibitions.* New York: James F. Carr, 1970.

Onondaga Historical Association. *Johann Mongles Culverhouse in Syracuse.* (Three-page ditto sheet compilation of newspaper articles) July, 1971.

DEAS, Charles

McDermott, John Francis. "Charles Deas: Painter of the Frontier." *Art Quarterly* 13 (Autumn 1950): 293-311.

Tuckerman, Henry T. *Sketches of Eminent American Painters.* New York: D. Appleton & Co., 1849. pp. 202-214.

DURAND, Asher Brown

Cowdrey, Bartlett. "Asher Brown Durand, 1796-1886." *Panorama* 2 (October 1946): 13-23.

Durand, John. *The Life and Times of A. B. Durand.* New York: Charles Scribner's Sons, 1894.

Montclair Art Museum. *A. B. Durand, 1796-1886* (exhibition catalog). Newark: 1971.

Sherman, Frederic F. "Asher B. Durand as a Portrait Painter." *Art in America* 18 (October 1930): 309-316.

Sweet, Frederick A. "Asher B. Durand. . . ." *Art Quarterly* 8 (Spring 1945): 140-160.

EAKINS, Thomas

Goodrich, Lloyd. *Thomas Eakins, His Life and Work.* New York: Whitney Museum of American Art, 1933.

Hoopes, Donelson F. *Eakins Watercolors.* New York: Watson-Guptill, 1971.

McKinney, Roland J. *Thomas Eakins.* New York: Crown Publishers, 1942.

National Gallery of Art. *Thomas Eakins, a Retrospective Exhibition* (exhibition catalog). Washington, D.C.: 1961.

Pennsylvania Academy of the Fine Arts. *Memorial Exhibition . . .* (exhibition catalog). Philadelphia: 1918.

Porter, Fairfield. *Thomas Eakins.* New York: G. Braziller, 1959.

Whitney Museum of American Art. *Thomas Eakins Retrospective Exhibition* (exhibition catalog). New York: 1970.

EICHHOLTZ, Jacob

Beal, Rebecca J. *Jacob Eichholtz, 1776-1842, Portrait Painter of Pennsylvania.* Philadelphia: Historical Society of Pennsylvania, 1969.

Hensel, William U. "An Artistic Aftermath." *Lancaster County Historical Society Papers* 17 (1913): 106-111.

————. "Jacob Eichholtz, Painter." *Lancaster County Historical Society Papers* 16 (1912): supplement.

Pennsylvania Academy of the Fine Arts. *Jacob Eichholtz, 1776-1842, Pennsylvania Painter, a Retrospective Exhibition* (exhibition catalog). Philadelphia: 1969.

Philadelphia Art Alliance. *Jacob Eichholtz, 1776-1842, American Artist* (exhibition catalog). Philadelphia: 1943.

Richardson, Edgar P. "Portraits by Jacob Eichholtz." *Art in America* 27 (January 1939): 14-22.

Thorpe, R. W. "Jacob Eichholtz." *Antiquarian* 6 (March 1926): 31-33.

FIELD, Erastus Salisbury

Abby Aldrich Rockefeller Folk Art Collection. *Erastus Salisbury Field, 1805-1900* (exhibition catalog), Mary C. Black. Williamsburg: 1963.

Black, Mary. "Rediscovery: Erastus Salisbury Field." *Art in America* 54 (January-February 1966): 49-56.

Dods, Agnes M. "Erastus Salisbury Field (1805-1900)." *Old-Time New England* 33 (October 1942): 26-32.

FREEMAN, James Edward

Freeman, James E. *Gatherings from an Artist's Portfolio.* New York: D. Appleton & Co., 1877.

Freeman, James E. *Gatherings from an Artist's Portfolio in Rome.* Boston: Roberts Bros., 1883.

"James Edward Freeman." *Dictionary of American Biography.* New York: Charles Scribner's Sons, 1960.

GAUL, William Gilbert

Braus Galleries. *Memorial Exhibition of Paintings by Gilbert Gaul* (exhibition catalog). New York: n.d.

Dreiser, Theodore. "A Painter of Travels." *Ainslee's Magazine* 1 (June 1898): 391-398.

Gaul, Gilbert. "Jamaica." *Century* 45 (March 1893): 682-688.

————. "Personal Impressions of Nicaragua." *Century* 46 (May 1893): 64-71.

Gilder, Jeannette L. "A Painter of Soldiers." *Outlook* 59 (2 July 1898): 570-573.

Lathrop, George Parsons. "An American Military Artist." *The Quarterly Illustrator* 1 (October-December 1893): 235-241.

GUY, Seymour Joseph

"Seymour Joseph Guy." *Dictionary of American Biography.* New York: Charles Scribner's Sons, 1960.

HAHN, William

Los Angeles County Museum of Art. *The American West* (exhibition catalog), Larry Curry. New York: Viking Press, 1972.

Smith, H. Armour. *William Hahn, Painter of the American Scene.* Yonkers: Hudson River Museum at Yonkers, 1942.

Thieme, Ulrich and Willis, Fred C. *Allgemaines Lexicon der Bildenden Künstler.* Leipzig: E. A. Seemann, 1922. vol. 15, p. 480.

HAMILTON, James

The Brooklyn Museum. *James Hamilton, 1819-1878, American Marine Painter* (exhibition catalog), Arlene Jacobowitz. Brooklyn: 1966.

HEALY, George Peter Alexander

Bigot, Mme. Charles. *Life of George P. A. Healy by His Daughter, Mary.* . . . n.p., nd.

de Mare, Marie. *G. P. A. Healy, American Artist.* New York: McKay, 1954.

Healy, George Peter Alexander. *Reminiscences of a Portrait Painter.* Chicago: A. C. McClurg & Co., 1894.

Pattison, James William. "Centenary of George Peter Alexander Healy." *Fine Arts Journal* 28 (April 1913): 227-242.

Virginia Museum of Fine Arts. *A Souvenir of the Exhibition Entitled Healy's Sitters.* . . . (exhibition catalog). Richmond: 1950.

HENRY, Edward Lamson

Cowdrey, Mary Bartlett. "Edward Lamson Henry, an American Genre Painter." *American Collector* 14 (July 1945): 6-7, 12, 16.

Fuller, L. F. "E. L. Henry, N.A." *Scribner's* 68 (August 1920): 250-256.

McCausland, Elizabeth. *The Life and Work of Edward Lamson Henry, N.A., 1841-1919.* New York State Museum Bulletin No. 339. Albany: University of the State of New York, 1945.

HESSELIUS, Gustavus

Hart, Charles H. "The Earliest Painter in America." *Harper's New Monthly Magazine* 96 (March 1898): 566-570.

Hart, Charles H. "Gustavus Hesselius." *Pennsylvania Magazine of History and Biography* 29 (April 1905): 129-133.

Keyes, Homer E. "Doubts Regarding Hesselius." *Antiques* 34 (September 1938): 144-146.

Philadelphia Museum of Art. *Gustavus Hesselius, 1682-1755.* Philadelphia: 1938.

Richardson, Edgar P. "Gustavus Hesselius." *Art Quarterly* 12 (Summer 1949): 220-226.

Tolles, Frederick B. "A Contemporary Comment on Gustavus Hesselius." *Art Quarterly* 17 (Autumn 1954): 271-273.

HOMER, Winslow

Downes, William Howe. *The Life and Works of Winslow Homer.* Boston and New York: Houghton Mifflin Co., 1911.

Goodrich, Lloyd. *Winslow Homer.* New York: Macmillan Co., 1944.

Hoopes, Donelson F. *Winslow Homer Watercolors.* New York: Watson-Guptill, 1969.

Whitney Museum of American Art. *Winslow Homer* (exhibition catalog), Lloyd Goodrich. New York: 1973.

Wilmerding, John. *Winslow Homer.* New York: Praeger Publishers, 1972.

HUNTINGTON, Daniel

Benjamin, S. G. W. "Daniel Huntington." *American Art and American Art Collections* 1 (1889): 19-36.

Catalogue of the Collection of Paintings Formed by D. Huntington. (sale catalog). Keeler Art Galleries. New York: 1916.

"Daniel Huntington." *Dictionary of American Biography.* New York: Charles Scribner's Sons, 1961.

Tuckerman, Henry T. *Book of the Artists.* . . . New York: G. P. Putnam and Sons, 1867. pp. 321-332.

JOHNSON, Eastman

Baur, John I. H. "Eastman Johnson, Artist-Reporter." *American Collector* 9 (February 1940): 6-7.

The Brooklyn Museum. *An American Genre Painter: Eastman Johnson, 1824-1906* (exhibition catalog), John I. H. Baur. Brooklyn: 1940.

Crosby, Everett U. *Eastman Johnson at Nantucket.* . . . Nantucket: Privately printed, 1944.

Hartmann, Sadakichi. "Eastman Johnson: American Genre Painter." *Studio* 43 (March 1908): 106-111.

Whitney Museum of American Art. *Eastman Johnson* (exhibition catalog), Patricia Hills. New York: C. N. Potter, 1972.

KEITH, William

Brother Cornelius. *Keith, Old Master of California.* 2 vol. New York: G. P. Putnam's Sons, 1942.

Neuhaus, Eugen. *William Keith: the Man and the Artist.* Berkeley: University of California Press, 1938.

KIP, Henry De Valcourt

Manley, G. Atwood. "Clues to Identification of Salathiel Ellis Unfold." *Watertown Daily Times,* 11 September 1961.

LEUTZE, Emanuel Gottlieb

Stehle, Raymond Louis. "Emanuel Leutze, 1816-1868." *Columbia Historical Society Records* 69-70 (1969-1970): 306-331.

———. "Virginia Episodes in the Life of Emanuel Leutze." *Virginia Magazine of History and Biography* 75 (January 1967): 3-10.

Tuckerman, Henry T. *Book of the Artists.* . . . New York: G. P. Putnam & Sons, 1867. pp. 333-345.

MATTESON, Tompkins Harrison

Sherburne Art Society. *Thompkins H. Matteson, 1813-84* (exhibition catalog). Sherburne, N.Y.: Sherburne News, 1949.

MILLET, Francis Davis

American Art Association. *Catalogue of the Finished Paintings, Drawings and Studies Left by the Late Francis Davis Millet* (sale catalog). New York: 1914.

American Federation of Arts. *Francis Davis Millet Memorial Meeting.* Washington, D.C.: Gibson Bros., 1912.

Brown, Glenn. "Francis Davis Millet." *American Institute of Architects Quarterly Bulletin* 13 (April 1912): 19-23.

Hastings, Thomas. *Commemorative Tributes to John La Farge, Edwin Austin Abbey, Francis Davis Millet.* . . . New York: American Academy of Arts and Letters, 1922.

"Memorial Issue." (Six articles on Millet). *Art and Progress* 3 (July 1912): 635-655.

Skinner, Charles M. "The Domestic Pictures of Frank D. Millet." *International Studio* 32 (October 1907): CXI-CXX.

MORA, Francis Luis

"F. Luis Mora, 65, A Noted Painter." *New York Times,* 6 June 1940. p. 25, col. 4.

"Francis Luis Mora." *National Cyclopaedia of American Biography.* New York: J. T. White Co., 1893. vol. 30, pp. 225-226.

MORSE, Samuel Finley Breese

Larkin, Oliver W. *Samuel F. B. Morse and American Democratic Art.* Boston: Little, Brown & Co.: 1954.

Mabee, Carleton. *The American Leonardo; A Life of Samuel F. B. Morse.* New York: A. A. Knopf, 1943.

The Metropolitan Museum of Art. *Samuel F. B. Morse, American Painter* (exhibition catalog), Henry B. Wehle. New York: 1932.

Morse, Edward L., ed. *Samuel F. B. Morse; His Letters and Journals.* Boston and New York: Houghton Mifflin Co., 1914.

———. "Samuel F. B. Morse, the Painter." *Scribner's Magazine* 51 (March 1912): 346-359.

National Academy of Design. *Morse Exhibition of Arts and Science . . .* (exhibition catalog). New York: 1950.

MOUNT, William Sidney

Cowdrey, Bartlett and Williams, Hermann Warner, Jr. *William Sidney Mount, 1807-1868; an American Painter.* New York: Columbia University Press, 1944.

Frankenstein, Alfred. *Painter of Rural America; William Sidney Mount, 1807-1868.* (exhibition catalog). Washington, D.C.: 1968.

Suffolk Museum at Stony Brook. *The Mount Brothers: an Exhibition* (exhibition catalog), Mary Bartlett Cowdrey. Stony Brook, Long Island, 1947.

NAHL, Charles Christian

"Charles Christian Nahl." *California Art Research.* San Francisco: n.p., 1937. vol. 1, pp. 19-54.

Neuhaus, Eugen. *Charles Christian Nahl, the Painter of California Pioneer Life.* San Francisco, 1937. Paper presented at the 14th International Congress of Art History at the University of Bern, Switzerland, 6 September 1936.

NARJOT, Erneste Etienne de Francheville

Dressler, Albert. *California's Pioneer Artist, Ernest Narjot. . . .* San Francisco: Albert Dressler, 1936.

PAGE, William

Akers, Paul. "Our Artists in Italy: William Page." *Atlantic Monthly* 7 (February 1861): 129-137.

Paradise, Scott H. "William Page." *Phillips Bulletin* 27 (October 1933): 13-22.

Richardson, E. P. "Two Portraits by William Page." *Art Quarterly* 1 (Spring 1938): 91-103.

Taylor, Joshua C. *William Page, the American Titian.* Chicago: University of Chicago Press, 1957.

PEALE, Charles Willson

Pennsylvania Academy of the Fine Arts. *Catalogue of an Exhibition of Portraits by Charles Willson Peale and James Peale and Rembrandt Peale* (exhibition catalog). Philadelphia: 1923.

Sellers, Charles Coleman. *Charles Willson Peale.* Memoirs of the American Philosophical Society. Philadelphia: n.p., 1947. vol. 23, pts. 1-2.

———. *Portraits and Miniatures by Charles Willson Peale.* Transactions of the American Philosophical Society. Philadelphia: American Philosophical Society, 1952. vol. 42, pt. 1.

Washington County Museum of Fine Arts. *The Peale Heritage, 1763-1963* (exhibition catalog). Hagerstown, Md.: 1963.

QUIDOR, John

Brooklyn Institute of Arts and Sciences Museum. *John Quidor, 1801-1881* (exhibition catalog), John I. H. Baur. Brooklyn: 1942.

Munson-Williams-Proctor Institute. *John Quidor* (exhibition catalog). Utica: 1965.

RANNEY, William Tylee

Grubar, Francis S. *William Ranney, Painter of the Early West.* New York: Clarkson N. Potter, Inc., 1962.

RIMMER, William

Bartlett, Truman H. *The Art Life of William Rimmer. . . .* Boston: J. R. Osgood & Co., 1882.

———. "Dr. William Rimmer." *American Art Review* 1 (September-October 1880): 461-468.

Gardner, Albert T. "Hiram Powers and William Rimmer. . . ." *Magazine of Art* 36 (February 1943): 43-47.

Kirstein, Lincoln. "The Rediscovery of William Rimmer." *Magazine of Art* 40 (March 1947): 94-95.

Rimmer, William. *Art Anatomy.* Boston: Little, Brown & Co., 1877.

———. *Elements of Design.* Boston: J. Wilson and Son, 1864.

Smith, E. R. "Dr. William Rimmer." *Architectural Record* 21 (March 1917): 187-204, 221.

Whitney Museum of American Art. *William Rimmer, 1816-1879* (exhibition catalog). New York: 1946.

RONDEL, Frederic

Groce, George C. and Wallace, David H. *The New-York Historical Society's Dictionary of Artists in America, 1564-1860.* New Haven: Yale University Press, 1957.

Naylor, Maria, compl. and ed. *The National Academy of Design Exhibition Record, 1861-1900.* New York: Kennedy Galleries, 1973.

ROSSITER, Thomas Prichard

Brumbaugh, Thomas B. "A Venice Letter from Thomas P. Rossiter to John F. Kensett—1843." *American Art Journal* 5 (May 1973): 74-78.

Flynn, James J. "The Legend of Breakneck." *New York Folklore Quarterly* 15 (Spring 1959): 48-58. (Contains excerpts and summary of "The Legend of Breakneck" a long, undated ms. poem by Rossiter).

ROTHERMEL, Peter Frederick

Coddington, Edwin B. "Rothermel's Paintings of the Battle of Gettysburg." *Pennsylvania History* 27 (January 1960): 1-27.

"Peter Frederick Rothermel." *Dictionary of American Biography.* New York: Charles Scribner's Sons, 1963.

SARGENT, Henry

Addison, Julia De Wolf. "Henry Sargent, a Boston Painter." *Art in America* 17 (October 1929): 279-284.

"Henry Sargent." *Dictionary of American Biography.* New York: Charles Scribner's Sons, 1963.

SCHUSSELE, Christian

Michel, Bernard E. "Christian Schussele: Portrayer of America." *Moravian Historical Society Transactions* 20 (1965): 249-267.

SPENCER, Lilly Martin

National Collection of Fine Arts. *Lilly Martin Spencer: 1822-1902, the Joys of Sentiment.* Washington, D.C.: Smithsonian Institution Press, 1973.

STANLEY, John Mix

Los Angeles County Museum of Art. *The American West* (exhibition catalog), Larry Curry. New York: Viking Press, 1972.

University of Michigan Museum of Art. *John Mix Stanley: a Traveller in the West* (exhibition catalog). Ann Arbor: 1969.

TANNER, Henry Ossawa

Frederick Douglass Institute and National Collection of Fine Arts. *The Art of Henry O. Tanner (1859-1937)* (exhibition catalog). Washington, D.C.: 1969.

Mathews, Marcia M. *Henry Ossawa Tanner, American Artist.* Chicago: University of Chicago Press, 1969.

THOMPSON, Jerome B.

"Jerome B. Thompson." *Dictionary of American Biography.* New York: Charles Scribner's Sons, 1964.

TOJETTI, Dominico

"Signor Dominico Tojetti." *California Art Research,* San Francisco: n.p., 1936. vol. 3, pp. 24-41.

TRUMBULL, John

Durand, John. "John Trumbull." *American Art Review* 2 (1881): 181-191, 221-230.

Morgan, John Hill. *Paintings by John Trumbull at Yale University.* . . . New Haven: Yale University Press, 1926.

Sizer, Theodore. *The Works of Colonel John Trumbull.* . . . New Haven: Yale University Press, 1950.

Trumbull, John. *Autobiography, Reminiscences and Letters.* New York and London: Wiley & Putnam, 1841.

Weir, John F. *John Trumbull.* . . . New York: Charles Scribner's Sons, 1901.

ULRICH, Charles Frederick

"Charles Frederick Ulrich." *National Cyclopaedia of American Biography.* New York: J. T. White Co., 1893. vol. I, p. 202.

"Obituary." *New York Times,* 21 May 1908. p. 7, col. 5.

Thieme, Ulrich and Becker, Felix. *Allgemeines Lexicon der Bildenden Künstler.* Leipzig: E. A. Seemann, 1939.

VANDERLYN, John

Dunlap, William. *History of the Rise and Progress of the Arts of Design.* 2 vol. New York: B. Blom, 1965. vol. 2, pp. 157-169.

Schoonmaker, Marius. *John Vanderlyn, Artist, 1775-1852.* Kingston, N.Y.: Senate House Assn., 1950.

State University of New York at Binghamton. *The Works of John Vanderlyn . . .* (exhibition catalog), Kenneth C. Lindsay. Binghamton: 1970.

Tuckerman, Henry T. *Book of the Artists.* . . . New York: G. P. Putnam & Sons, 1867. pp. 126-135.

VEDDER, Elihu

Soria, Regina. *Elihu Vedder; American Visionary Artist in Rome (1836-1923).* Rutherford: Fairleigh Dickinson University Press, 1970.

———— "Elihu Vedder's Mythical Creatures." *Art Quarterly* 26 (Summer 1963): 180-193.

Smithsonian Institution. *Paintings and Drawings by Elihu Vedder* (exhibition catalog). Washington, D.C.: 1966.

Vedder, Elihu. *The Digressions of V.* . . . Boston and New York: Houghton Mifflin Co., 1910.

WEIR, Robert Walter

Emrich, Duncan. *Folklore on the American Land.* Boston and Toronto: Little, Brown and Company, 1972. pp. 288-293.

Weir, Irene. *Robert W. Weir, Artist.* New York: House of Field Doubleday, Inc., 1947.

WEST, Benjamin

Evans, Grose. *Benjamin West and the Taste of His Times.* Carbondale, Ill.: Southern Illinois University Press, 1959.

Flexner, James T. "Benjamin West's American Neo-Classicism. . . ." *New York Historical Society Quarterly* 36 (January 1952): 5-41.

Galt, John. *The Life, Studies and Works of Benjamin West.* London: Printed for T. Cadell and W. Davies, 1820.

Sawitzky, William. "The American Work of Benjamin West." *Pennsylvania Magazine of History and Biography* 62 (October 1938): 433-462.

WEST, William Edward

Dunn, N. P., "An Artist of the Past: William Edward West and His Friends at Home and Abroad." *Putnam's Monthly* 2 (September 1907): 658-669.

WIMAR, Charles Ferdinand

"Charles Ferdinand Wimar." *American Art Review* 2 (1881): 175-182.

Hodges, William R. *Carl Wimar.* Galveston: Charles Reymershoffer, 1908.

City Art Museum of St. Louis. *Charles Wimar . . .* (exhibition catalog), Perry Rathbone. St. Louis: 1946.

WINNER, William E.

Groce, George C. and Wallace, David H. *The New-York Historical Society's Dictionary of Artists in America, 1564-1860.* New Haven: Yale University Press, 1957.

WOOD, Thomas Waterman

Benjamin, S. G. W. *Our American Artists.* Boston: D. Lothrop & Co., 1879. chap. 8.

M.J. "Three Paintings by Thomas Waterman Wood (1823-1903). . . ." *California Palace of the Legion of Honor Museum Bulletin* 2 (May 1944): 9-15.

Sheldon, G. W. *American Painters.* New York: D. Appleton & Co., 1879. pp. 109-110.

Thomas W. Wood Gallery of Fine Arts. *Catalogue of the Pictures . . . the Thomas W. Wood Collection.* Montpelier: Capital City Press, 1913.

Wood Art Gallery. *Thomas Waterman Wood, P.N.A.: 1823-1903: a Loan Exhibition of Paintings, Watercolors, and Sketches . . .* (exhibition catalog), William Lipke. Montpelier: 1972.

Index by title of painting

Index to works in exhibition by name of artist

Designed in Los Angeles by Louis Danziger.
All text set in 9 & 10 pt. Garamond by
Hallmark Press, New York City.
The catalog is printed on Kimberly-Clark's
Shorewood Suede by Halliday Lithograph,
West Hanover, Massachusetts.

The color plates were printed by
Princeton Polychrome, Princeton, N.J.
Bound by American Book-Stratford
Press, Saddle Brook, N.J.
in a paperbound edition of 32,500 and
a clothbound edition of 2000.